PRIMARY
SOURCES

SELECTED WRITINGS
ON COLOR FROM
ARISTOTLE TO ALBERS

PRIMARY SOURCES

SELECTED WRITINGS ON COLOR FROM ARISTOTLE TO ALBERS

EDITED BY PATRICIA SLOANE

DESIGN PRESS

First Edition, First Printing

Copyright ©1991 by Patricia Sloane

Printed in the United States of America

Designed by Gilda Hannah

Reproduction or republication of the content in any manner, without the express written permission of the publisher, is prohibited. The publisher takes no responsibility for the use of any of the materials or methods described in this book, or for the products thereof.

Credits and copyright notices for the individual selections contained in this book are given on pages 237–239 which constitute an extension of the copyright page.

Library of Congress Cataloging-in-Publication Data

Primary sources : selected writings on color from Aristotle to Albers
 Patricia Sloane, editor.
 p. cm.
 Includes bibliographical references.
 ISBN 0-8306-3481-9
 1. Color. I. Sloane, Patricia.
QC495.P75 1991 89-49485
535.6—dc20 CIP

Design Press offers posters and The Cropper, a device for cropping artwork, for sale. For information, contact Mail-order Department. Design Press books are available at special discounts for bulk purchases for sales promotions, fund raisers, or premiums. For details contact Special Sales Manager. Questions regarding the content of the book should be addressed to:

Design Press
11 West 19th Street
New York, NY 10011

Design Press books are published by Design Press, an imprint of TAB BOOKS. TAB BOOKS is a Division of McGraw-Hill, Inc. The Design Press logo is a trademark of TAB BOOKS.

For their assistance in the preparation of the manuscript for this book, I want to thank my research assistant, Gaye Rose; Christine de Vallet, Assistant Librarian at the Art and Architecture Library at Yale University; Gina Webster and Nancy Green at Design Press.

CONTENTS

PRIMARY SOURCES

SELECTED WRITINGS
ON COLOR FROM
ARISTOTLE TO ALBERS

PREFACE

This anthology is representative rather than exhaustive, and is designed primarily for students, artists, and general readers. It includes writings on color by artists as well as selections from the work of color theorists, philosophers, and scientists, whose ideas have influenced artists directly or indirectly. Hard choices had to be made as a result of limited space and many fine examples could not be included.

Perhaps because color has been called an illusion, many questions about its nature are never settled. Some have faded away. During the 1600s, Sir Isaac Newton argued bitterly with Robert Hooke about an issue we regard as semantic—whether a ray of white light is white or just looks white. Goethe had little patience with Newton's ideas about color and, in turn, his own ideas were dismissed by the philosopher Rudolph Carnap and the physicist Max Planck. Based on these and other similarly impolite exchanges between theorists, the history of color theory has been called remarkable for its nastiness. We can also read it as a fascinating chapter in the history of human thought.

Simple and Complex Colors

The earliest recorded reasoning about color, like the earliest religious reasoning, is analogical. Colors are compared with other phenomena that were thought to be better understood and with which parallels could be drawn.

Aristotle regarded colors as combinations of light and darkness. Some colors were simple and others were complex, though no consensus emerged among ancient writers on which colors belonged in each class. The simplicity of the simple colors was comparable to the simplicity of air, earth, fire, and water, which were considered then as the elements.

Today, with over 100 known chemical elements ranging from hydrogen, the lightest, to Lawrencium, the heaviest, we rarely compare colors to the elements. Nor do we expect the world to be based on simple mathematical

measures that anyone is able to understand. The idea of color as a mixture of light and darkness confuses us, because, rightly or wrongly, we assume that darkness is a nullity. But colors can actually be ranked from the lightest to the darkest. Aristotle's metaphor is not quite right. But it has its small grain of truth, limited because the Greeks were not experimenters. Aristotle left no recipes telling how to create the various individual colors or how to mix light and darkness.

The division into simple and complex colors lingers in the modern belief that some colors are primary (simple) and others are secondary or tertiary (complex). The primary colors, in theory, can be mixed to create all other colors. Or, in another definition, we cannot mix any primary color from other colors. Neither definition is quite right. The lustre of silver, gold, and metallic colors can be photographically captured with colored camera film, which contains layers of red, yellow, and blue (magenta, yellow, and cyan) dye. But no paint in a metallic color can be matched by mixing paints of these colors.

Colors and Music

Plato's ideas about color proved as enduring as Aristotle's. Plato discerned unity, and therefore beauty, in an unbroken expanse of color and in a musical tone. Nothing could be considered beautiful unless it posessed extension in space (color) or in time (music), since this was proof of existence.

Writers in later centuries remembered the comparison between music and color, which was carried further than it should have been. Newton may have contributed through his belief that the world was based on a measure of seven, including seven major hues in the rainbow and seven musical notes.

Color is a natural phenomenon. Music—unlike sound—is a human artifact, a constructed system with elaborate rules. Although we shouldn't expect colors to correlate with musical notes, numerous schemes comparing them sought to show similarities between harmony in musical chords and harmony (beauty) of color. In an offshoot of this reasoning, color organs of various kinds were built. The colors produced on a viewing screen were controlled by the musical notes input into the instrument.

The assumed correlation between colors and notes survived into its dotage, long after it was known that the scientific laws pertaining to sound waves did not correspond to those pertaining to light waves. The long survival, even into the twentieth century, was only partly because theorists could defend their systems by pointing to Plato. Among additional factors, the Greeks discovered that a mathematical ratio exists between the frequency of a vibrating string and the musical note the string emits. The discovery raised hope—later dashed—that simple rules could be found to identify color chords: combinations of colors that are harmonious and not

discordant (musical terms that were often applied to color which, respectively, mean beautiful and not beautiful). A few theorists were bold enough to say that all color combinations are beautiful, eliminating any need for recipes to separate the lovely from the unlovely.

The assumption of a correlation between color and music was also encouraged because music was much mentioned by early Modernist artists and art critics from the late 1800s into the early twentieth century. The issue was the relationship between music, the visual arts, and literature. Though Aristotle regarded art as an imitation of reality, we know that artists often imagine realities that never existed or that they have not experienced first hand. Books (including the Bible and other sacred texts) provide a frequent source of inspiration. For example, not one single painting of the crucifixion of Christ—one of the most popular subjects in Christian religious art—was created by an artist-observer who was watching, or had watched, the crucifixion.

A count of representational works of art from all parts of the world, from ancient through modern times, would probably show that the number of works with subject matter drawn from literature (or from stories passed down by word of mouth in societies with no written language) exceeds the number in which the subject is something the artist actually saw. Representational art, we still say, tells stories. It can be regarded as a handmaiden of literature, an idea not altogether pleasing to artists. The visual arts are devalued by implying that they depend on another art for their content.

Some artists went beyond saying that literary subject matter was not needed, and denied the importance of subject matter altogether. Take, for example, a painting by Rubens, *The Daughters of Cecrops finding the Infant Erechthonius*. What do we need to know to look at the painting? Is understanding significantly impaired for the viewer unfamiliar with Greek myths about Cecrops and Erechthonius?

The question was argued and continues to be argued. Abstract art went to the core by developing in tandem with a new metaphor that was often expressed in the following form: theorists urged the development of an art that would not rely on literature. It would follow the example set by music, which can have a narrative or literary content but does not necessarily require it. The comparison must have had a familiar ring. If colors can be correlated with musical notes, it follows that an abstract art made of colors—devoid of representational imagery—is comparable to music.

The sayings of Cézanne, supplemented by twentieth-century Minimalist and Conceptual art, refined what was vague in the syllogism. Non-objective art is neither "just colors" nor "shapeless," though it avoids representational shapes. Its shapes can be described by reference to geometry or as deviations—sometimes, extreme deviations—from geometrical shapes.

Color and Language

Language limits conceptualization, in the case of color as elsewhere. The wave theory of light explains the difference between the various colors of the rainbow or solar spectrum in terms of wave length, the distance (measured in millimicrons or angstrom units) between the peak of one wave of that particular color and the peak of the next wave. But we see far more variations in color than just the differences between the various colors of the rainbow. These further differences are often overlooked in scientific theory and awkwardly explained in everyday language, if they can be translated into words at all.

Among many examples, the fairly common terms "warmness" and "coolness," which correlate colors with tactile sensations, are poor names for the visual difference we see between the colors in the spectrum that have the longer wave lengths (red, orange, and yellow) and those with the shorter wave lengths (blue, green, and violet). We see more than we can translate into words, and the inadequacy of the names and terms used for colors has been a subject of complaint for at least a century.

The National Bureau of Standards has estimated that approximately ten million colors can be differentiated by the unaided human eye. No human language includes ten million color names, nor could anyone remember that many. As a result, any given color name, say, *blue* or *light cerulean blue*, refers to thousands of varieties. We bridge the gap visually by looking to see whether two samples of light cerulean blue match—one might be lighter, brighter, or more greenish than the other.

Black and *white* stand out as particularly complex color names, because of the many moral and psychological associations we impose on the words. We equate black and white with wrong and right, night and day, darkness and light, and with extremes on a scale. These links are learned through acculturation and persist through habit. Goethe, Vanderpoel, and other writers who allude to the moral associations they find in colors seldom, if ever, address the question of why colors should be more likely to have moral associations than stones, trees, or weather conditions.

The failure of these writers to fully explain their reasoning need not deter our untangling the rationale that constructs a morality of color usage—a set of rules about propriety in choosing and using color. A preference for bright colors, especially large amounts of bright red, has been called crude, tasteless, shocking, or barbaric, evaluations far less common in the late twentieth century than during the eighteenth and nineteenth.

Colors and color combinations are rarely, if ever, called shocking or barbaric if they seem too dark, pale, or monotonous. Strong or bright color is the issue. The association is with primitive art and folk art, stereotyped as brightly colored. Goethe believed that persons of refinement preferred subdued colors, and that this taste was not shared by the uneducated.

The chaotic literature of color theory, spread over half a dozen disciplines, allows enough room for conflicting ideas to survive alongside one another. The Impressionist painters were called madmen because their colors were thought to be too strong. But strong or bright color is not, as a matter of fact, typical of the many published examples of art made by the insane.

Egyptian jewelry of stone and faience, Chinese and Japanese (but not Korean) ceramics and lacquerware, Byzantine mosaics, and Islamic tilework are more brightly colored than the traditional arts of many tribal peoples. Artists and artisans in a society without a fairly advanced technology are largely limited to the use of natural coloring materials, including vegetable dyes. With the exception of some brightly colored stones (which can be difficult to cut), few natural materials have colors that are both bright and long-lasting. Bird feathers fade (as do colored shells) and deteriorate. Making brightly colored ceramic glazes (which are resistant to fading and deterioration) is a highly sophisticated technology, discovered by the Chinese and kept a trade secret for many centuries.

The assumption that primitive peoples prefer bright colors seems to predate the nineteenth century, the period when ethnography museums in Europe and the United States assembled collections of primitive art and were able to exhibit this art to the public. Far older than the museums were stories of fabulous trades—or mean-spirited deceptions—effected by offering one or another tribal group a handful of brightly colored glass or ceramic beads. Famously, the island of Manhattan is supposed to have been traded for $24 worth of colored beads.

Even if the event occurred as reported, the interpretation—that the Indians used poor judgment—is superficial. Whatever we may think of the traders who set out with the purpose of cheating them, the Indians were just being human. The quality of color available in ceramic glazes and variegated glass fascinates everyone to this day. It must have seemed astonishing to those previously unfamiliar with the ceramic and glass-making arts. Also, except in modern cities where we grow jaded, a glimpse of color brighter than the general coloration of the environment fascinates—it catches the eye and often causes an inexplicable surge of emotion. This is perhaps why so many poets have set down their feelings on seeing a rainbow, a scarlet tanager or a bluejay.

The assumption that tribal peoples preferred bright colors co-existed for about seventy years with a theory that said just the opposite: that many ancient and primitive peoples could not see the full range of colors. Based on ideas first published by William Ewart Gladstone, an amateur color theorist and student of the classics who served as Queen Victoria's Prime Minister, the theory held that color vision had developed only in relatively recent times and not in all parts of the world. Occasionally mentioned by

anthropologists today, Gladstone's theory gave rise to heated arguments during the late nineteenth and early twentieth centuries but was rarely taken seriously after 1924. Extreme proponents claimed to have evidence that some tribal peoples living today see no colors other than black, white and gray. Usually the peoples said to be so afflicted lived on remote islands and archipelagos that scarcely any researchers had visited except those who made the report!

Nobody noticed the discrepancy between the theory that primitive peoples could not see colors and the assumption that they could be easily bamboozled by flashing the enchanting colors of glass trade beads. The trade beads were still being manufactured in all the colors of the rainbow while Gladstone and his followers propounded their theories of color blindness and called for field research to test these theories.

Taste, fashion, and theories change, and their permutations mask an underlying stability in the associations made with colors in any given society. The preference for bright color, common today, might be interpreted to mean that we no longer regard strong color as shocking or primitive. Or it may mean that we like to play the role of neo-barbarians, free souls who boldly embrace what used to shock—mainly *because* it used to shock. An irony of taste is its ability to reverse itself. Nothing prevents recycling yesterday's version of bad taste in the use of color by reviving it as today's good taste.

Black

When light is present, we see a larger range of colors than in the darkness and are better able to see differences between one color area and another. To Plato, this meant that the experience of seeing colors required three conditions: light, one or more objects reflecting the light, and a functional eye into which the reflected light is received. Passed along unquestioned by Newton, Plato's reasoning was eventually incorporated into scientific theory. It leaves black—or the color of the darkness that we see in the absence of light—in a conceptual limbo. The color black has been variously defined as an absence of light, not a color, and in other confusing terms that point to problems in Plato's reasoning.

The only necessary condition for color is a functioning eye capable of being stimulated, and a stimulus for that eye. How the eye is stimulated is secondary. Newton admitted that a blow to the eye could cause a sensation of seeing colors. But we need not assume pathological conditions. Many people understood instinctively that the black or gray color we see at night simply should not be there if every color experience requires the presence of light and the reflection of that light from the surfaces of objects. Naum Gabo and Louise Nevelson argue that black is a color, a persistent theme in the writings of artists. The physiologist Helmholtz agreed. Bertrand Russell

went further by suggesting that the explanation of color in physics is philosophically weak.

French Impressionism

The tangled matter of Impressionist color theory, which developed in the late nineteenth century, has yet to receive a definitive analysis. The Impressionists used brighter colors than their predecessors because brighter paints had come on the market—a result of rapid advances in dye and pigment technology that began in the mid-1850s. But in thinking of the French Impressionists, we think first and foremost of their theories about color. They claimed to be following scientific ideas gleaned from Goethe, Chevreul, Rood, Newton, and Maxwell. In a stance hard to reconcile with how their paintings look, the Impressionists seemed to regard themselves as laboratory workers or technicians, students of light whose interest was scientific before it was aesthetic.

Today we find the grayed pastels of Impressionist paintings conventional and even soothing. The colors are not excessively bright by modern standards. At the time, however, Impressionist color use—especially the use of colors in shadows—offended a majority of critics. The colors were said to be garish, bizarre, and capable of injuring the eyes of viewers. Dr. Charcot, the mentor of Freud, announced that the Impressionists were hysterical, victims of nervous derangement, as could be seen by their manner of using color.

Given these conditions, a claim to scientific verisimilitude in color usage has a serendipitous political utility. I mean by this that any theory called "scientific" intimidates. The colors in their paintings—the Impressionists said—followed scientific theory, and therefore were scientifically correct. Shadows are really colored and may be, say, blue, lavender, or yellow. Unfriendly critics unable to understand needed to learn to see in a more scientifically correct manner.

Impressionism was eventually accepted. Either the public became accustomed to this new kind of art with its new way of using color or the talk of scientific investigation made Impressionist painting seem more respectable. The Impressionists were sincere in what they said (but so are those who ask us to buy their brand of toothpaste based on what they tell us are scientific findings).

New art, and new ways of using color, have not always been explained by citing science as an authority. For Picasso, in his *Statement of 1938*, the supreme authority is the artist's personality. The artist works in any manner he or she chooses. Those who like Cubism—Picasso said—can look at it. Those who do not are invited to look elsewhere.

These words were genuinely innovative when written. The Impressionists had never grown bold enough to say that they simply used color in the

way they wanted to use it, that their intentions could be called subjective or anarchistic as easily as science-driven. Among the post-Impressionists, Van Gogh selected color schemes for his paintings by playing with scraps of colored yarn to find combinations he liked. Van Gogh's letters, however, say nothing about what this implies—that he used color combinations he liked rather than color combinations seen in the model.

The idea of the artist as arbiter of the color in his or her painting did not originate with Picasso, however. It developed gradually, in opposition to the older idea that the artist is a copyist who imitates the colors of the natural world. Aphorisms passed from one generation of painting students to the next subtly encouraged a choice of colors that were not necessarily matches for the colors seen in the model or in the natural world. I was taught, when painting from life, to choose colors somewhat brighter than the colors actually seen. Only by using this trick could the painting be made to look "right." Matisse, putting the idea in a more generalized manner, told his students that the colors in a representational painting are an independent system. They do not match the colors of the natural world.

But can they? The answer is no. We cannot exactly match the colors of the natural world, even in color photographs. Each film has its own color sensitivity. One color photo of a scene will look slightly pink, another slightly green, and so forth. Though the Aristotelian conception, honored for centuries, classified art as an imitation of reality, approximation is a more appropriate word. Though Aristotle said human beings delight in what looks real, at most we are charmed by what looks almost real. Surrealist art and Non-objective art suggest we can be equally fascinated by deviations from any semblance of our conception of reality.

On Liking Colors

Art, as Picasso said, does not develop. Consequently, we gain no insight into it by using metaphors drawn from the technologies. For example, we no longer make or use the kinds of tools made in the Stone Age, and for this reason Stone Age tool-making methods can be called an obsolete technology. But Franco-Cantabrian cave paintings are never called obsolete—we still look at them and some people may prefer them to art made in later centuries. This bears on the questionable practice of regarding art history as a dialectic—a logical argument that seeks a goal in the manner of all logical arguments. The history of art, and of color usage, is much easier to understand as a simple record of what human beings have preferred at various times and places. Van Gogh is a great painter because we think he is, an opinion not widely held in his lifetime. Rembrandt and Matisse are great colorists because we think they are. Future humans might not agree.

Taste meanders and does not progress. It suggests fashion and subjectivity, both trivialized by the language we speak. Built into English are idioms

such as "just fashion" or "only subjective"—yet we never say "just intel-
lect" or "only objective." We need to come to terms with subjectivity—
with human consciousness—to understand how color has been used and
what we like about it collectively or individually. There may be no other
game in town.

Liking certain colors and color combinations is an existential concept.
The colors I like are only the colors I like at the moment. I can become
bored—as can anyone—by seeing too much of, say, a certain shade of yel-
low combined with a certain shade of maroon. Human consciousness
seeks change, rapidly in some societies and slowly in others. Or, some
societies and some individuals are future-oriented, while others give a
higher priority to preserving and perpetuating whatever was found pleasing
in the past.

Scientific theories about color harmony—about choosing combinations
of colors—rely on an absolute conception of beauty that we know today is
untenable. Any theory that assumes beauty will never change leaves no
room for the concept of time and how time affects taste. Whether a certain
blue combined with a certain yellow pleases me—whether it attracts my
attention—depends on what other colors I have seen lately. It also depends
on the sum total of my color experiences through a lifetime, and what those
experiences have meant to me.

"Taste" in color, as this suggests, follows the paradigm it cites: the sense
of taste. Whether I want chicken for dinner depends on whether I like
chicken, how the chicken is prepared, and my priorities pertaining to
chicken-preparation. Whether I've been eating chicken too often lately is
important.

In color and art, as with food, taste and boredom are complementary
concepts, one needed to understand the other. I know of no artist earlier
than Andy Warhol who said he liked being bored. But in the 1920s, T. S.
Eliot complained of being bored and of the boredom of a generation.

Everyone defines boredom differently. I think of it as an interim when
interest fails. When bored, I do not know what I want, how to choose, or
how to act. Relief from boredom comes through the exercise of one's taste.
Anyone might reasonably say that he or she likes colors and color combina-
tions that are interesting, not boring. To provide a better understanding of
what interesting and boring mean, applied to color or to anything else, we
need a new kind of physical science that takes human sensibility into
account.

Color in painting looks different from the late nineteenth century
onward. As said earlier, advances in paint technology contributed to the
effect; so did Impressionist color theory; so did Delacroix's advice to paint-
ers—not to be afraid of bright colors. Perhaps because designers visit muse-
ums to cull ideas, and recycle colors they see in modern paintings, the

colors of manufactured objects have come to resemble the colors of modern painting. Pop Art rounded out the equation in its way, introducing a new kind of realism. Manufactured objects became an inspiration for works of fine art, though the objects preferred were generally those thought to be stupid, boring, and tacky rather than elegant, exciting, or well-designed. Art can imitate life, life can imitate art, and in the hall of endless mirrors, life can imitate art imitating life.

From bed linens to cooking pots to cars, the colors popular today in manufactured objects are not those popular in the 1940s. Car buyers, along with car designers and car manufacturers, no longer give weight to Henry Ford's observation that if all cars were the same color (black), manufacturing economies would result and cars could be made more affordable. The degree of manufacturing economy is even greater with, say, underwear, which is cheaper to produce in one color (white) than when additional steps are added to the manufacturing process to allow it to be dyed in bright colors. But underwear in bright colors sells, as do cars in all the colors of the rainbow.

Léger complained of a monotonous leaden color in modern cities, and called for streets and housing projects to be painted blue and yellow. This we have not done, at least not to the degree Léger envisioned. Among objects that brighten our lives and offices, the red IBM Selectric typewriter and the black cube-shaped NEXT computer are memorable. But color styling for business machines is generally more timid than that for automobiles, kitchen utensils, clothing, and other objects that can be regarded as expressions of personal taste.

Hilaire Hiler explains modern love of bright color by reference to technology, which makes bright dyes and pigments available. But the limitations of technology are a factor in the colors of the television screens watched each year by millions of people for billions of hours. The colors of a television screen, like those of a computer terminal, are the colors seen in comic books, brighter and less subtle than the colors seen in the natural world. Technology, at least thus far, cannot reproduce or record more exactly. In a good color photograph, a trained eye may be needed to notice that the colors are not exact matches for the colors of the scene. On the television screen, the deviation is more extreme and everyone notices.

A preference for bright color can be interpreted as a relaxing of inhibitions. Alternately, it can suggest a deadening of sensibility, an inability to appreciate color variations and combinations that are subtle. Finally, it can be no more than it is—a taste of the moment that may change in the future.

On Imitation

Scientific studies in the reflection of light led to a fascinating discovery much discussed during the late nineteenth century. White light is consider-

ably brighter than the brightest white paint. How, then, can an artist paint the sun? For many, the answer is found in simultaneous contrast, Chevreul's finding that any color looks more intense when surrounded by colors that greatly differ from it.

Observant souls during earlier centuries must have noticed that light is brighter than paint, and that this is not a barrier to painting pictures of sunrise. Why did it take until the nineteenth century for the idea to be closely examined? And, why would anyone have been surprised to discover that a painted sun is not as bright as the real sun? Though Aristotle said art was imitation (and Plato found it inferior for that reason), Roman historians brought great profundity to their discussions about whether an imitation of reality—an exact recording—is possible. The truth about a battle cannot be recorded because it would have to be the whole truth, leaving out no detail. Historians are selective, and therefore subjective, since they choose which details to include.

Almost 2000 years passed before it was noticed that the colors we see in the world cannot be exactly recorded, for much the same reasons that a battle cannot be exactly recorded. First, the amount of detail is overwhelming. Second, a translation occurs. The historian translates the battle into words and the painter translates light effects into paint. No language exactly matches any other.

The lag before these limitations were widely discussed in relation to the visual arts can probably be explained on the basis of the art-historical record—by examining art history. The Romans made death masks of deceased family members by casting their faces in plaster. Death masks of famous persons continued to be made for many centuries, with the practice declining in popularity only after the invention of the camera. Capturing every wrinkle and wart, a plaster cast of a face impresses us as an exact imitation of the forms of that face, which could easily lead—and apparently did lead—to the mistaken assumption that the way the world looks can be exactly recorded (imitated). But a plaster cast of a face is *not* an exact imitation, since it records forms but not colors. The question of whether a painting could imitate the colors of a face as closely as a plaster cast imitates its three dimensional forms was given little or no attention.

An intelligent child might have noticed the discrepancy and asked, say, why a plaster cast of a face is called an exact imitation of that face when the cast is the color of plaster and the face is various colors. An adult, more sophisticated about society's value systems—or more brainwashed and less in touch with the senses—might teach the child the conventional answer which is familiar to all of us: that colors should not be expected in a plaster cast and their absence, therefore, is not significant. But the child simply, and quite reasonably, asked why something would be called "exact" which is not exact. The adult has not answered the question, or even

thought seriously about it. The conventional answer just teaches the child that adults do not regard the question as important and it should not be asked repeatedly. The most interesting questions in the world are those we teach children not to ask.

Color in Sculpture

The issue of whether sculpture should be painted has a history of its own. We know that ancient stone sculpture of the human figure was sometimes colored to make it appear more lifelike. Several Egyptian examples, protected by the dry climate and by having been enclosed in tombs, have survived with their paint almost entirely intact. Stone carvings from Greece, Cyprus, and other parts of the Mediterranean show remains of paint that has worn away over the centuries. Bright colors may have been used in ancient Greece to accent parts of a piece of sculpture. If we may rely on reports in Homer's *Iliad* and *Odyssey*, paint in bright colors may also have been used to accent exterior parts of marble temples.

Over the centuries, as we know, the paint wore away on most painted examples of ancient sculpture. Those who saw the sculpture in modern museums grew accustomed to the idea that large-scale sculpture was generally the color of the material from which it was made, a material often admired in its own right. The whiteness of, say, Carrara marble makes it an excellent surface for receiving paint. But many people would object to hiding the natural color of Carrara marble. In a similar vagary of taste, painting oak floors is thought objectionable—it conceals the surface of the oak—but painting pine is relatively acceptable.

Among peoples ranging from the Egyptians to the Eskimos, unpainted wood carvings often had colored materials set in to replicate the colors of the eye, raising the question of why one part of the body should be given extra attention or colored more naturalistically than the rest. Possibly in the earliest painted sculpture, only the eyes were painted, and certainly the practice, like the huge eyes in Sumerian votive figures, relates to a traditional complex of ideas about the role of the human eye in social interchange. We attribute great importance to the eye, regard it as the mirror of the soul, train children to look people in the eye, and so forth. The eye, unlike, say, the hand, is not satisfyingly reproduced in sculpture by replicating its shape alone. We associate the eye with its distinctive colors: the eyeball is white, the pupil is black, the iris can be any of several colors. If the Greeks, as is believed, painted only certain parts of their sculpture, we reasonably assume that the eyes were among the parts to which color was applied.

Sculpture is an art of volumes and some modern sculptors deplore any element, including applied color, that draws attention to surfaces. The question of whether sculpture could be painted without losing its sculptural

quality was capable of raising hackles during the 1960s. A more extreme question was whether aesthetic quality could be maintained if life-sized sculpture of the human figure was painted to imitate the colors of human skin and hair, a kind of coloration once associated exclusively with department store mannikins. Because standards of what constitutes art are not unchanging, both questions could be answered by "Why not?" George Segal's ghostly white plaster castings of his friends were succeeded by Duane Hanson's technicolor imitations of human beings in fiberglass, three-dimensional cousins to Chuck Close's enlargements of Polaroid photographs.

Whether contemporary sculpture is painted tends to depend, however, on practical considerations and the material from which the sculpture is made. Color, for stone carvers, is generally the natural color of the stone. Large outdoor works of welded steel can be protected from deterioration by painting them. Among woods, pine is more likely to be painted than, say, rosewood or mahogany. Plastics are either transparent or colored—applying paint to the surface is not necessary if the plastic is already the desired color—and the surfaces of many plastics will not hold paint.

Paint is not a necessary element in making sculpture, and the aesthetics of sculpture differs from that of painting. Where color fits is by no means certain, though a sculpture that has been painted evokes a different response than a sculpture that derives its color from the natural color of its materials. For example, an unpainted stone carving made of several pieces of marble in different colors is, in a sense, a found object so far as its colors are concerned. Although the artist chose those stones, the stones happened to be those colors and, so far as intention is concerned, the colors were accepted by the artist as given. We rarely complain that, say, a piece of green serpentine is too dark a green, or that the sculpture would have been more attractive if the artist had looked for another piece of serpentine with a more interesting grain.

A painted limestone carving presents another order of intention. The artist mixed the paint applied to the surface, and could have mixed paint in any color. We assume we have a right to be more critical about exact nuances of color—to ask, given the large number of choices available, whether the paint would have been more interesting if somewhat darker, lighter, or more bluish.

The reverse side of the equation is that a sculptor who made painted sculpture might be praised as an excellent colorist if the paints were thought to be pleasing. The sculptor who simply chose and combined beautifully colored materials might be less likely to be appreciated as a colorist, on the grounds that he or she combined, but did not create, the colors of the materials. This, in turn, is one of many instances in which aesthetic standards applied to the fine arts differ from those applied to the minor arts

or crafts. Egyptian jewelry, for example, has been much admired for its colors, which the jewelry-makers created by skillfully combining coral, lapis lazuli, turquoise, and gold.

There are, of course, many other questions about color in sculpture that on the one hand are aesthetic, and on the other hand concern the nature and limits of human consciousness or human psychology. I will suggest a few of those questions but not explore them: Can aesthetic response to a marble carving focus on shape but filter out awareness of color and material? Is a viewer missing the point by focusing on surface color and ignoring volumes and shapes? Can we simultaneously look at the surface of a piece of sculpture *and* sense its volume? Or, do we, instead, perceive these elements separately and combine the sensations?

1 • SCHOOL OF ARISTOTLE
(322 – 269 B.C.)

"De Coloribus" ("On Colors") is a six-part manuscript usually included among Aristotle's writings, but he was probably not the author. It may have been written by either Theophrastus or Strato, who presided over the Academy in Athens after Aristotle's retirement in 322 B.C.

The reasoning in "De Coloribus" is largely analogical, as in correlating the simple (or elemental) colors with air, earth, fire, and water (the elements). Colors are explained as mixtures of darkness and light (or of black and white), black being "that from which no light is conveyed to the eyes."

Goethe admired "De Coloribus" (and Boyle's *Experiments and Considerations*) for the author's reliance on commonplace visual observations, a reliance that even underlies ideas that are unusual by modern standards. Colors, for example, are rarely or never defined today as mixtures of light and darkness. Yet the definition, which probably arose from observations of sunrise and sunset, is not without merit. Bright colors, primarily reds and yellows, appear in the sky at these times and, using a bit of poetic license, the reds and yellows seen at these transitions could be regarded as a result of the meeting or mingling of day (white or light) and night (black or darkness).

Other ideas in "De Coloribus" have been more enduring in their original form. Newton passed along, unchanged, the conception that black is an absence of light, and that no definition can be provided that states what darkness is rather than what darkness is not. Yet we do not care for negative definitions, and would feel uneasy defining red as an absence of blue, or a cat as an absence of a dog. A question that failed to come to the surface over a period of many centuries is whether black can be defined as the presence, not the absence, of some quantifiable item. The question, like many in color theory, extends into other disciplines. Modern cosmologists, who study the nature of the universe, recognize that the black emptiness of

1

interstellar space—the space between the stars that we interpret as the blackness of the night sky—is not empty in any traditional sense. This and cosmological interest in a missing black matter or dark matter that appears to exist in the universe in large quantities, but that cannot be seen or detected by instruments, may eventually contribute to more refined definitions of black, blackness, and the color we see when perceiving the darkness of the night.

From THE COMPLETE WORKS OF ARISTOTLE

On Colours

Simple colours are those which belong to the elements, i.e., to fire, air, water, and earth. Air and water in themselves are by nature white, fire (and the sun) yellow, and earth is naturally white. The variety of hues which earth assumes is due to dying, as is shown by the fact that ashes turn white when the moisture that tinged them is burnt out. It is true they do not turn a pure white, but that is because they are tinged by the smoke, which is black. And this is the reason why lye-mixture turns yellow, the water being coloured by hues of flame and black.

Black is the proper colour of elements in process of transmutation. The remaining colours, it may easily be seen, arise from blending by mixture of these.

Darkness is due to privation of light. For we see black under three different conditions. Either the object of vision is naturally black (for black light is always reflected from black objects); or no light at all passes to the eyes from the object (for an invisible object surrounded by a visible patch looks black); and objects always appear black to us when the light reflected from them is rare and scanty. This last condition is the reason why shadows appear black. It also explains the blackness of ruffled water, e.g., of the sea when a ripple passes over it: owing to the roughness of the surface few rays of light fall on the water and the light is dissipated, and so the part which is in shadow appears black. The same principle applies to very dense cloud, and to masses of water and of air which light fails to penetrate; for water and air look black when present in very deep masses, because of the extreme rarity of the rays reflected, the parts of the mass between the illuminated surfaces being in darkness and therefore looking black. There are many arguments to prove that darkness is not a colour, but merely privation of light, the best being that darkness, unlike all other objects of vision,

is never perceived as having any definite magnitude or any definite shape.

Light is clearly the colour of fire; for it is never found with any other hue than this, and it alone is visible in its own right whilst all other things are rendered visible by it. But there is this point to be considered, that some things, though they are not in their nature fire nor any species of fire, yet seem to produce light. So we cannot say that the colour of fire is identical with light, and yet light is the colour of other things besides fire, but we can say that this colour is to be found in other things besides fire, and yet light is the colour of fire. Anyhow it is only by aid of light that fire is rendered visible, just as all other objects are made visible by the appearance of their colour.

The colour black occurs when air and water are thoroughly burnt by fire, and this is the reason why burning objects turn black, as e.g., wood and charcoal when the fire is put out, and smoke from clay as the moisture in the clay is all secreted and burnt. This is also why the blackest smoke is given off by fat and greasy substances like oil and pitch and resinous wood, because these objects burn most completely, and the process of combustion is most continuous in them.

Again, things turn black through which water percolates if they first become coated with lichen and then the moisture dries off. The stucco on walls is an example of this, and much the same applies to stones under water, which get covered with lichen and turn black when dried.

This then is the list of simple colours.

From these the rest are derived in all their variety of chromatic effects by blending of them and by their presence in varying strengths. The different shades of crimson and violet depend on differences in the strength of their constituents, whilst blending is exemplified by mixture of white with black, which gives grey. So a dusky black mixed with light gives crimson. For observation teaches us that black mixed with sunlight or firelight always turns crimson, and that black objects heated in the fire all change to a crimson colour, as e.g., smoky tongues of flame, or charcoal when subjected to intense heat, are seen to share a crimson colour. But a vivid bright violet is obtained from a blend of feeble sunlight with a thin dusky white. That is why the air sometimes looks purple at sunrise and sunset, for then the air is especially dusky and the impinging rays feeble. So, too, the sea takes a purple hue when the waves rise so that one side of them is in shadow: the rays of the sun strike without force on the slope and so produce a violet colour. The same thing may also be observed in birds', wings, which get a purple colour if extended in a certain way against the light, but if the amount of light falling on them is diminished the result is the

dark colour called brown, whilst a great quantity of light blended with primary black gives crimson. Add vividness and lustre, and crimson changes to flame-colour.

For it is after this fashion that we ought to proceed in treating of the blending of colours, starting from an observed colour as our basis and making mixtures with it. (But we must not assign to all colours a similar origin, for there are some colours which, though not simple, bear the same relation to their products that simple colours bear to them, inasmuch as a simple colour has to be mixed with one other colour to produce them.) And when the constituents are obscure in the compound product, we must still try to establish our conclusions by reference to observation. For, whether we are considering the blend which gives violet or crimson, or whether we are considering the mixtures of these colours which produce other tints, we must explain their origin on the same kind of principles, even though they look dissimilar. So we must start from a colour previously established, and observe what happens when it is blent. Thus we find that wine colour results from blending airy rays with pure lustrous black, as may be seen in grapes on the bunch, which grow wine-coloured as they ripen; for, as they blacken, their crimson turns to a violet. After the manner indicated we must treat all differences of colours, getting comparisons by moving coloured objects, keeping our eye on actual phenomena, assimilating different cases of mixture on the strength of the particular known instances in which a given origin and blending produce a certain chromatic effect, and varifying our results. But we must not proceed in this inquiry by blending pigments as painters do, but rather by comparing the rays reflected from the aforesaid known colours, this being the best way of investigating the true nature of colour-blends. Verification from experience and observation of similarities are necessary if we are to arrive at clear conclusions about the origin of different colours, and the chief ground of similarities is the common origin of nearly all colours in blends of different strengths of sunlight and firelight, and of air and water. At the same time we ought to draw comparisons from the blends of other colours with rays of light. Thus charcoal and smoke, and rust, and brimstone, and birds' plumage blent, some with firelight and others with sunlight, produce a great variety of chromatic effects. And we must also observe the results of maturation in plants and fruit, and in hair, feathers, and so on (1219–21).

2 • LEONARDO DA VINCI
(1452 – 1519)

Leonardo da Vinci's *Trattato della Pittura (Treatise on Painting)* was begun about 1492 and until the nineteenth century it was more widely known than his scientific writings. Over a third of the 365 chapters in *Trattato* deal with color and another quarter discuss light and shadow. Leonardo, the complex Renaissance genius, who was also childlike and simple in his curiosity about many things, left further notes about color and light scattered throughout his notebooks on optics, astronomy, botany and art.

In *Trattato* Leonardo identified the simple or elementary colors in an inconsistent manner. Though he defined the simple colors as those that cannot be mixed, his listing of eight simple colors includes "Green, and Tawny or Umber, and . . . Purple." All of these are regarded today as mixtures—colors that can be matched by mixing paints. In another listing, Leonardo omitted umber and purple (but not green), reducing the number of simple colors to six.

Beyond which colors are simple and why, a greater problem is the building block metaphor, based on the Greek idea that the world could be reduced to elementary particles (basic building blocks) called atoms. Over the centuries, this idea proved reasonably fruitful in the physical sciences. But, despite dominating the history of color theory, the building block metaphor falters when applied to color. Ancient and medieval writers often compared simple colors to elements, hoping to isolate a set of simple colors from which all other colors could be derived. From a modern perspective, one argument against the usefulness of such a model lies in the lack of consensus about how many colors, and exactly which colors, are simple. Though Leonardo named six or eight simple colors, Plato and the Pythagoreans thought there were ten. Theophrastus named four and Aristotle suggested seven. The author of "De Coloribus" reduced the simple colors to

two—all colors are mixtures of white and black (or mixtures of light and darkness).

This lack of consensus survived the centuries, noted by few except Chevreul, but grew more subtle, turning on such issues as exactly which among many varieties of blue was to be regarded as the simple, pure, primary, basic, or elemental blue. The Munsell system recognizes ten major hues ("simple colors"). The Ostwald system has eight, or twenty-four with two intermediaries between each. Nor surprisingly, the exact hues chosen for each system are not a match for those of the other system.

From THE ART OF PAINTING

Of the Mixture of Colours

. . . I call etc. I call those simple colours, which are not composed, and cannot be made or supplied by any mixture of other colours. Black and White are not reckoned among colours; the one is the representative of darkness, the other of light: that is, one is a simple privation of light, the other is light itself. Yet I will not omit mentioning them, because there is nothing in painting more useful and necessary; since painting is but an effect produced by lights and shadows, viz. *chiara-scuro*. After Black and White come Blue and Yellow, then Green, and Tawny or Umber, and then Purple and Red. These eight colours are all that Nature produces. With these I begin my mixtures, first Black and White, Black and Yellow, Black and Red; then Yellow and Red

Of the Colours Produced by the Mixture of other Colours,
Called Secondary Colours

The first of all simple colours is White, though philosophers will not acknowledge either White or Black to be colours; because the first is the cause, or the receiver of colours, the other totally deprived of them. But as painters cannot do without either, we shall place them among the others; and according to this order of things, White will be the first, Yellow the second, Green the third, Blue the fourth, Red the fifth, and Black the sixth. We shall set down White for the representative of light, without which no colour can be seen; Yellow for the earth; Green for water; Blue for air; Red for fire; and Black for total darkness.

If you wish to see by a short process the variety of all the mixed, or composed colours, take some coloured glasses, and, through them, look at all the country round; you will find that the colour of each

object will be altered and mixed with the colour of the glass through which it is seen; observe which colour is made better, and which is hurt by the mixture. If the glass be yellow, the colour of the objects may either be improved, or greatly impaired by it. Black and White will be most altered, while Green and Yellow will be meliorated. In the same manner you may go through all the mixtures of colours, which are infinite. Select those which are new and agreeable to the sight; and following the same method you may go on with two glasses, or three, till you have found what will best answer your purpose (138 – 39).

Of Colours in Shadow

It happens very often that the shadows of an opake body do not retain the same colour as the lights. Sometimes they will be greenish, while the lights are reddish, although this opake body be all over of one uniform colour. . . . We often see a white object with red lights, and the shades of a blueish cast; this we observe particularly in mountains covered with snow, at sun-set, when the effulgence of its rays makes the horizon appear all on fire (156).

Of the Blueish Appearance of Remote Objects in a Landscape

Whatever be the colour of distant objects, the darkest, whether natural or accidental, will appear the most tinged with azure. By the natural darkness is meant the proper colour of the object; the accidental one is produced by the shadow of some other body (169).

3 • GIOVANNI PAOLO LOMAZZO
(1538 – 1600)

Lomazzo's *Trattato dell' arte della pittura, scultura ed architettura (Treatise on the Arts of Painting, Sculpture and Architecture*, 1584) includes a section on color beginning with a definition according to Aristotle. Like Ludovico Dolce, Raffaello Borghini, and other Italian art theorists of the late sixteenth century, Lomazzo upheld the Aristotelian belief that seven principal colors existed. These could be correlated with the seven planets, the seven virtues, the seven deadly sins, the seven ages of man, the seven days of creation, and so forth.

Color symbolism as we know it today arose over the centuries from these linkages, which had a more immediate purpose for the faithful. Studying the correlations offered insight—it was thought—into the symmetries that a perfect Creator God had imposed on the world He created. Nearly a century after Lomazzo, Newton also took up the idea that, as the significant objects of the world had been created in sets of seven, seven principal colors existed, and this mathematical (therefore, perfect) pattern could be regarded as evidence of God's perfection.

From SYMBOLISM OF THE PRINCIPAL COLORS

The first color therefore, is yellow, which is dedicated to the sun since it resembles its rays, and to gold, the principal metal and admittedly the most important. And furthermore, the sun whose center is tinged with red and whose rays are absorbed by the earth, signifies nobility, wealth, religion, clarity, gravity, justice, faith and corruption. White signifies and represents innocence, purity, and in man it represents old age. In

the seasons it follows autumn, among the virtues, being an immaculate color, it signifies justice. Among the elements it represents water, among metals, silver, and among theological virtues, hope, which must be pure and impeccable. Red which among the elements represents fire, and among the planets represents the sun, signifies courage, greatness, victory, blood, martyrdom. Considering the darker and duller red of Mars, it symbolizes anger in man. In theological virtues it symbolizes charity, which must be brightened with ardent love, and among the seasons it represents summer. Ultramarine blue which corresponds to Jupiter, signifies a sanguine temperament, greatness, glory, dignity, sincerity, happiness and the like, and among the elements, air. Black means melancholy, sadness, deep pain, and stability, and its name is Saturn. Of all the seasons it represents winter, of temperaments, melancholy, of virtues, prudence, of the elements, the earth, which still appears somewhat yellowish because of its dryness. Of age it represents decrepitude and of accidents, death, which implies division and separation . . . Green which symbolizes spring and corresponds to Venus, signifies happiness, vagueness, hope, goodness, mirth and such. In age it represents youth and among the elements it is the equivalent of water. Purple, which is composed of all of the above, is none other than the color we call old rose It is assigned to Mercury and signifies triumph, praise, honor, principle and the like, with which the Romans bedecked themselves in triumph as well as the emperors. Christ also had a similar undergarment besides the royal robe which was mockingly placed upon him. It signifies further an abundance of prosperity, in age, youth, and of the virtues, temperance. It denotes even the pure grace of God, and of the days, the Holy Sabbath (427 – 28).

4 • ROBERT BOYLE
(1627 – 1691)

Robert Boyle, one of the founders of modern chemistry, is remembered primarily for his formulation of Boyle's Law, which concerns the expansion of gases. At the age of thirty-seven, Boyle published *Experiments and Considerations Touching Colours* . . . , a 400-page collection of essays in which he reports his own experiments and theories, and summarizes the history of color theory. The essays are addressed to his nephew, Richard Jones, who is referred to as Pyrophilus.

Although Boyle published nothing further on color, *Experiments and Considerations* . . . was immensely popular during his lifetime. A century later, it was admired by Goethe, but otherwise it was largely forgotten after Newton.

From EXPERIMENTS AND CONSIDERATIONS TOUCHING COLOURS . . .

. . . the Peripatetick Schools, though they dispute amongst themselves divers particulars concerning Colours, yet in this they seem Unanimously enough to Agree, that Colours are Inherent and Real Qualities, which the light doth but Disclose, and not concurr to Produce. Besides there are *Moderns*, who with a slight variation adopt the Opinion of *Plato*, as he would have Colour to be nothing but a Kind of Flame consisting of Minute Corpuscles as it were Darted by the Object against the Eye, to whose Pores their Littleness and Figure made them congruous, so those would have Colour to be an Internal Light of the more Lucid [transparent] parts of the Object, Darken'd and consequently Alter'd

by the Various Mixtures of the less Luminous parts. There are also others, who in imitation of some of the Antient *Atomists*, make Colour not to be a Lucid Stream, but yet a Corporeal *Effluvium* issuing out of the Colour'd Body, but the knowingest of these have of late Reform'd their Hypothesis, by acknowledging and adding that some External Light is necessary to Excite, and as *they* speak, Sollicit these Corpuscles of Colour as *they* call them, and Bring them to the Eye. Another and more principal Opinion of the *Modern* Philosophers, to which this last nam'd may by a Favorable explication be reconcil'd, is that which derives Colours from the Mixture of Light and Darkness, or rather Light and Shadows. And as for the *Chymists* [alchemists] 'tis known, that the generality of them ascribes the Origine of Colours to the Sulphureous Principle in Bodies, though I find, as I elsewhere largely shew, that some of the Chiefest of them derive Colours rather from Salt than Sulphur, and others, from the third Hypostatical Principle, *Mercury*. And as for the *Cartesians* [followers of Descartes] I need not tell you, that they, supposing the Sensation of Light to bee produc'd by the Impulse made upon the Organs of Sight, by certain extremely Minute and Solid Globules, to which the Pores of the Air and other Diaphanous bodies are pervious, endeavor to derive the Varieties of Colours from the Various Proportion of the Direct Progress or Motion of these Globules to their Circumvolution or Motion about their own Centre, by which Varying Proportion they are by this Hypothesis suppos'd qualify'd to strike the Optick Nerve after several Distinct manners, so to produce the perception of Differing Colours (84–86).

5 • SIR ISAAC NEWTON
(1642 – 1727)

Newton, an eccentric and many-faceted genius, developed the binomial theorem and (as did Leibniz) an early form of differential calculus, one of the most important mathematical innovations since the time of the ancient Greeks. Newton's theories about the gravitational forces that kept the planets in their orbits, set forth in the great *Principia Naturalis Principia Mathematica (Mathematical Principles of Natural Philosophy)*, stood for 200 years until replaced by Einstein's theory of relativity. Newton's work on color and light, which gave full scope to his unusual inventiveness in designing experiments and instruments, revolutionized fields as diverse as color theory and telescope making.

In 1666, Newton performed his most famous color experiment, which consisted of sending a ray of light through two prisms. His earliest report of the experiment, six years later, appeared in *Philosophical Transactions of the Royal Society of London* 80:3075 – 3087 (19 February, 1671 – 72). The report led to an acrimonious debate between Newton and Robert Hooke (1635 – 1703), who had begun his scientific careeer as Robert Boyle's assistant. In 1675, Newton complained, "I was so persecuted with discussions arising out of my theory of light that I blamed my own imprudence for parting with so substantial a blessing as my quiet to run after a shadow."

Newton's major work on color and light, *Opticks* (1704), was published 30 years after his prism experiments. It expands on his early work with prisms and reports a series of carefully organized experiments and the theories drawn from those experiments.

Newton, called the perfect scientific man, was meticulous in reporting what he saw. His followers overgeneralized from his experiments. The seventeenth experiment, given a broad interpretation by others, is familiar through the popular misconception that objects reflect light of their own colors. Actually, objects reflect rays of many colors, the foundation for

modern colorimetry. The local or apparent colors of some objects cannot even be matched with rays of those particular colors. For a simple example, brown light rays do not exist. Therefore the color of brown objects cannot be explained by saying that these objects are reflecting brown light rays.

In Experiment 17, Newton refers to homogenal (homogenous) light, by which he means spectral light of a single color that cannot be divided into light of two or more colors by passing it through a prism.

From PHILOSOPHICAL TRANSACTIONS

Newton to Oldenburg

Trin: College Cambridge Feb: 6th. 1671/2.

Sir,

. . . in the beginning of the Year 1666 (at which time I applyed my self to the grinding of Optick glasses of other figures than *Spherical*,) I procured me a Triangular glass-Prisme, to try therewith the celebrated *Phenomena of Colors* And in order thereto having darkened my chamber, and made a small hole in my window-shuts, to let in a convenient quantity of the Suns light, I placed my Prisme at its entrance, that it might be thereby refracted to the opposite wall. It was at first a very pleasing divertisement, to view the vivid and intense colours produced thereby; but after a while applying my self to consider them more circumspectly, I became surprised to see them in an *oblong* form; which, according to the received laws of Refraction, . . . I expected should have been *circular*.

They were terminated at the sides with streight lines, but at the ends, the decay of light was so gradual, that it was difficult to determine justly, what was their figure; yet they seemed *semicircular*.

Comparing the length of this coloured *Spectrum* with its breadth, I found it about five times greater; a disproportion so extravagant, that it excited me to a more then ordinary curiosity of examining, from whence it might proceed. I could scarce think, that the various *Thickness* of the glass, or the termination with shadow or darkness, could have any Influence on light to produce such an effect; yet I thought it not amiss to examine first these circumstances, and so tryed, what would happen by transmitting light through parts of the glass of divers thicknesses, or through holes in the window of divers bignesses, or by setting the Prisme without, so that the light might pass through it, and be refracted before it was terminated by the hole:

But I found none of those circumstances material. The fashion of the colours was in all these cases the same.

Then I suspected, whether by any *unevenness* in the glass, or other contingent irregularity, these colours might be thus dilated. And to try this, I took another Prisme like the former, and so placed it, that the light, passing through them both, might be refracted contrary ways, and so by the latter returned into that course, from which the former had diverted it. For, by this means I thought, the *regular* effects of the first Prisme would be destroyed by the second Prisme, but the *irregular* ones more augmented, by the multiplicity of refractions. The event was, that the light, which by the first Prisme was diffused into an *oblong* form, was by the second reduced into an *orbicular* one with as much regularity, as when it did not at all pass through them. So that, what ever was the cause of that length, 'twas not any contingent irregularity.

I then proceeded to examine more critically, what might be effected by the difference of the incidence of Rays coming from divers parts of the Sun; and to that end, measured the several lines and angles, belonging to the Image. . . .

Having made these observations, I first computed from them the refractive power of that glass, . . . [a]nd then, . . . I computed the Refractions of two Rays flowing from opposite parts of the Sun's *discus*, so as to differ 31' in their obliquity of Incidence, and found, that the emergent Rays should have comprehended an angle of about 31', as they did, before the incident.

But because this computation was founded on the Hypothesis of the proportionality of the *sines* of Incidence, and Refraction, which though by my own & others . . . Experience I could not imagine to be so erroneous, as to make that Angle but 31', which in reality was 2 deg. 49'; yet my curiosity caused me again to take my Prisme. And having placed it at my window, as before, I observed, that by turning it a little about its *axis* to and fro, so as to vary its obliquity to the light, more then by an angle of 4 or 5 degrees, the Colours were not thereby sensibly translated from their place on the wall, and consequently by that variation of Incidence, the quantity of Refraction was not sensibly varied. By this Experiment therefore, as well as by the former computation, it was evident, that the difference of the Incidence of Rays, flowing from divers parts of the Sun, could not make them after decussation diverge at a sensibly greater angle, than that at which they before converged; which being, at most, but about 31 or 32 minutes, there still remained some other cause to be found out, from whence it could be 2 deg. 49'.

Then I began to suspect, whether the Rays, after their trajection through the Prisme, did not move in curve lines, and according to their more or less curvity tend to divers parts of the wall. And it increased my suspition, when I remembred that I had often seen a Tennis-ball, struck with an oblique Racket, describe such a curve line. For, a circular as well as a progressive motion being communicated to it by that stroak, its parts on that side, where the motions conspire, must press and beat the contiguous Air more violently than on the other, and there excite a reluctancy and reaction of the Air proportionably greater And for the same reason, if the rays of the light should possibly be globular bodies, and by their oblique passage out of one medium into another acquire a circulating motion, they ought to feel the greater resistance from the ambient [E]ther, on that side, where the motions conspire and thence be continually bowed to the other But notwithstanding this plausible ground of suspition, when I came to examine it, I could observe no such curvity in them. And besides (which was enough for my purpose) I observed, that the difference betwixt the length of the Image, and diameter of the hole, through which the light was transmitted, was proportionable to their distance.

The gradual removal of these suspitions at length led me to the *Experimentum Crucis* . . . , which was this: I took two boards, and placed one of them close behind the Prisme at the window, so that the light might pass through a small hole, made in it for that purpose, and fall on the other board, which I placed about 12 foot distance, having first made a small hole in it also, for some of that Incident light to pass through. Then I placed another Prisme behind this second board, so that the light, trajected through both the boards, might pass through that also, and be again refracted before it arrived at the wall. This done, I took the first Prisme in my hand, and turned it to and fro slowly about its Axis, so much as to make the several parts of the Image, cast on the second board, successively pass through the hole in it, that I might observe to what places on the wall the second Prisme would refract them. And I saw by the variation of those places, that the light, tending to that end of the Image, towards which the refraction of the first Prisme was made, did in the second Prisme suffer a Refraction considerably greater then the light tending to the other end. And so the true cause . . . of the length of that Image was detected to be no other, then that *Light* consists of *Rays differently refrangible*, which, without any respect to a difference in their incidence, were, according to their degrees of refrangibility, transmitted towards divers parts of the wall.

When I understood this, I left off my aforesaid Glass-works; for I

saw, that the perfection of Telescopes was hitherto limited, not so much for want of glasses truly figured according to the prescriptions of Optick Authors, . . . (which all men hitherto imagined,) as because that Light it self is a *Heterogeneous mixture of differently refrangible Rays*. So that, were a glass so exactly figured as to collect any one sort of rays into one point, it could not collect those also into the same point, which having the same Incidence upon the same Medium are apt to suffer a different refraction. Nay, I wondered, that seeing the difference of refrangibility was so great, as I found it, Telescopes should arrive to that perfection they are now at. For measuring the refractions in one of my Prismes, I found, that supposing the common *sine* of Incidence upon one of its planes was 44 parts, the *sine* of refraction of the utmost Rays on the red end of the Colours, made out of the glass into the Air, would be 68 parts, and the *sine* of refraction of the utmost rays on the other end, 69 parts: So that the difference is about 24th or 25th part of the whole refraction. . . . And consequently, the object-glass of any Telescope cannot collect all the rays, which come from one point of an object so as to make them convene at its *focus* in less room then in a circular space, whose diameter is the 50th part of the Diameter of its Aperture; which is an irregularity, some hundreds of times greater, then a circularly figured *Lens*, of so small a section as the Object of long Telescope are, would cause by the unfitness of its figure, were Light *uniform*.

This made me take *Reflections* into consideration, and finding them regular, so that the Angle of Reflection of all sorts of Rays was equal to their Angle of Incidence; I understood, that by their mediation Optick instruments might be brought to any degree of perfection imaginable, provided a *Reflecting* substance could be found, which would polish as finely as Glass, and *reflect* as much light, as glass *transmits*, and the art of communicating to it a *Parabolick* figure be also attained. But these seemed very great difficulties, and I almost thought them insuperable, when I further considered, that every irregularity in a reflecting superficies makes the rays stray 5 or 6 times more out of their due course, than the like irregularities in a refracting one: . . . So that a much greater curiosity would be here requisite, than in figuring glasses for Refraction.

Amidst these thoughts I was forced from *Cambridge* by the Intervening Plague . . . and it was more then two years, before I proceeded further (*Philosophical Transactions*, 3075 – 87).

From OPTICKS, OR A TREATISE OF THE REFLECTIONS, REFRACTIONS, INFLECTIONS, & COLOURS OF LIGHT

Exper. 15. In attempting to compound a white, by mixing the colour'd Powders which Painters use, I consider'd that all colour'd Powders do suppress and stop in them a very considerable Part of the Light by which they are illuminated. For they become colour'd by reflecting the Light of their own Colours more copiously, and that of all other Colours more sparingly, and yet they do not reflect the Light of their own Colours so copiously as white Bodies do. If red Lead, for instance, and a white Paper, be placed in the red Light of the colour'd Spectrum made in a dark Chamber by the refraction of a Prism, . . . the Paper will appear more lucid than the red Lead, and therefore reflects the red-making Rays more copiously than red Lead doth. And if they be held in the Light of any other Colour, the Light reflected by the Paper will exceed the Light reflected by the red Lead in a much greater Proportion. And the like happens in Powders of other Colours. And therefore by mixing such Powders, we are not to expect a strong and full White, such as is that of Paper, but some dusky obscure one, such as might arise from a Mixture of Light and Darkness, or from white and black, that is, a grey, or dun, or russet brown, such as are the Colours of a Man's Nail, of a Mouse, of Ashes, of ordinary Stones, of Mortar, of Dust and Dirt in High-ways, and the like. And such a dark white I have often produced by mixing colour'd Powders (*Opticks* 150 – 51).

. . . Every Body reflects the Rays of its own Colour more copiously than the rest, and from their excess and predominance in the reflected Light has its Colour.

Exper. 17. For if in . . . homogeneal Lights [spectral lights of a single color] . . . you place Bodies of several Colours, you will find, . . . that every Body looks most splendid and luminous in the Light of its own Colour. Cinnaber [vermilion] in the homogeneal red Light is most resplendent, in the green Light it is manifestly less resplendent, and in the blue Light still less. Indigo in the violet blue Light is most resplendent, and its splendor is gradually diminish'd, as it is removed thence by degrees through the green and yellow Light to the red. By a Leek the green light, and next that the blue and yellow which compound green are more strongly reflected than the other Colours red and violet, and so of the rest. But to make these Experiments the

more manifest, such Bodies ought to be chosen as have the fullest and most vivid Colours, and two of those Bodies are to be compared together. Thus, for instance, if Cinnaber and *ultra*-marine blue, or some other full blue be held together in the red homogeneal Light, they will both appear red, but the Cinnaber will appear of a strongly luminous and resplendent red, and the *ultra*-marine blue of a faint obscure and dark red; and if they be held together in the blue homogeneal Light, they will both appear blue, but the *ultra*-marine will appear of a strongly luminous and resplendent blue, and the Cinnaber of a faint and dark blue. Which puts it out of dispute that the Cinnaber reflects the red Light much more copiously than the *ultra*-marine doth and the *ultra*-marine reflects the blue Light much more copiously than the Cinnaber doth. The same Experiment may be tried successfully with red Lead and Indigo, or with any other two colour'd Bodies, if due allowance be made for the different strength or weakness of their colour and Light.

And as the reason of the Colours of natural Bodies is evident by these Experiments, so it is farther confirmed and put past dispute . . . [that] in such Bodies the reflected Lights which differ in Colours do differ also in degrees of Refrangibility. For thence it's certain, that some Bodies reflect the more refrangible, others the less refrangible Rays more copiously.

And that this is not only a true reason of these Colours, but even the only reason, may appear farther from this Consideration, that the Colour of homogeneal Light cannot be changed by the Reflexion of natural Bodies.

For if Bodies by Reflexion cannot in the least change the Colour of any one sort of Rays, they cannot appear colour'd by any other means than by reflecting those which either are of their own Colour, or which by mixture must produce it.

But in trying Experiments of this kind care must be had that the Light be sufficiently homogeneal. For if Bodies be illuminated by the ordinary prismatick Colours, they will appear neither of their own Day-light Colours, nor of the Colour of the Light cast on them, but of some middle Colour between both, as I have found by Experience. Thus red Lead (for instance) illuminated with the ordinary prismatick green will not appear either red or green, but orange or yellow, or between yellow and green, accordingly as the green Light by which 'tis illuminated is more or less compounded. For because red Lead appears red when illuminated with white Light, wherein all sorts of Rays are equally mix'd, and in the green Light all sorts of Rays are not equally mix'd, the Excess of the yellow-making, green-making and

blue-making Rays in the incident green Light, will cause those Rays to abound so much in the reflected Light, as to draw the Colour from red towards their Colour. And because the red Lead reflects the red-making Rays most copiously in proportion to their number, and next after them the orange-making and yellow-making Rays; these Rays in the reflected Light will be more in proportion to the Light than they were in the incident green Light, and thereby will draw the reflected Light from green towards their Colour. And therefore the red Lead will appear neither red nor green, but of a Colour between both (*Opticks* 179 – 82).

6 • JOHANN WOLFGANG VON GOETHE

(1749 – 1832)

In addition to a prodigious literary output, Goethe left fourteen volumes of writings on color theory, botany, and other sciences. Like James Clerk Maxwell, Goethe is said to have considered his writing on color to be his most important. His *Farbenlehre* (*Color Book*), based on experiments he conducted over a period of twenty years, was read primarily by artists and viewed unsympathetically by those in the physical sciences.

From THEORY OF COLOURS

. . . A shadow cast by the sun, in its full brightness, on a white surface, gives us no impression of colour; it appears black, or, if a contrary light (here assumed to differ only in degree) can act upon it, it is only weaker, half-lighted, grey.

Two conditions are necessary for the existence of colored shadows: first, that the principal light tinge the white surface with some hue; secondly, that a contrary light illumine to a certain extent the cast shadow.

Let a short, lighted candle be placed at twilight on a sheet of white paper. Between it and the declining daylight let a pencil be placed upright, so that its shadow thrown by the candle may be lighted, but not overcome, by the weak daylight: the shadow will appear of the most beautiful blue.

That this shadow is blue is most immediately evident; but we can only persuade ourselves by some attention that the white paper acts as

a reddish yellow, by means of which the complemental blue is excited in the eye. . . .

In all coloured shadows, therefore, we must presuppose a colour excited or suggested by the hue of the surface on which the shadow is thrown. This may be easily found to be the case by attentive consideration, but we may convince ourselves at once by the following experiment.

Place two candles at night opposite each other on a white surface; hold a thin rod between them upright, so that two shadows be cast by it; take a coloured glass and hold it before one of the lights, so that the white paper appear coloured; at the same moment the shadow cast by the coloured light and slightly illumined by the colourless one will exhibit the complemental hue.

An important consideration suggests itself here, to which we shall frequently have occasion to return. Colour itself is a degree of darkness. . . . As it is allied to shadow, so it combines readily with it; it appears to us readily in and by means of shadow the moment a suggesting cause presents itself. . . .

Select the moment in twilight when the light of the sky is still powerful enought to cast a shadow which cannot be entirely effaced by the light of a candle. The candle may be so placed that a double shadow shall be visible, one from the candle towards the daylight, and another from the daylight towards the candle. If the former is blue the latter will appear orange-yellow: this orange-yellow is in fact, however, only the yellow-red light of the candle diffused over the whole paper, and which *becomes visible in shadow*.

This is best exemplified by the former experiment with two candles and coloured glasses. The surprising readiness with which shadow assumes a colour will again invite our attention in the further consideration of reflections and elsewhere.

Thus the phenomena of colored shadows may be traced to their cause without difficulty. Henceforth let any one who sees an instance of the kind observe only with what hue the light surface on which they are thrown is tinged. Nay, the colour of the shadow may be considered as a chromatoscope of the illumined surface, for the spectator may always assume the colour of the light to be the opposite of that of the shadow, and by an attentive examination may ascertain this to be the fact in every instance.

These appearances have been a source of great perplexity to former observers: for, as they were remarked chiefly in the open air, where they commonly appeared blue, they were attributed to a certain inherent blue or blue coloring quality in the air. The inquirer can, however, convince himself, by the experiment with the candle in a room, that no

kind of blue light or reflection is necessary to produce the effect in question. The experiment may be made on a cloudy day with white curtains drawn before the light, and in a room where no trace of blue exists, and the blue shadow will be only so much the more beautiful (29 – 33).

. . . People experience a great delight in colour, generally. The eye requires it as much as it requires light. We have only to remember the refreshing sensation we experience, if on a cloudy day the sun illumines a single portion of the scene before us and displays its colours. That healing powers were ascribed to coloured gems may have arisen from the experience of this indefinable pleasure.

The colours which we see on objects are not qualities entirely strange to the eye; the organ is not thus merely habituated to the impression; no, it is always predisposed to produce colour of itself, and experiences a sensation of delight if something analogous to its own nature is offered to it from without; if its susceptibility is distinctly determined towards a given state.

From some of our . . . observations we can conclude, that general impressions produced by single colours cannot be changed, that they act specifically, and must produce definite, specific states in the living organ.

They likewise produce a corresponding influence on the mind. Experience teaches us that particular colours excite particular states of feeling

In order to experience these influences completely, the eye should be entirely surrounded with one colour; we should be in a room of one colour, or look through a coloured glass. We are then identified with the hue, it attunes the eye and mind in mere unison with itself.

The colours on the *plus* side are yellow, red-yellow (orange), yellow-red (minium, cinnebar). The feelings they excite are quick, lively, aspiring.

This [yellow] is the colour nearest the light. It appears on the slightest mitigation of light, whether by semi-transparent mediums or faint reflections from white surfaces

In its highest purity it always carries with it the nature of brightness, and has a serene, gay, softly exciting character.

In this state, applied to dress, hangings, carpeting &c., it is agreeable. Gold in its perfectly unmixed state, especially when the effect of polish is superadded, gives us a new and high idea of this colour; in like manner, a strong yellow, as it appears on satin, has a magnificent and noble effect.

We find from experience, again, that yellow excites a warm and agreeable impression. Hence in painting it belongs to the illuminated and emphatic side.

This impression of warmth may be experienced in a very lively manner if we look at a landscape through a yellow glass, particularly on a grey winter's day. The eye is gladdened, the heart expanded and cheered, a glow seems at once to breathe towards us.

If, however, this colour in its pure and bright state is agreeable and gladdening, and in its utmost power is serene and noble, it is, on the other hand, extremely liable to contamination, and produces a very disagreeable effect if it is sullied, or in some degree tends to the *minus* side. Thus, the colour of sulphur, which inclines to green, has something unpleasant in it.

When a yellow colour is communicated to dull and coarse surfaces, such as common cloth, felt, or the like, on which it does not appear with full energy, the disagreeable effect alluded to is apparent. By a slight and scarcely perceptible change, the beautiful impression of fire and gold is transformed into one not undeserving the epithet foul; and the colour of honour and joy reversed to that of ignominy and aversion . . .

The colours on the *minus* side are blue, red-blue, and blue-red. They produce a restless, susceptible, anxious impression.

As yellow is always accompanied with light, so it may be said that blue still brings a principle of darkness with it.

This colour [blue] has a peculiar and almost indescribable effect on the eye. As a hue it is powerful, but it is on the negative side, and in its highest purity is, as it were, a stimulating negation. Its appearance, then, is a kind of contradiction between excitement and repose.

As the upper sky and distant mountains appear blue, so a blue surface seems to retire from us.

But as we readily follow an agreeable object that flies from us, so we love to contemplate blue, not because it advances to us, but because it draws us after it.

Blue gives an impression of cold, and thus, again, reminds us of shade. We have before spoken of its affinity with black.

Rooms which are hung with pure blue, appear in some degree larger, but at the same time empty and cold.

The appearance of objects seen through a blue glass is gloomy and melancholy (304 – 11).

7 • MICHEL EUGENE CHEVREUL
(1786 – 1889)

Along with the writings of Ogden Rood, Chevreul's classic *De la loi du contraste simultané des couleurs* influenced the Impressionists. His law of simultaneous contrast states that the appearance of a color is affected by the adjacent colors or those in its environment. The brightness of a given red varies according to whether the red is seen in an environment of similar reds, greens, yellows, whites, blacks, or dull tones.

It follows that if colors are affected by those surrounding them, context will be of the essence, and we will be limited in the generalities we can make about such things as the absolute brightness of individual colors. A color that looks bright in one environment will be less bright in another, and will have no constant visual brightness. Chevreul's observations also acknowledge the unity of any environment, and the fallacy in assuming that any object can be "isolated" from surrounding objects.

Simultaneous contrast, whether or not known by that name, is an important concept to painters, who visually test the effect of one spot of paint against another of different color. It also needs to be taken into account in clothing design, interior design, or any activity in which color choices are made.

From THE PRINCIPLES OF HARMONY AND CONTRAST OF COLOURS

In explaining the applications of the law of contrast to the colours of male clothing, my intention is to discuss principally the question of the combination of colours in military uniforms as a matter of State econ-

omy; and, in the case of female clothing, the combinations which are most suitable for a portrait. The first question is entirely one of administrative economy; the second belongs solely to the domain of art.

I shall attain my end if, in the views set forth, the portrait-painter find the means of selecting associations of colours which, by imparting to his works more brilliancy and harmony, render them thereby less likely to appear antiquated when the prevailing fashion of his time is forgotten.

Men's Clothing

A dress composed of cloths of different colours may be worn much longer, and will appear better, although nearly worn out, than a suit of a single colour, even when the latter is of a piece of cloth identical with one of the first. The law of contrast fully gives the reason of this fact.

Of the Advantages of Contrast Considered with Regard to the Apparent Cleanliness of Cloths for Clothing

Contrast in the colours of cloths composing a dress is not only advantageous to the brightness and *apparent preservation* of the colours of these cloths, but also to render less visible the inequalities which a cloth presents on account of the colouring material not having equally penetrated to the centre of the stuff; the surface wearing unequally, according as it is exposed to different degrees of friction, the colour of the cloth becomes lighter, or, as it is commonly called, *whitens*, in the parts most exposed to friction. Many blue, scarlet, and madder-red cloths present this result, especially on the salient parts of the vestment, such as the seams.

This defect which certain cloths have of *whitening in the seams* is much less apparent in a coat of two or more colours than it is in a monochromous coat; because *the vivid contrast of different colours, fixing immediately the attention of the spectator, prevents the eye from perceiving the inequalities, which would be visible in a monochromic coat.*

For this reason stains, on the same ground, will always be less apparent in a polychromous than in a monochromous garment or dress.

For the same reason also a coat, waistcoat, and trousers of the same colour cannot be worn together with advantage, except when new for when one of them has lost its freshness, by having been worn more than the others, the difference will be increased by contrast. Thus new black trousers worn with a coat and waistcoat of the same colour, but old and slightly *rusty*, will bring out this latter tint, while at the same time the black of the trousers will appear brighter. White trousers or reddish-gray will

correct the effect of which I speak. We see, then, the advantage of having a soldier's trousers of another colour than his coat, especially if, wearing this coat all the year, he only wears trousers of the same cloth during winter. We see also why white trousers are favourable to coats of every colour.

Female Clothing

Although there are many varieties of the human race with respect to the colour of the skin, yet we may arrange them in the three following divisions:—The Caucasian, or white race; the American Indians, whose skin is red or copper-coloured; the negro race, the Malays, &c., who have black or olive skins.

Colours for the Dress of Women with White Skins

To give precision to this subject, we must begin by establishing certain distinctions.

1. That of the two types, with skins more or less white and rosy:—
The one with light hair and blue eyes.
The other with black hair and black eyes.

2. That of the juxtaposition of the articles of the toilet, whether pertaining to the hair or to the complexion; for a colour may contrast favourably to the hair, yet produce a disagreeable effect with the skin.

3. That of the modifications of the complexion, by coloured rays emanating from the head-dress, and which, being reflected on the skin, tinge it with their peculiar colour.

The colour of light hair being essentially the result of a mixture of red, yellow, and brown, we must consider it as a *very pale subdued orange-brown*; the colour of the skin, although a lower tone, is analogous to it, except in the red parts. Blue eyes are really the only parts of the fair type which form a contrast of colour with the whole; for the red parts produce, with the rest of the skin, only a harmony of analogy of hue, or at most a contrast of hue, and not of colour; and the parts of the skin contiguous to the hair, the eyebrows, and eyelashes, give rise only to a harmony of analogy, either of scale or of hue. The harmonies of analogy, then, evidently predominate in the fair type over harmonies of contrast.

The type with black hair shows the harmonies of contrast predominating over the harmonies of analogy. The hair, eyebrows, eyelashes, and eyes, contrast in tone and colour, not only with the white of the skin, but also with the red parts, which in this type are really redder, or less roseate, than in the blonde type; and we must not forget that a decided red, associated with black, gives to the latter a character of an *excessively deep* colour, either blue or green.

Of the Colours of the Hair and Head-dress

The colours which are usually considered as assorting best with light or black hair, are precisely those which produce great contrasts; thus, sky-blue, known to accord well with blondes, is the colour that approaches the nearest to the complementary of orange, which is the basis of the tint of their hair and complexions. Two colours, long esteemed to accord favourably with black hair—yellow, and red more or less orange—contrast in the same manner with them. Yellow and orange-red, contrasting by colour and brilliancy with black, and their complemen-taries, violet and blue-green, in mixing with the tint of the hair, are far from producing a bad result.

Of the Colours of the Complexion and the Contiguous Drapery

The juxtaposition of the drapery with the different flesh tints of women offers to portrait-painters a host of remarks, which are all the results of the principles already laid down. We shall state the most general: thus—

ROSE RED cannot be put in contrast with even the rosiest complexions without causing them to lose some of their freshness. *Rose-red, maroon,* and *light crimson* have the serious disadvantage of rendering the com-plexion more or less green. This is shown in the following experiment:—

Place two sheets of paper of either of the above colours beside two sheets of flesh-colored paper, when it will be seen how much they are mutually injured, the lighter becoming greenish, and the darker rather of a violet hue. By substituting light green for the red, we shall find them mutually heightened and improved. The height of tone of the green influences the result: a very deep green, acting by contrast of tone, so enfeebles the complexion, that the slight contrasts of its colours will be inappreciable; a deep red, by contrast of analogy, blanches the com-plexion. It is necessary, then, to separate the rose from the skin, in some manner; and the simplest manner of doing this, is to edge the draperies with a border of *tulle,* which produces the effect of grey by the mixture of white threads, which reflect light, and the interstices, which absorb it; there is also a mixture of light and shade, which recalls the effect of grey, like the effect of a casement-window viewed at a great distance. Dark red is less objectionable for certain complexions than rose-red, because, being higher than the latter, it tends to impart whiteness to them in consequence of contrast of tone.

DELICATE GREEN is, on the contrary, favourable to all fair complexions which are deficient in rose, and which may have more imparted to them without disadvantage. But it is not as favourable to complexions that are more red than rosy; nor to those that have a tint of orange mixed with

brown, because the red they add to this tint will be of a brick-red hue. In the latter case a dark green will be less objectionable than a delicate green.

YELLOW imparts violet to a fair skin, and in this view it is less favourable than the delicate green.

To those skins which are more yellow than orange it imparts white; but this combination is very dull and heavy for a fair complexion.

When the skin is tinted more with orange than yellow, we can make it rosy by neutralizing the yellow. It produces this effect upon the black-haired type, and it is thus *that it suits brunettes*.

VIOLET, the complementary of yellow, produces contrary effects; thus it imparts some greenish-yellow to fair complexions. It augments the yellow tint of yellow and orange skins. The little blue there may be in a complexion it makes green-violet. This, then, is one of the least favourable colours to the skin, at least when it is not sufficiently deep to whiten the skin by contrast of tone.

BLUE imparts orange, which combines favourably with white, and the light flesh tints of fair complexions, which have already a more or less determined tint of this colour. Blue is thus suitable to most blondes, and in this case justifies its reputation.

It will not suit brunettes, since they have already too much of orange.

ORANGE is too brilliant to be elegant; it makes fair complexions blue, whitens those which have an orange tint, and gives a green hue to those of a yellow tint.

LUSTRELESS WHITE, such as cambric muslin, assorts well with a fresh complexion, of which it relieves the rose colour; but it is unsuitable to complexions which have a disagreeable tint, because white always exalts all colours by raising their tone; consequently it is unsuitable to those skins which, without having this disagreeable tint, very nearly approach it.

VERY LIGHT WHITE draperies, such as muslin or lace, appear more grey than white. . . . We must thus regard every white drapery which allows the light to pass through its interstices, and which is only apparent to the eyes by the surface opposed to that which receives incident light.

BLACK draperies, by lowering the tone of the colours with which they are in juxtaposition, whiten the skin; but if the vermillion, or rosy parts, are somewhat distant from the drapery, it will follow that, although lowered in tone, they appear relatively to the white parts of the skin contiguous to the same drapery, redder than if not contiguous to the black. . . .

The Head-dress in Relation to the Coloured Rays
Which It May Reflect upon the Skin

The effect of coloured bonnets on the complexion can now be readily understood; and whether it is true, as is generally believed, that a

rose-coloured bonnet gives a rose tint to the skin, while a green bonnet gives a green tint to it, in consequence of the coloured rays which each of them reflects upon it, it is no longer a question about those head-dresses which, being too small or too much thrown back to give rise to these reflections, can only produce the effects of contrast, as I have said above, when treating of the juxtaposition of coloured objects with the hair and skin. . . .

If an object in relief is illuminated exclusively by a coloured light, it will appear tinted with the colour of this light. A white plaster figure, for example, placed in an enclosure where the red rays illuminate it, will appear red, at least to most eyes, and under most circumstances; for certain eyes, in some cases, may perceive the sensation of the complementary of the coloured rays in looking at some parts of the figure.

But if the figure is placed so as to receive, at the same time, coloured rays and diffused daylight, there will be produced on the eyes of a spectator, suitably placed, a complex effect; resulting—

1. From some parts of the figure being white, reflecting to the eyes of the spectator the coloured rays falling from above.

2. From some parts of the figure reflecting diffused daylight in sufficient quantity to appear white, or almost white.

3. From there being between the parts which reflect coloured light to the eye, and those which send diffused daylight, some part in a condition which appears to be complementary to the reflected coloured light.

One very remarkable consequence of this is, that the rays of mutually complementary colours, successively lighting the same object, concurrently with the diffused daylight, give rise to *the same coloration*.

This may be proved thus:—Between two windows directly opposite to each other, admitting diffused daylight, place a white plaster figure in such a position that each half shall be lighted directly by only one of the windows. On completely intercepting the light of one of the windows, and hanging a coloured curtain before the other, the figure appears only of the colour of the curtain; but if we open the other window, so that the figure is lighted by diffused daylight, while it is at the same time lighted by the coloured light, we then perceive some parts white, and some parts tinted with the complementary of the coloured light transmitted by the curtain.

This experiment, then, teaches us, that if a bonnet, rose-coloured, for example, give rise to a reflection of this colour on a complexion, the parts thus made rosy by the effect of contrast, themselves give rise to green tints, since the figure, while it receives rosy reflections, receives also diffused daylight.

To consider the real influence of the bonnet, we place three white plaster casts of the same model in a position equally illuminated by

daylight; then observe them comparatively, after having clothed the middle cast with a white bonnet, and the two others with bonnets of which the colour of one is complementary to that of the other. *In this way we may satisfy ourselves that the influence of reflection in colouring a figure is very feeble, even when the bonnet is placed in the most favourable manner for observing the phenomenon.*

Rose-coloured Bonnet.—Rose colour reflected upon the skin is very feeble, except on the temples; wherever the rosy parts are contiguous to parts feebly lighted by daylight, the latter will appear very lightly tinged with green.

Green Bonnet.—Green colour reflected upon the skin is very feeble, except on the temples; wherever the green parts are contiguous to parts feebly lighted by daylight, the latter will appear slightly rosy; the effect of green in colouring it rose, is greater than the effect of reflected rose in colouring it green.

Yellow Bonnet.—Yellow colour reflected upon the skin is very feeble, except on the temples; wherever the yellow parts are contiguous to parts feebly illuminated by daylight, the latter will appear very sensibly violet.

Violet Bonnet.—Violet colour reflected on the skin is very feeble, except on the temples; wherever the violet parts are contiguous to parts feebly illuminated by daylight, the latter will appear slightly yellow; but this coloration is very feeble, because the reflections of violet have it themselves.

Sky-blue Bonnet.—Blue colour reflected on the skin is very feeble, except on the temples; wherever the blue parts are contiguous to parts feebly illuminated by daylight, the latter will appear to be slightly orange.

Orange Bonnet.—Orange colour reflected on the skin is very feeble, except on the temples; wherever the parts are contiguous to parts feebly illuminated by daylight, the latter will appear slightly blue.

It is evident, then, from these experiments, that a coloured bonnet produces much more effect by virtue of contrast, arising from juxtaposition with the flesh-tints, than by the coloured reflections which it imparts to them.

Let us now see what advantage the painter can derive from the preceding observations, when he prescribes a bonnet to a model, belonging either to the light-haired or to the black-haired type.

Fair-Haired Type

A black bonnet with white feathers, with white rose or red, suits a fair complexion.

A *lustreless white bonnet* does not suit well with fair and rosy complexions. It is otherwise with bonnets of gauze, crape, or lace; they are

suitable to all complexions. The white bonnet may have flowers, either white, rose, or particularly blue.

A *light blue bonnet* is particularly suitable to the light-haired type; it may be ornamented with white flowers, and in many cases with yellow and orange flowers, but not with rose or violet flowers.

A *green bonnet* is advantageous to fair or rosy complexions; it may be trimmed with white flowers, but preferably with rose.

A *rose-coloured bonnet* must not be too close to the skin; and if it is found that the hair does not produce sufficient separation, the distance from the rose colour may be increased by means of white, or green, which is preferable. A wreath of white flowers in the midst of their leaves has a good effect.

I shall not advise the use of a light or deep red bonnet, except when the painter desires to diminish too warm a tint in the complexion.

Finally, the painter should never prescribe either yellow or orange-coloured bonnets, and be very reserved in the use of violet.

Type with Black Hair

A *black bonnet* does not contrast so well with the general appearance of the type with black hair as with the other type, yet it may produce a good effect, and receive advantageously accessories of white, red, rose, orange, and yellow.

A *white bonnet* demands the same notice as that, concerning its use, in connexion with the blonde type . . . except that for brunettes it is better to give preference to accessories of red, rose, orange, and yellow, rather than of blue.

Bonnets of *rose-red or cherry-colour* are suitable for brunettes, when the hair separates, as much as possible, the bonnet from the complexion. White feathers accord well with red; and white flowers, with abundance of leaves, have a good effect with rose.

A *yellow bonnet* suits a brunette very well, and receives with advantage violet or blue accessories. The hair must always interpose between the complexion and the head-dress.

It is the same with bonnets of an *orange* colour, more or less broken, such as chamois, with which blue trimmings are eminently suitable.

A *green bonnet* is suitable to fair and light rosy complexions, rose-red or white flowers are preferable to all others.

A *blue bonnet* is only suitable to a fair or light-red complexion; nor can it be allied to such as have a tint of orange-brown. When it suits a brunette, it may take with advantage yellow or orange trimmings.

A *violet bonnet* is always unsuitable to every complexion, since there are none to which the addition of yellow will be favourable. Yet, if we in-

terpose between the violet and the skin, not only the hair, but also yellow accessories, a bonnet of this colour may become favourable.

Whenever the colour of a bonnet does not realize the intended effect, even when the complexion is separated from the head-dress by large masses of hair, it is advantageous to place between the latter and the bonnet certain accessories, such as ribbons, wreaths, and detached flowers, &c., of a colour complementary to that of the bonnet, as I have prescribed for the violet bonnet. The same colour must also be placed on the outside.

On the Assortment of Colours in the Dress of Women with Copper-coloured Skin

The tint of the complexions of the women of the North American Indian races is too positive to induce them to endeavor to dissimulate, either by lowering its tone, or by neutralizing it. There is, then, no alternative but heightening it, for which purpose we must use draperies of white or of blue strongly inclining to green, when the tint will become of a redder orange.

On the Assortment of Colours in the Dress of Women with Black or Olive Skins

If I have prescribed the harmony of contrast of tone where the colour of the complexion is copper-red, there is a stronger reason for it when we have to drape olive or black skins; we can then use either white or the most brilliant colours, as red, orange, and yellow. The consideration of contrast determines which one we ought to choose in a particular case. If the complexion is intense black, dark olive, or greenish-black, red is preferable to every other colour; if the black is bluish, then orange is particularly suitable. Yellow will best accord with a violet-black.

Results Applicable to Portrait-painting

The tint may be heightened without leaving its scale:—

1. By a white drapery which heightens by contrast of tone.
2. By a drapery the colour of which is exactly the complementary of the tint, and of which the tone is not too high; such as perhaps a green drapery for a rosy complexion; or perhaps a blue drapery for the orange complexion of a blonde. The tint may be heightened by making it leave its scale:—

1. By a green drapery of a light tone upon an orange complexion.
2. By a blue drapery of a light tone upon a rosy complexion.

3. By a yellow, canary, or straw-coloured drapery, upon an orange complexion, of which the complementary violet neutralizes some of the yellow of the complexion, and heightens its rose.

Note.—The modifications resulting from the juxtaposition of parts diversely coloured are much more positive than those arising from reflection by one part upon another.

If the Painter Wishes to Dissimulate a Tint of the Complexion

As above, he must distinguish two cases:—

1st, When he sees the colours modified by juxtaposition only, *when the tint may be lowered without leaving its scale:*—

1. By a black drapery, which lowers it by contrast of tone. 2. By a drapery of the same scale as that of the tint, but of a much higher tone.

Such, perhaps as a red drapery upon a rosy complexion; or, an orange drapery upon an orange-tinted complexion; or, the effect of a dark-green drapery on a complexion of a green tint.

2nd, *The tint may be lowered by making it leave its scale.*

1. By a green drapery of very dark tone, upon an orange complexion. 2. By a blue drapery of a dark tone, upon a rosy complexion. 3. By a very dark yellow drapery, upon a very pale orange complexion (239 – 59).

8 • GEORGE FIELD
(1777? – 1854)

Field, a color theorist, looked askance at Chevreul's reliance on "the judgment of the eye," and searched for a genuinely scientific understanding of color that would neatly categorize and arrange phenomena. His *Rudiments of the Painter's Art* and *Chromatography* are theoretical rather than practical, proposing links between colors and numbers that the modern reader may find recondite or bizarre. He associated yellow, red, and blue with 3, 5, and 8, which he then used as a foundation for computing further links. Green, for example, can be mixed from blue and yellow, so its value for Field is 11, the sum of 8 (blue) and 3 (yellow). He sought color balance and beautiful color combinations through computations involving the arithmetical values of the different colors.

From RUDIMENTS OF THE PAINTER'S ART; OR, A GRAMMAR OF COLOURING

Elements of Colours

The elements or natural powers by which colours are produced are the positive and negative principles of Light and Darkness, and these in painting are represented by *white* and *black*, which are thence elementary colours; between the extremes of which exists an infinite gradation of shades or mixtures, which are called *greys*, affording a scale of neutral colors. . . .

As by the deflection of a *point in space* may be generated all the elementary and complex figures and forms of geometrical and constructive

science, so from a like deflection of a *spot in place* may be generated all the elementary and compound hues and colours; the science of which is called Chromatics.

Thus a spot of any shade or colour on a ground or medium, lighter or darker than itself, being viewed by a Lensic Prism, will be deflected by the ordinary refraction of light and shade into an orb of three colours. . . . These three colours are the known *Blue, Red,* and *Yellow* which as they are incapable of being produced by composition, and also of being resolved into other colours by analysis, are simple, original, and *primary colours,* elicited by the electrical excitement, or concurrence of the light and shade of the ground and spot.

Accordingly, if the ground and spot be varied from light to dark, or from black to white, the same process will afford the same three colours, differing only in the inversion of their arrangement, . . . being the order of the colours in the celestial phenomenon of the rainbow,—"the triple bow" of the poets,—in which the sun supplies the central spot of light, which is deflected or refracted by the rain and atmosphere on the dark screen of the sky.

This evolution of colours from the positive and negative or polar principles of light and darkness is a simple fact of nature, however the colours may be produced by electrical influence, wherewith it accords that a due reunion of the three colours, or their compounds, will discharge the colours excited and restore the colourless spots and grounds; and in like manner the negative or *neutral* colours may be composed by mixture of the positive material colours, or pigments of the painter. And thus we have educed from nature the first order of colours in the sequence of their relation to black and white. . . .

In these experimental evolutions of transient colours from light and darkness, a polar influence determines the blue colour, and its allies towards black or darkness as the negative pole, and the yellow, followed by red and their allies, toward the positive pole of light, or white. And this is a constant law of chromatism, by which all the relations of colours are determined, as well in respect to vision and the requirements of taste and arrangement as to their physical properties and calorific powers. And it coincides also with the electrical affinities by which colours are determined chemically according to an undoubted universal law.

The Three Orders of Colours

By the inverted arrangement of the *primary colours* . . ., Red takes the place of Blue, Yellow that of Red, and Blue that of Yellow; and if these pairs of colours cross each other, or be alternately mixed they constitute an order of *secondary colours*: thus if Blue be mixed with Yellow, they will form *Green*; if

Yellow be mixed with Red, they form *Orange* colour; and if Red be mixed with Blue, they form *Purple*; and these second denominations, *Green, Orange, and Purple, constitute the second order of colours.*

Finally, in like manner, by the alternate compounding or mixing of these secondary colours in pairs is produced a third order of colours, thence called *tertiary colours*: thus if Green be mixed with Orange colour, they will form a *Citrine,* or citron colour; if Orange be mixed with Purple, they form *Russet*; and if Purple be mixed with Green, they form *Olive* colour; and these new denominations of colours, *Citrine, Russet, and Olive, constitute the third order of colours,* each of which is variously compounded of the *three* original or primary colours, as the second order is of *two*; the primary order being *single* and uncompounded; and lastly by duly mixing or compounding either of the three orders of colours, *Black* will be produced, terminating the series in *neutrality of colour.*

We have thus attained a scale of the three orders of colours, by a regular gradation from White to Black, each colour of which partakes of the positive and negative distinctions of light and dark. . . .

By the varied and due admixture of these colours is produced the infinity of hues, shades, and tints with which the works of nature are decorated, and which abound in the works of art; and all those individual colours which every season of fashion brings forth under new de- nominations, but which have been regarded by vulgar uncultivated sense as individually distinct, without order or dependence, the arbitrary inventions of fancy. . . .

By an indefinite and disproportionate mixture, however, of the three colours of either order, or of the whole together, will be produced only the hues usually called dirty, or the anomalous colour *Brown*. The browns are nevertheless a valuable class of colours of predominantly warm hues; whence we have *Red and Yellow Browns,* and browns of all hues except *Blue,* which is especially a cold colour affording in like manner the very useful but anomalous class of *Greys,* distinguished from the neutral *Grey,* being also the contrary and contrast of Brown.

Our scale may therefore be regarded as an alphabetical guide to the instructed eye and industrious hand, for imitating and composing with regularity and certainty every variety of *Hue, Shade, Tint,* and expression of colours. So much for the natural and artificial composition and production of colours by mixture. . . .

Finally this definitive scale presents the regulation according to which colours should interpose and succeed each other in series, agreeably to the eye in light and shade, with a mellowness that may be compared to the melody of successive notes and cadences in music. And, according to a similar analogy, colours harmonize each other in opposition, . . .

Contrasts and Accordances of Colours

. . . [c]olours are primarily elicited analytically from the positive and negative principles or poles of light and shade, represented by White and Black, which are Neutral as colours, and that consequently by a due reunion or composition of the colours thus educed, they are restored to the neutral shade of *Black, White,* or *Grey.*

Upon this fact depend all the relations, accordances, contrasts, and harmonies among colours; a subject of much intricacy, boundless extent, and universal interest, as well as of important utility in the arts of decoration, design, and ornament. It is nevertheless simple in principle, . . . the three primary colours are placed in intermediate relations, and opposed in correlative contrasts to the three secondary colours: Blue to *Orange,* Red to *Green;* and Yellow to *Purple.*

The colours of the . . . scale are numbered according to the proximate relative and opposed powers with which they accord, contrast and harmonize each other in juxtaposition or opposition, and neutralize each other in mixture. Their individual effects are also denoted opposite each colour: that of the Blue as *cold,* the Orange as *hot,* Red as the *extreme,* Green as the *mean* or middle colour, Yellow as *advancing* on the eye with light, and Purple as *retiring* into shade.

Such opposed colours, in adequate proportions, are called complementary from the equivalence with which they neutralize each other; their powers in which respect we have demonstrated to be according to the . . . Scale of Chromatic Equivalents. . . .

In this *Scale of Equivalents* the fundamental powers of the primary colours in compensating and neutralizing, contrasting and harmonizing their opposed secondary colours, are approximately as *three* Yellow, *five* Red, and *eight* Blue; consequently the secondary *Orange,* composed of three Yellow and five Red, is the equivalent of *Blue* the power of which is eight: they are accordingly equal powers in contrast, and compensating in mixture, and as such are properly in equal proportions for harmonizing effect.

Again *Green* being composed of Blue the power of which is eight, and Yellow the power of which is three, is equivalent in contrast and mixture as eleven, to *Red* the power of which is five; being nearly as two to one.

And finally *Purple* composed of Blue as eight, and Red the power of which is five, is equivalent in mixture or contrast as thirteen, to *Yellow* the power of which is three, or nearly as four to one. And such proportions of these opposed colours may be employed in forming agreeable and harmonious contrasts, in colouring and decorative painting, either in pairs of contrasts, or several, or all together; and also for subduing each other in mixture.

And further it is apparent that all compound hues of these colours will partake of their compound numbers and contrast each other according to a corresponding compound equivalence. Thus an intermediate Red-purple will contrast a like opposite Green-yellow with the power of eighteen to fourteen, and so on without limit all round the scale; and the triple compounds or tertiary colours of the central star of the Scale are subject to its like regulation as denoted on the graduated margin.

There is no invariable necessity, nevertheless, that this regulation of contrasts should be followed strictly, according to their numbers in harmonizing colours, although they denote their principal and most powerful effects; for every individual colour has its appropriate expression, for which it may be employed predominately as a key; thus affording an infinity of distinct harmonies to fertilize taste and invention, by brilliant and delicate or sober and sombre effects according to the purpose of the Artist or Decorator . . . (*Rudiments* 1–7).

From CHROMATOGRAPHY, A TREATISE ON COLOURS AND PIGMENTS FOR THE USE OF ARTISTS

On Chevreul's Definition of "Tone"

Chevreul defines "Tone" as "the word employed to designate the modifications which a colour, at its greatest intensity, is capable of receiving from the addition of white, which lowers its tone, or black, which heightens it."

Chevreul here uses "Colour" in the sense of pigment; but the distinction between the mixture of colours and the mixture of pigments, on which we have previously laid such stress, is not here of any great importance, for when white or black is one of two ingredients the results are so similar.

The effect of mixing a pigment with black is simply to diminish its *luminosity*. The effect of mixing it with white is to diminish its *Purity* or *Richness*, while its luminosity will be increased, diminished, or left unaltered according to circumstances. By "white" we of course include grey as white of low luminosity. Chevreul by "white" meant our most luminous white pigments. And it is true that, as these are more luminous than any others we possess, any pigment will be increased in luminosity by mixing it with, say, white lead. But the essential result is not this increased luminosity, which is an accidental circumstance, but the diminution in richness.

We thus see that the effects of mixing black and white with colours are not *opposite*, as Chevreul seems to assume; but are *essentially different in kind*, and therefore require two terms for their description.

On the Defects of Chevreul's Descriptive and Experimental Work

It is absolutely necessary for descriptive purposes to define one's standard colour. Chevreul has not done this. It may perhaps be imagined that he means his colours as seen against a white background to be taken as standards of comparison. Yet he describes the *effect* of white on colours. (It, he says, makes them brighter and deeper. By this he means that they appear richer in tint, and deeper in tone. But with respect to their appearance, on what background do they appear richer? It is certainly not true for *all* backgrounds.)

As a matter of fact it is probable that Chevreul did not employ any constant background; but performed all his experiments by placing colours singly, or juxtaposed, upon a background of some convenient colour, and the existence of which, as it was common to all the colours, he considered he might ignore. Thus in one place he remarks that "red isolated appears differently than when juxtaposed with a white, black, blue, or yellow surface." We should much like to know how Chevreul *isolated* his colour. A colour can only be isolated by considering a surface so large that the whole of the retina is occupied, and in this case it cannot be used directly for purposes of comparison.

He means, of course, that he placed all his colours, whether juxtaposed or by themselves, upon a common background, which he does not define and which he leaves out of the question as inoperative. Now in all his experiments conducted in this way, the results will vary with the background we employ, and we shall have in every case, . . . the mutual effect, not of two but of three contrasted colours.

Again, in studying contrast effects, Chevreul went entirely by the judgment of the eye. This method is open to much objection, as even the most carefully trained eyes are liable to be misled, and influenced by association. It seems to us that there is an infinitely better way of attacking the question, i.e. by adapting Maxwell's colour-top, and we have arranged an apparatus for the purpose. Thus, suppose two precisely similar green discs are, . . . placed on two larger discs which are green and white respectively. They of course appear very different to sensitive eyes. Now, by making the small discs part of colour tops, we can combine one of them with other coloured discs until adjustment occurs for the particular eye in question, and the two discs appear precisely similar. The kind of change can then be ascertained and its quantity measured for given relative areas (*Chromatography* 65–68).

9 • EUGENE DELACROIX
(1798 – 1863)

The French painter Eugène Delacroix, was the leader of the Romantic school. He recorded in his notebooks many sensitive observations about color in art and nature. Less widely reprinted than Leonardo's notebooks or Van Gogh's letters, Delacroix's notebooks seem to generally follow the sensible dictum, which would be set down later by Cézanne, that artists should study both the paintings of the masters in museums and the phenomena of the natural world.

From THE JOURNAL OF EUGENE DELACROIX

NOVEMBER 3, 1850

Rubens frankly places the gray half-tint of the edge of the shadow between his local tone for the flesh and his transparent rub-in. In his work this tone reigns throughout. Paul Veronese lays on flat the half-tint of the flesh and that of the shadow. (I have noticed in my own experience that this procedure gives already an astonishing amount of illusion.) He is satisfied to bind one with the other by a grayer tone applied locally, when the underpainting is dry. In the same way, skimming over the surface, he lays on the vigorous and transparent gray tone which borders the shadow on the side where it is gray. . . .

[While taking a walk with Villot at Champrosay some two weeks ago,] we observed some astonishing effects. It was at sunset: the *chrome* and *lake* tones were the most brilliant at the side where the light was, the shadows were blue and cold to the last degree. It seems that the warmer the light tones are the more nature exaggerates the contrast

with gray: witness the half-tints in the Arabs and in people of coppery complexion. The reason why that effect was so vivid in the landscape was precisely that law of contrast (249)

MONDAY, FEBRUARY 23, 1852

Painters who are not colorists produce illumination and not painting. All painting worthy of the name, unless one is talking about a black-and-white, must include the idea of color as one of its necessary supports, in the same way that it includes chiaroscuro and proportion and perspective. Proportion applies to sculpture as to painting; perspective determines the contour; chiaroscuro gives relief through the disposition of lights and shadows in their relationship with the background; color gives the appearance of life, etc.

The sculptor does not begin his work with a contour; with his material, he builds up an appearance of the object which, rough at first, immediately presents the chief characteristic of sculpture—actual relief and solidity. The colorists, the men who unite all the phases of painting, have to establish, at once and from the beginning, everything that is proper and essential to their art. They have to mass things in with color, even as the sculptor does with clay, marble or stone; their sketch, like that of the sculptor, must also render proportion, perspective, effect and color.

The contour is as much a thing of idea and convention in painting as it is in sculpture; it should result naturally from the right placing of the essential parts. The combined preparation of the effect (including perspective) and of color will approach more or less closely to its definitive appearance, according to the ability of the artist; but in this point of departure, there will be an unmistakable beginning of what is to come later on (263).

FRIDAY, NOVEMBER 13, 1857

It is difficult to say what colors were employed by men like Titian and Rubens to produce those flesh tones which are so brilliant and have remained so, especially those half-tints in which the transparence of the blood under the skin makes itself felt despite the gray that every half-tint brings with it. For my own part, I am convinced that they mix the most brilliant colors in order to produce them.

When the tradition was interrupted with David who, like his school, introduced other mistakes, people got to the principle—so to name it—that sobriety is one of the elements of the beautiful. Let me explain: after the debauchery of drawing and the inappropriate brilliance of color which brought the decadent schools to outrage truth and taste in every way, it was necessary to return to the simplicity in every depart-

ment of art. Drawing was tempered anew in the water from antique springs: that opened a whole new horizon to the men who had a feeling for what is noble and true. Color partook of the reform; but that reform was indiscreet, since people believed that color could always remain attenuated and reduced to what was considered that it should be, i.e., to a simplicity which does not exist in nature. One finds in David (in the *Sabines* for example), the prototype of his reform, color that is relatively right: yet consider the tones that Rubens produces with frank, vigorous colors like the clear greens, the ultramarines, etc., and then see how David and his school think to recover them with black and white to make blue, black and yellow to make green, red ocher and black to make violet, and so on. Moreover he uses earth colors, umbers or Cassel earths, ochers, etc. Each of these relative blues and relative greens plays its part in that attenuated scale, especially when the picture is placed in a strong light which, as it penetrates their molecules, gives them all the brilliance of which they are capable; but if the picture is placed in shadow or if it recedes under the light, the earth becomes earth once more and the tones *no long play*, so to speak. Above all, if it is placed alongside of a picture having full color, as do those of Titian and Rubens, it shows up as the thing it really is: earthy, dull, and without life. *Dust thou art to dust returning.*

Van Dyck uses more earthy colors than does Rubens, ocher, red, brown, black, etc. . . . (608–609).

JANUARY 1, 1861

As to *yellowish high-lights on flesh*. I find in the notebook of 1852, October 11, an experiment that I was making in this direction. On figures at the Hôtel de Ville, reddish or purplish in color, I risk some high-lights of *Naples yellow*. Although this is against the law demanding cold highlights, putting yellow ones on a violet tone in the flesh brought about the effect successfully. In the *Kermesse*, etc. (691).

10 • DAVID RAMSAY HAY
(1798 – 1866)

Hay, like Bacon, was a nineteenth-century color theorist who devised tidy explanations of color, that drew loosely on scientific theory, to defend various recipes for color usage. Although he wrote vaguely of various principles, such as activeness and passiveness, said to be present in colors, and failed to recognize that recipes for color usually reflect the passing taste of their day, Hay's work paved the way for the writings of Munsell, Ostwald, and Birren during the twentieth century.

From THE PRINCIPLES OF BEAUTY
IN COLOURING SYSTEMATIZED

On the Nature and Relation of Colours

Light may be considered an active, and darkness a passive principle, in the economy of Nature, and colour an intermediate phenomenon arising from their joint influence. It is usual to consider colour as an inherent quality in light, and to suppose that every coloured body absorbs a certain class of its rays, and reflects or transmits the remainder; but it appears to me, that colour is more probably the result of certain modes in which the opposite principles of motion and rest, or force and resistance, operate in the production and modification of light, and that each colour is mutually related to these active and passive principles. In the three colours, yellow, red, and blue, now universally acknowledged as the primary elements of chromatic beauty, these principles seem to operate in progressive ratios, for, if the purest powdered pigments be mixed in the proportion of 1

Fig. 1

	Relation to Light	Relation to Darkness	Medial Power as a Color
Yellow,	45	15	30
Red,	30	30	30
Blue,	15	45	30
Neutral Gray,			90

yellow, 2 red, and 3 blue, a cool-toned gray is the result, resembling a mixture of black and white: if the mixture be changed to 1 blue, 2 red, and 3 yellow, we have a warm-toned brown; but the neutral gray in which light, shade, and colour are equally represented, is the result of a mixture of equal quantities.

White and black are the representatives of light and darkness, while yellow, red, and blue are the primary elements of colour. From the union of these elements in certain proportions, every conceivable variety of colour and hue arises; but their nature and qualities in relation to light and shade, and to one another, must be well understood before proper modes of combination can be adopted. White and black, therefore, being only the representatives of light and darkness, cannot be reckoned colours, but merely their modifiers, in reducing them by their attenuating and sub-duing qualities to tints and shades respectively.

The relations that yellow, red, and blue, bear to light and darkness, and the mode in which those relations operate throughout the colorific circle, may be shown in the following manner:—Let us suppose the active principle of light divided into 180 parts, and the passive principle of shade into the same number, so that the medial gray arising from their joint influence, will be to each of these principles or powers as 90, that is, in the ratio of 1 to 2, because they mutually neutralize each other; and the following [in Fig. 1] are the proportions in which light and shade will be found to be combined in the primary elements of colour.

Fig. 2

	Light	Darkness	
Yellow,	3	1	2
Red,	2	2	2
Blue,	1	3	2
Neutral Gray,		6	

Fig. 3

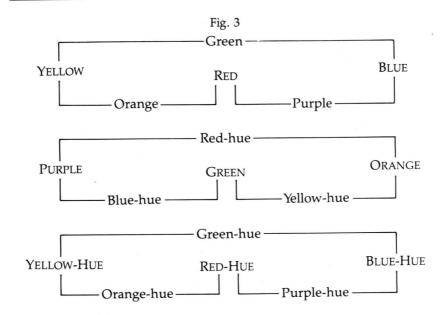

They may here, however, be reduced to their lowest denominations, as the higher are only useful in reducing colours to tints and shades. . . . These numbers are [shown in Fig. 2].

Red, it will be observed, is the most perfect colour, from its having an equal relation to light and shade, the two principles being exhibited in it in the same ratio as in neutral gray, but in a different and more vigorous mode. In yellow, the active principle being to the passive of 3 to 1,

Fig. 4

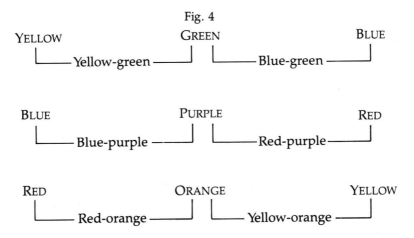

Fig. 5

ORANGE		GREEN		PURPLE	
Yellow,	2	Yellow,	2	Blue,	2
Red,	2	Blue,	2	Red,	2

BLUE-HUE		RED-HUE		YELLOW-HUE	
Yellow,	2	Yellow,	2	Yellow,	4
Red,	2	Red,	4	Red,	2
Blue,	4	Blue,	2	Blue,	2

ORANGE-HUE		GREEN-HUE		PURPLE-HUE	
Yellow,	6	Yellow,	6	Yellow,	4
Red,	6	Red,	4	Red,	6
Blue,	4	Blue,	6	Blue,	6

and in blue, as 1 to 3, these colours when united in green, exhibit the two principles acting, as in red, in equal ratios; thus constituting green the most perfect of compounded colours. The secondary colours are, orange, green, and purple, and are produced by the pairing of the primaries. In the hues, the three primary colours are combined, and these combinations are of two classes—primary, and secondary. The primary class arise from pairing the secondary colours, and are generally called citrine, russet, and olive, but, for the sake of perspicuity, I shall name them after the primaries to which they belong. From the pairing of these primary hues, the semi-neutrals, or secondary class of hues, are produced. These various modes of union are shown in [Figs. 3–4].

The secondary colours may have an excess of either of the two primaries of which they are severally composed, and their tone thus be altered in various degrees.

Fig. 6

YELLOW-ORANGE		YELLOW-GREEN		RED-ORANGE	
Yellow,	4	Yellow,	4	Yellow,	2
Red,	2	Blue,	2	Red,	4

BLUE-PURPLE		RED-PURPLE		BLUE-GREEN	
Blue,	4	Blue,	2	Blue,	4
Red,	2	Red,	4	Yellow,	2

Fig. 7

PRIMARY COLOURS	RELATION TO LIGHT	RELATION TO DARKNESS	DEGREES OF CONTRAST	RELATIVE POWERS
Yellow,	3	1		
Red,	2	2		8
Blue,	1	3		
			First	
SECONDARY COLOURS				
Orange,	5	3		
Green,	4	4		4
Purple,	3	5		
			Ninth	
PRIMARY HUES				
Yellow-hue,	9	7		
Red-hue,	8	8		2
Blue-hue,	7	9		
			Eleventh	
SECONDARY HUES				
Orange-hue	17	15		
Green-hue,	16	16		1
Purple-hue,	15	17		

. . . From the binary union of these modified secondaries, no farther variety of hue arises than the predominance or subordination of one or other of the primaries in proportions similar to what arise from ternary modes of union to be afterwards explained.

The following may be taken as the relative quantities of the primary elements in these three classes of compound colours [see Fig. 5].

From these quantities, it will be seen, that the hues owe their distinction exclusively to the proportionate predominance of one of the primary colours in each of the first class, and a like subordination of one of these in each of the second. This rule holds good throughout every species of colouring in nature and art.

The primary elements are in the modified secondaries as follows [in Fig. 6].

The relations and powers of the three classes of colours, as they naturally arise out of the binary mode of union, are shown in [Fig. 7].

The powers of the colours and hues in the foregoing table, it will be observed, are in an inverse ratio to the quantities which express their mode of combination, but as each successive mode is a step towards neutralization, these quantities express the rate of their approach to that negative quality (17–24).

11 • CHARLES BAUDELAIRE
(1821 – 1867)

Baudelaire, the French poet, literary critic, and friend of Delacroix, was also a major art critic of the nineteenth century. "On Color" is a rich blend of poetic observation and scientific theory.

From THE MIRROR OF ART

On Colour

Let us suppose a beautiful expanse of nature, where there is full licence for everything to be as green, red, dusty or iridescent as it wishes; where all things, variously coloured in accordance with their molecular structure, suffer continual alteration through the transposition of shadow and light where the workings of latent heat allow no rest, but everything is in a state of perpetual vibration which causes lines to tremble and fulfills the law of eternal and universal movement. An immensity which is sometimes blue, and often green, extends to the confines of the sky; it is the sea. The trees are green, the grass and the moss are green; the tree-trunks are snaked with green, and the unripe stalks are green; green is nature's ground-bass, because green marries easily with all the other colours. . . . What strikes me first of all is that everywhere—whether it be poppies in the grass, pimpernels, parrots, etc.—red sings the glory of green; black (where it exists—a solitary and insignificant cipher) intercedes on behalf of blue or red. The blue—that is, the sky—is out across the airy flecks of white or with grey masses, which pleasantly temper its bleak crudeness; and as the

vaporous atmosphere of the season—winter or summer—bathes, softens, or engulfs the contours, nature seems like a spinning-top which revolves so rapidly that it appears grey, although it embraces within itself the whole gamut of colours.

The sap rises, and as the principles mix, there is a flowering of *mixed tones*; trees, rocks, and granite boulders gaze at themselves in the water and cast their *reflections* upon them; each transparent object picks up light and colour as it passes from nearby or afar. According as the daystar alters its position, tones change their values, but, always respecting their natural sympathies and antipathies, they continue to live in harmony by making reciprocal concessions. Shadows slowly shift, and colours are put to flight before them, or extinguished altogether, according as the light, itself shining, may wish to bring fresh ones to life. Some colours cast back their reflections upon one another, and by modifying their own qualities with a *glaze* of transparent, borrowed qualities, they combine and recombine in an infinite series of melodious marriages which are thus made more easy for them. When the great brazier of the sun dips beneath the waters, fanfares of red surge forth on all sides; a harmony of blood flares up at the horizon, and green turns richly crimson. Soon vast blue shadows are rhythmically sweeping before them the host of orange and rose-pink tones which are like a faint and distant echo of the light. This great symphony of today, which is an eternal variation of the symphony of yesterday, this succession of melodies whose variety ever issues from the infinite, this complex hymn is called *colour.*

In colour are to be found harmony, melody, and counterpoint.

It is often asked if the same man can be at once a great colourist and a great draughtsman.

Yes and no; for there are different kinds of drawing.

The quality of pure draughtsmanship consists above all in precision, and this precision excludes *touch*; but there are such things as happy touches, and the colourist who undertakes to express nature through colour would often lose more by suppressing his happy touches than by studying a greater austerity of drawing.

Certainly colour does not exclude great draughtsmanship—that of Veronese, for example, which proceeds above all by ensemble and by mass; but it does exclude the meticulous drawing of detail, the contour of the tiny fragment, where touch will always eat away line.

The love of air and the choice of subjects in movement call for the employment of flowing and fused lines.

Exclusive draughtsmen act in accordance with an inverse procedure which is yet analogous. With their eyes fixed upon tracking and surprising their line in its most secret convolutions, they have no time to see air and light—that is to say, the effects of these things—and they even compel

themselves *not* to see them, in order to avoid offending the dogma of their school.

It is thus possible to be at once a colourist and a draughtsman, but only in a certain sense. Just as a draughtsman can be a colourist in his broad masses, so a colourist can be a draughtsman by means of a total logic in his linear ensemble; but one of these qualities always engulfs the detail of the other.

The draughtsmanship of colourists is like that of nature; their figures are naturally bounded by a harmonious collision of colored masses.

Pure draughtsmen are philosophers and dialecticians.

Colourists are epic poets (48–52).

12 • HERMANN VON HELMHOLTZ
(1821 – 1894)

Von Helmholtz, German philosopher and scientist, invented the ophthalmoscope and published many important papers in the areas of dynamics, hydrodynamics, electrodynamics, meteorological physics, and optics. He investigated vision in *Physiological Optics* (1856 – 66) and hearing in *Sensations of Tone* (1862).

From HELMHOLTZ'S TREATISE ON PHYSIOLOGICAL OPTICS

. . . [M]any attempts have been made to divide the intervals of colour in the spectrum on the same basis as that of the division of the musical scale, that is, into whole tones and semi-tones. Newton tried it first. However, at that time the undulatory theory was still undeveloped and not accepted; and not being aware of the connection between the width of the separate colours in the prismatic spectrum and the nature of the refracting substance, he divided the visible spectrum of a glass prism, . . . directly into seven intervals, of widths proportional to the intervals in the musical scale, namely, 9/8, 16/15, 10/9, 9/8, 10/9, 16/15, 9/8; and so he distinguished seven corresponding principal colours; *red, orange, yellow, green, blue, indigo* and *violet*. The reason why two kinds of blue are mentioned here, while golden yellow, yellow-green, and sea-green, which appear to the eye at least just as different from the adjacent principal colours as indigo is from cyan-blue and violet, are omitted, is because of the peculiar variation of the index of refraction, . . . which

causes the more refrangible colours in a prismatic spectrum to be elongated more than the less refrangible ones. The distribution of colours in the interference spectrum has nothing to do with the character of the refracting medium and depends simply on the wave-length; and here the blue-violet region is much narrower, and if the intervals were determined in the same way, this span would not be resolved into three parts, whereas the red-orange portion would be in about three parts.

. . . [S]uppose that the spectrum as we now know it is divided on the same principle as the musical scale using the vibration-numbers of the aether waves; . . . then if the yellow of the spectrum answers to the tenor C . . . we obtain for the separate half-tones the following scale of colours analogous to the notes of the piano [see Fig. 1].

Fig. 1

F#,	end of Red	d#,	Cyan-blue
G,	Red	e,	Indigo blue
G#,	Red	f,	Violet
A,	Red	f#,	Violet
A#,	Orange-red	g,	Ultra-violet
B,	Orange	g#,	Ultra-violet
c,	Yellow	a,	Ultra-violet
c#,	Green	a#,	Ultra-violet
d,	Greenish-blue	b,	Ultra-violet

The hues that comprise octaves are placed side by side. . . . The end of the infra-red spectrum, according to Fizeau and Foucault, calculated on the same basis, would be about *D*, two octaves below cyan-blue; and if Cauchy's formula for the connection between wave-length and index of refraction can be supposed to be valid so far; the extreme limit of the spectrum of the arclight would be at *b'*, an octave higher than the ultra-violet end of the solar spectrum.

The colour-scale divided in half-tones, as above shows that at both ends of the spectrum the colours do not change noticeably for several half-tone intervals, whereas in the middle of the spectrum the numerous transition colours of yellow into green are all comprised in the width of a single half-tone. This implies that in the middle of the spectrum the eye is much keener to distinguish vibration-frequencies than towards the ends of the spectrum; and that the magnitudes of the colour intervals are not at all like the gradations of musical pitch in being dependent in vibration-frequencies (76–77).

Previous to the time of Newton, the theory of colour consisted chiefly of vague hypotheses. The intensity of the coloured light that was

derived from the total white light being always necessarily less than that of the whole, the old-fashioned idea was that this decrease of intensity was an essential thing about colour, and Aristotle's opinion that colour is a mixture of white and black had many adherents. He himself was undecided whether this mingling of white and black was to be considered as a real blending or more as an atomic superposition or juxtaposition. He supposed that darkness must be due to reflection from bodies, because every time light is reflected, it gets fainter. This was the prevalent view until the beginning of more modern times, . . . And in very recent times Goethe has tried to uphold it again in his *Farbenlehre*. This theory of colour does not pretend to give an explanation of colour phenomena in the physical sense—considered in that way, Goethe's propositions would be void of any meaning; but all that he tries to do is to formulate in a general way the conditions of the production of colours. Colours must be manifested distinctly in some original phenomenon. . . . He considers the colours of cloudy media as being this original phenomenon. Many media of this sort give a red colour to light that passes through them, whereas the incident light as seen against a dark background looks blue. Thus, although Goethe follows Aristotle's view in general, and supposes that light is darkened or has to be mixed with darkness to produce colours, he imagines that in the phenomena of cloudy media he has discovered the special kind of darkening that produces, not what we call grey, but colours as usually understood. What change occurs in the light itself under these circumstances, he never does explain. He does, perhaps, say that the cloudy medium gives the light something corporeal, shadowy, which is necessary for the production of colour. But what he means by it, he does not explain more precisely. He cannot possibly suppose that something corporeal escapes from bodies along with the light they emit; and yet as a physical explanation scarcely any other meaning can be attached to it.

Moreover, in Goethe's way of looking at the matter, all transparent bodies are a little cloudy; and this is true of a prism, too. Thus, he assumes that the prism communicates something of its cloudiness to the image which the spectator beholds. Apparently, what he means by this is that the image in a prism is never quite sharp, but is confused and indistinct; for in his theory of colour he classifies such images with the secondary images produced by plane parallel glass plates and crystals of Iceland spar. The image made by a prism certainly is confused in heterogeneous light, but is perfectly sharp in homogeneous light; but this is something that apparently Goethe never did see, as he disdained to consider at all the array of arguments that prove this fact. When a bright surface on a dark background is viewed through a prism, his idea is that the image is shifted and clouded by the prism. The anterior

edge of the bright area is shifted over the dark background, and being a bright cloud over darkness, looks blue. But the other edge of the bright area, being overlapped by the cloudy image of the black background that succeeds it, is a bright thing behind a dark cloud, and is therefore yellow-red. Why the anterior edge appears in front of the background and the other edge behind it, and not the other way, he does not explain. This presentation of the matter is likely absolutely meaningless if it is intended to be a physical explanation. For the prism image, as thus seen, is a potential one and is therefore simply the geometrical place where the rays of light that come to the spectator would intersect if they were prolonged backwards; and hence this image cannot have the physical effects of an image seen through a cloudy medium. These representations of Goethe's are therefore not to be regarded as physical explanations at all, but merely as figurative illustrations of the process. In his scientific work he does not attempt anyhow to go beyond the domain of sensory perception. But every physical explanation must be in terms of the forces that come into play, and these forces, of course, can never be the object of sensory perception, but are simply concepts of the mind.

The experiments which Goethe uses to support his theory of colour are accurately observed and vividly described. There is no dispute as to their validity. The crucial experiments with as homogeneous light as possible, which are the basis of Newton's theory, he seems never to have repeated or to have seen. The reason of his exceedingly violent diatribe against Newton . . . was more because the fundamental hypotheses in Newton's theory seemed absurd to him, than because he had anything cogent to urge against his experiments or conclusions. But Newton's assumption that white light was composed of light of many colours seemed so absurd to Goethe, because he looked at it from his artistic standpoint which compelled him to seek all beauty and truth in direct terms of sensory perception. The physiology of the sense-perceptions was at that time still undeveloped. The complexity of white light, which Newton maintained, was the first decisive empirical step in the direction of recognizing the merely subjective significance of the sense-perceptions. Goethe's presentiment was, therefore, correct when he violently opposed this first advance that threatened to ruin the "fair glory" . . . of the sense-perceptions.

The great sensation produced in Germany by Goethe's *Farbenlehre* was partly due to the fact that most people, not being accustomed to the accuracy of scientific investigations, are naturally more disposed to follow a clear, artistic presentation of the subject than mathematical and physical abstractions. Moreover, Hegel's natural philosophy used Goethe's theory of colour for its purposes. Like Goethe, Hegel wanted

to see in natural phenomena the direct expression of certain ideas or of certain steps of logical thought. This is the explanation of his affinity with Goethe and of his chief opposition to theoretical physics.

In developing the theory of the rainbow, Descartes advanced a new hypothesis, by assuming that the particles of which light is composed not only had a rectilinear motion but also rotated about their axes, and that the resultant colour was due to the velocity of rotation. Moreover, the action of transparent bodies may change the rotation and along with it the colour also. Similar mechanical conceptions were formulated by Hooke and de la Hire. The latter assumed that the colours were dependent on the force of the impact of the light on the optic nerve.

Finally, Newton . . . proved the heterogeneous nature of white light. He isolated homogeneous light from it, and showed that this latter light was coloured. This colour was characteristic homogeneous light, and could not be altered any more by absorption and refraction. He found that light of different colours had different refrangibilities; and that the colours of natural bodies were due to peculiarities of absorption and reflection. Incidentally, he explained the colour of the rays of light as being entirely the result of their action on the retina. The rays themselves were not red, but they produced the sensation of red. He leaned towards the emission (corpuscular) theory of light; but he advanced no hypotheses as to the physical differences between homogeneous kinds of light of different colours.

About the same time, in 1690, Huygens proposed the hypothesis that light consisted in undulations of a delicate elastic medium. Euler showed how Newton's discoveries could be explained on this basis, and deduced the result that the simple colours in the spectrum were the effects of light of different frequencies of vibration. As a matter of fact, however, his first assumption was that the red vibrations were the faster ones, but subsequently he discovered the mistake. Hartley correctly supported this view in explaining the colours of thin plates. But a crucial test could not be made until the principle of interference had been discovered by Young and Fresnel; and it was this discovery also that led first to a general acceptance of the undulatory theory.

Newton's inference that the colours of the rays depended on the refrangibility and that light of given refrangibility was homogeneous in all other ways and invariable in colour, was opposed by Brewster. He thought he had found that homogeneous light could change colour in traversing a coloured medium, and that in this way it might be possible to get white light from homogeneous light. He was led thus to infer that there were three different kinds of light, corresponding to the three so-called fundamental colours, red, yellow and blue, and that each of these kinds of light gave rays of every degree of refrangibility within the

range of the spectrum, in such fashion, however, that red light predominates at the red end, yellow light in the middle, and blue light at the blue end. His idea was that light of given refrangibility would be absorbed by media of various colours to different extents, and that the colours would be separated in this way. Brewster's views were opposed by Airy, Draper, Melloni, Helmholtz and F. Bernard. Outside of some cases in which, owing to contrast effects with adjacent vivid colours, the hue appeared to be different after the light had been greatly reduced in intensity by being filtered through coloured glasses, and some other cases in which the above mentioned variation of colour was connected with the intensity of light, most of Brewster's observations were probably due to the circumstance, to which attention has already been called, that small quantities of white light were diffused over the field of view as a result of repeated reflections at the various surfaces or of scattered reflection inside the prism substance and in the ocular media (114–16).

. . . [H]omogeneous light of different refrangibilities and frequencies produces sensations of different colours in the organ of vision. Now when one and the same place on the retina is stimulated at the same time by light of two or more different vibration-frequencies, new kinds of colour sensations are produced which, generally speaking, are different from those of the simple colours of the spectrum. A peculiarity of these sensations is that is not possible to recognize the simple colours that are contained in the mixture. The fact is that generally the sensation of any given compound colour may be produced by several different combinations of spectral colours, without its being possible for the most practised eye to tell by itself what simple colours are concealed in the compound light. In this respect, there is a fundamental difference between the eye in its reaction to the aether vibrations and the ear, which responds to sound-waves of different pitch by combining the separate notes, it is true, in a compound sensation of a chord, and yet is able to detect separately each single note in it. Thus, two chords consisting of different musical notes never do appear identical to the ear, as different aggregates of compound colours may be for the eye (120).

13 • JAMES CLERK MAXWELL
(1831 – 1879)

The nineteenth century, like the sixteenth and seventeenth, was a period of major scientific advances in optics and the study of light. The most important theoretician was Maxwell, a Scottish physicist and mathematician whose fame rests primarily on his formulation of electromagnetic theory—the greatest achievement in the physical sciences since Newton's *Principia*. Although Maxwell's papers on color, for which he won the Rumford Medal of the Royal Society of London, attract far less attention today than his work on electromagnetic theory, Maxwell considered his papers on color to be his most important scientific contribution.

He recognized fourteen ways in which colors could be mixed, of which only two—the mechanical mixture of paints and the mixture of two or more light beams—are considered in conventional color theory. Optical mixture, in which separate areas of color appear to fuse "in the eye," is an equally important natural phenomenon and was the basis for the color theories of the Impressionists and neo-Impressionists.

Maxwell illustrated optical mixing through the Maxwell disc or Maxwell wheel, a fascinating gadget devised while he was a student. It consists of a spinning disc painted in two or more colors and powered by a motor, rubber band, piece of string or other device. As the multi-colored disc spins, its colors merge to a single color, an effect that disappears when the disc comes to rest. Until about 1924, the Maxwell disc was popular in the schools as a means of illustrating the presumed laws of color mixing. A modern variation can be constructed by cutting a piece of cardboard to the size and shape of a phonograph record and spinning it on a turntable.

Popularized by Ogden Rood, Maxwell's ideas reached a wide public, including many artists, by the late nineteenth century. Optical mixture was used to explain "broken color," the Impressionist technique in which small spots of different colors were to blend in the eye of the viewer. In pointil-

lism, Seurat's development of the technique, the spots were much smaller and more regularly applied, again in the belief that optical mixture would lead to colors more vivid than those obtained by mixing paints before applying them to the canvas.

From SCIENTIFIC PAPERS

Construction of Maxwell Discs

The coloured paper is cut into the form of discs, each with a small hole in the center, and divided along a radius, so as to admit of several of them being placed on the same axis, so that part of each is exposed. By slipping one disc over another, we can expose any given portion of each colour. These discs are placed on a little top or teetotum, consisting of a flat disc of tin-plate and a vertical axis of ivory. This axis passes through the centre of the discs, and the quantity of each colour exposed is measured by a graduation on the rim of the disc, which is divided into 100 parts.

By spinning the top, each colour is presented to the eye for a time proportional to the angle of the sector exposed, and I have found, by independent experiments, that the colour produced by fast spinning is identical with that produced by causing the light of the different colours to fall on the retina at once.

By properly arranging the discs, any given colour may be imitated and afterwards registered by the graduation on the rim of the top. The principal use of the top is to obtain colour-equations. These are got by producing, by two different combinations of colours, the same mixed tint. For this purpose there is another set of discs, half the diameter of the others, which lie above them, and by which the second combination of colours is formed.

The two combinations being close together, may be accurately compared, and when they are made sensibly identical, the proportions of the different colours in each is registered, and the results equated.

These equations, in the case of ordinary vision, are always between four colours, not including black.

From them, by a very simple rule, the different colours and compounds have their places assigned on the triangle of colours. The rule for finding the position is this:—Assume any three points as the positions of your three standard colours, whatever they are; then form an equation between the three standard colours, the given colour and black, by arranging these colours on the inner and outer circles so as to produce an identity when spun. Bring the given colour to the left-hand side of the equation, and the

three standard colours to the right hand, leaving out black, then the position of the given colour is the centre of gravity of the three masses, whose weights are as the number of degrees of each of the standard colours, taken positive or negative as the case may be.

In this way, the triangle of colours may be constructed by scale and compass from experiments on ordinary vision (122–23).

14 • OGDEN NICHOLAS ROOD
(1831 – 1902)

Rood was a professor of physics at Columbia University and an amateur painter. He combined these interests by successfully popularizing scientific ideas about color and light and bringing them to the attention of artists and the general public. In the late nineteenth century, *Modern Chromatics,* in print for over 30 years, provided a theoretical basis for Impressionist and neo-Impressionist color theory; in the twentieth century it was read by the young Albert H. Munsell.

From STUDENTS' TEXTBOOK OF COLOUR; OR MODERN CHROMATICS, WITH APPLICATIONS TO ART AND INDUSTRY

The Colour Theory of Young and Helmholtz

It is well known to painters that approximate representations of all colours can be produced by the use of very few pigments. Three pigments or coloured powders will suffice, a red, yellow, and a blue; for example, crimson lake, gamboge, and Prussian blue. The red and yellow mingled in various proportions will furnish different shades of orange and orange-yellow; the blue and yellow will give a great variety of greens; the red and blue all the purple and violet hues. There have been instances of painters in water-colours who used only these three pigments, adding lampblack for the purpose of darkening them and obtaining the browns

61

and greys. Now, though it is not possible in this way to obtain as brilliant representatives of the hues of nature as with a less economical palette, yet substitutes of a more or less satisfactory character can actually be produced in this manner. These facts have been known to painters from the earliest ages, and furnished the foundation for the so-called theory of three primary colours, red, yellow, and blue. The most distinguished defender in modern times of this theory was Sir David Brewster, so justly celebrated for his many and brilliant optical discoveries. He maintained that there were three original or fundamental kinds of light, red, yellow, and blue, and that by their mixture in various proportions all other kinds of coloured light were produced, in the manner just described for pigments. Brewster in fact thought he had demonstrated the existence in the spectrum itself of these three sets of fundamental rays, as well as the absence of all others; and his great reputation induced most physicists for more than twenty years to adopt this view, Airy, Melloni, and Draper alone dissenting. This theory of the existence of three fundamental kinds of light, red, yellow, and blue, is found in all except the most recent text books on physics, and is almost universally believed by artists. Nevertheless, it will not be difficult to show that it is quite without foundation. If we look at the matter from a theoretical point of view, we reach at once the conclusion that it can not be true, because outside of ourselves there is no such thing as colour, which is a mere sensation that varies with the length of the wave producing it. Outside of and apart from ourselves, light consists only of waves, long and short—in fact, of mere mechanical movements; so that Brewster's theory would imply that there were in the spectrum only three sets of waves having three different lengths, which we know is not the case. If we take up the matter experimentally, we meet with no better result. According to the theory now under consideration, green light is produced by mixing blue and yellow light. This point can be tested with Maxwell's coloured disks. A circular disk, painted with chrome-yellow and provided with a radial slit, is to be combined with one prepared in the same way and painted with ultramarine-blue If the compound disk be now set in quite rapid rotation, the two kinds of coloured light will be mingled, and the resultant tint can be studied. It will not be green, but yellowish grey or reddish grey, according to the proportions of the two colours. These disks of Maxwell are ingeniously contrived so as to allow the experimenter to mingle the two colours in any desired proportion; but, vary the proportions as we may, it is impossible to obtain a resultant green hue, or indeed anything approaching it. Another way of making this experiment is simply to use a fragment of window-glass of good quality, as was done by Lambert and Helmholtz. . . . The glass is supported in a vertical position about ten inches above a board painted black, and on either side of it are placed the coloured papers. The blue paper is seen

directly through the glass, while the light from the yellow paper is first reflected from the glass and then reaches the eye. The result is that the two images are seen superimposed. . . . The relative luminosity or brightness of the two images can be varied at will; for instance, moving the papers further apart causes the blue to predominate, and bringing them nearer together produces the reverse effect. In this manner the resultant tint may be made to run through a variety of changes, which will entirely correspond to those obtained with the two circular disks; but, as before, no tendency to green is observed. Helmholtz has pushed this matter still further, and has studied the resultant hues produced by combining together the pure colours of the spectrum. The following experiment, which is easy to make, will give an idea of the mode of proceeding. A blackened screen of pasteboard is pierced with two narrow slits, . . . The light from a window is allowed to shine through the two slits and to fall on a prism of glass placed just before the eye, and distant from the slits about a metre. Then, as would be expected, each slit furnishes a prismatic spectrum, and owing to the disposition of the slits, the two spectra will overlap. . . . By moving the slits further apart or nearer together, all the different kinds of light which the spectrum contains may thus be mingled. Using a more refined apparatus, Helmholtz proved that the union of the pure blue with the pure yellow light of the spectrum produced in the eye the sensation, not of green, but of white light. . . . [I]t is evident that this total failure of blue and yellow light to produce by their mixture green light is necessarily fatal to the hypothesis of Brewster. Helmholtz also studied the nature of the appearances which misled the great English optician, and showed that they were due to the fact that he had employed an impure spectrum, or one not entirely free from stray white light.

As has been remarked above, there can be in an objective sense no such thing as three fundamental colours, or three primary kinds of coloured light. In a totally different sense, however, something of this kind is not only possible, but, as the recent advances of science show, highly probable. . . . [I]n the solar spectrum the eye can distinguish no less than a thousand different tints. Every small, minute, almost invisible portion of the retina of the eye possesses this power, which leads us to ask whether each atom of the retina is supplied with an immense number of nerve fibrils for the reception and conveyance of this vast number of sensations. The celebrated Thomas Young adopted another view: according to him, each minute elementary portion of the retina is capable of receiving and transmitting three different sensations; or we may say that each elementary portion of its surface is supplied with three nerve fibrils, adapted for the reception of three sensations. One set of these nerves is strongly acted on by long waves of light, and produces the sensation we call red; another set responds most powerfully to waves of medium

length, producing the sensation which we call green; and finally, the third set is strongly stimulated by short waves, and generates the sensation known as violet. The red of the spectrum, then, acts powerfully on the first set of these nerves; but, according to Young's theory, it also acts on the two other sets, but with less energy. The same is true of the green and violet rays of the spectrum: they each act on all three sets of nerves, but most powerfully on those especially designed for their reception. . . . [N]erves of the first kind are powerfully stimulated by red light, are much less affected by yellow, still less by green, and very little by violet light. Nerves of the second kind are much affected by green light, less by yellow and blue, and still less by red and violet. The third kind of nerves answer readily to violet light, and are successively less affected by other kinds of light in the following order: blue, green, yellow, orange, red. The next point in the theory is that, if all three sets of nerves are simultaneously stimulated to about the same degree, the sensation which we call white will be produced. These are the main points of Young's theory, which was published as long ago as 1802, and more fully in 1807. Attention has within the last few years been called to it by Helmholtz, and it is mainly owing to his labours and those of Maxwell that it now commands such respectful attention. Before making an examination of the evidence on which it rests, and of its applications, it may be well to remember, as Helmholtz remarks, that the choice of these three particular colours, red, green, and violet, is somewhat arbitrary, and that any three could be chosen which when mixed together would furnish white light. If, however, the end and middle colours of the spectrum (red, violet, and green) are not selected, then one of the three must have two maxima, one in the red and the other in the violet; which is a more complicated, but not an impossible supposition. The only known method of deciding this point is by the investigation of those persons who are colour-blind. . . . [T]he most common kind of this affection is colour-blindness to *red*, which indicates this colour as being one of the three fundamental sensations. But, if we adopt red as one of our three fundamental colours, of necessity the two others must be green and violet or blue-violet. Red, yellow, and blue, for example, will not produce white light when mingled together, nor will they under any circumstances furnish a green. Red, orange, and blue or violet would answer no better for a fundamental triad. . . . [C]olour-blindness to green exists to some extent, though by no means so commonly as the other case. Hence, thus far, the study of col-our-blindness has furnished evidence in favour of the choice of Young, and its phenomena seem explicable by it.

Let us now examine the explanation which the theory of Young furnishes of the production of the following colour-sensations, which are not fundamental [see Fig. 1].

Fig. 1

Orange-red	Yellow	Bluish-green
Red-orange	Greenish-yellow	Cyan-blue
Orange-yellow	Yellowish-green	Ultramarine-blue

Starting with yellow, we find that, according to the theory under consideration, it should be produced by the joint stimulation of the red and green nerves; consequently, if we present simultaneously to the eye red and green light, the sensation produced ought to be what we call yellow. This can be most perfectly accomplished by mixing the red and green light of the spectrum; it is possible in this way to produce a fair yellow tint. The method of rotating disks furnishes, when emerald-green and vermilion are employed, a yellow which appears rather dull for two reasons: first, because the pigments which we call yellow, such as chrome yellow or gamboge, are, as will hereafter be shown, relatively more brilliant and luminous than any of the red, green, blue, or violet pigments in use; so that these bright yellow pigments stand in a separate class by themselves. This circumstance influences our judgment, and, finding the resultant yellow far less brilliant than our (false) standard, chrome-yellow, we are disappointed. The second reason is that green light stimulates, as before mentioned, the violet as well as the green nerves; hence all three sets of nerves are set in action to a noticeable extent, and the sensation of yellow is mingled with that of white, and consequently is less intense than it otherwise would be. When the green and red of the spectrum are mingled, we have at least not to contend with a false standard, and only the second reason comes into play, and causes the yellow thus produced to look as though mingled with a certain quantity of white. It was found by the lamented J. J. Müller that green light when mingled with any other coloured light of the spectrum diminished its saturation, and caused it to look as though at the same time some white light had been added. . . . [This] is quite in consonance with the theory of Young and Helmholtz.

Having now accounted for the fact that the yellow produced by mixing red and green light is not particularly brilliant, it will be easy to show how several of the other colour-sensations are generated. If, for instance, we diminish the intensity of the green light in the experiment above mentioned, the resultant hue will change from yellow to orange, red-orange, orange-red, and finally to pure red. These changes are best followed by using the coloured light of the spectrum, but may also be traced by the help of Maxwell's disks . . . or by the aid of the glass plate of Helmholtz. . . . On the other hand, if, in the experiment now under consideration, the green light be made to preponderate, the resultant yellow hue will pass into greenish yellow, yellowish green, and finally green. This accounts for the production of more than half the col-

our-sensations in the list above given, and the remaining ones, such as ultramarine, cyan-blue, and bluish green, can be produced in the same way by mingling in proper proportions green and violet light, using any of the methods above mentioned.

In the cases thus far considered, we have presented to the eye mixtures of two different kinds of coloured light, or, to speak more accurately, two kinds of light differing in wave-length. It now remains for us to account for the production of colour-sensations in those cases where the eye is acted on by one kind of coloured light, or by light having one wave-length. In the case of red, green, or violet light, the explanation of course lies on the surface: the red light stimulates powerfully the red nerves and produces the sensation we call red, and so of the others. But this does not quite exhaust the matter; for, according to the theory of Young and Helmholtz, this same red light also acts to some extent on the green and violet nerves, and simultaneously produces to some small degree the sensations we call green and violet. The result, then, according to the theory, ought to be the production of a strong red sensation, mingled with much weaker green and violet sensations; or, in other words, even when the eye is acted on by the pure red light of the spectrum, this red light ought to appear as though mingled with a little white light, even if none is actually present. Experiment confirms this theoretical conclusion, and here again decides in favour of the correctness of our theory. The simplest way of making the experiment would be to temporarily remove, were it possible, the green and violet nerves from a portion of the retina of the eye, and then to throw on the whole retina the pure red light of the spectrum. This red light ought then to appear more intense and saturated when falling on the spot from which the green and violet nerves had been removed than when received on the rest of the retina, where all three kinds of nerves were present. Now, though we can not actually remove the green and violet nerves from a spot in the retina, yet we can by suitable means tire them out, or temporarily exhaust them, so that they become to a considerable extent insensitive. If a small spot of the retina be exposed for a few moments to a mixture of green and violet light so combined as to appear bluish green, the green and violet nerves will actually become to a considerable extent inoperative; and, when the eye is suddenly turned to the red of the spectrum, this spot of the retina will, if we may use the expression, experience a more powerful and purer sensation of red than the surrounding unfatigued portions, where the red will look as if diluted with a certain amount of white light. From this experiment of Helmholtz it appears, then, that it is actually possible to produce by artificial means colour-sensations which are more powerful than those ordinarily generated by the light of the spectrum. . . .

Having accounted now for the production of the colour-sensations red, green, and violet by red, green, and violet light, and noticed an interesting peculiarity connected with this matter, we pass on to the others. Taking up the yellow of the spectrum, we find that it can be produced by the action on the eye of waves of light intermediate in length between those which give the sensations red and green. These waves are too short to act very powerfully on the red nerves, and too long to set into maximum activity the green nerves, but they set both into moderate action; the result of this joint action of the two sets is a new sensation, which we call yellow. Furthermore, it may be remarked that the waves of the light called yellow are far too long to produce any but a feeble effect on the violet nerves; they affect them less than green light does. From this it results that the sensation of yellow, when directly produced by the yellow light of the spectrum, is less mingled with that of white, and is purer than is the case when it is brought about by mixing red light with green in the manner before described. And this explanation may serve to account for the fact that it is impossible, by mixtures of red and green light taken from the spectrum, to produce a yellow light as pure and brilliant as the yellow of the spectrum. Let us suppose, in the next place, that instead of presenting to the eye the yellow of the spectrum, we act on it by the light belonging to one of the other spaces—the blue, for example. The explanation is almost identical with that just given for the yellow: the waves constituting blue light being too short to powerfully affect the green nerves, and too long to accomplish this with the violet nerves, both green and violet nerves are moderately affected, giving the sensation we call blue. Meanwhile the blue light produces very little action on the red nerves, and hence very little of the sensation of white is mingled with that of blue; and consequently this blue hue is more saturated than when produced by the actual mixture of green and violet light. In fact, J. J. Müller found that green light, when mingled with light from any other part of the spectrum, produced a hue which was less saturated and more whitish than the corresponding tint in the spectrum which the mixture imitated. The production of all the other colour-sensations obtained by looking at the spectrum is explained in the same way by our theory. From all this one interesting conclusion can be drawn, viz.: that there are two distinct ways of producing the same colour-sensation; for we have seen that it may be accomplished either by presenting to the eye a mixture of green and violet light, or simply one kind of light, the waves of which are intermediate in length between those of green and violet. The eye is quite unable to detect the difference of origin, although a prism reveals it instantly.

Having examined thus, . . . the mode in which colour-sensations are accounted for by the theory of Young and Helmholtz, we pass to another

point. In order to give more exactness to this theory, it is necessary to define with some degree of accuracy the three fundamental colours; for there is a great variety of reds, greens, and violets. Helmholtz, as the result of his first investigation, selected a red not far from the end of the spectrum, a full green and violet; in other words, the tints chosen were the middle and end colours of the spectrum. Maxwell, who made a series of beautiful researches on points connected with Young's theory, was led to adopt as the fundamental colours a red which . . . is a scarlet-red with a tint of orange, and is represented by some varieties of vermilion. His green . . . finds among pigments an approximate representative in emerald-green. Instead of adopting a full violet, Maxwell selected a violet-blue . . . which is represented tolerably by artificial ultramarine-blue. By subjecting the results of experiments on the spectrum to calculation, it is possible to fix on the position of one of the fundamental colours, viz., the green. Thus Charles S. Pierce, using data given in Maxwell's paper, obtained for this colour a slightly different result from that just mentioned. . . .

According to his calculations, the fundamental green has a wave-length of 524 ten-millionths of a millimetre, . . . J. J. Müller, who conducted an important investigation on this subject by a quite different method, arrived at a somewhat different result for the position of the green, and assigned to it a wave-length of 506.3 ten-millionths of a millimetre. This position in the spectrum is nearer the blue than the positions given by Maxwell and Pierce, and the tint is more of a bluish green. Again, von Bezold, basing his calculations on the experimental results of Helmholtz and J. J. Müller, reached a conclusion not differing much from those of Maxwell or Pierce. He selects a green in the *middle* of the normal spectrum . . . None of these results differ very greatly All these greens may be imitated by using the pigment known as emerald-green, alone or mixed either with a small quantity of chrome-yellow or cobalt-blue. Hence all these green hues are of the most powerful or, as artists say, over-powering character.

The exact determination of the other two fundamental colours is a more difficult matter, so that even the advocates of Young's theory have not entirely agreed among themselves upon the exact colours, Maxwell taking the ultramarine-blue, Helmholtz and J. J. Müller violet, as the third fundamental. These fundamental colours are among the most saturated and intense of those furnished by the spectrum. Compared with them, the blue of the spectrum is a feeble tint, so that it has often been remarked by Rutherford that, in comparison with the other colours, it appears of a slaty hue. The greenish yellow is also feeble; and, as is well known, pure yellow is found in the spectrum in very small quantity and of no great intensity. The orange-yellow is also much weaker than the red, and the orange only becomes strong as it approaches redness in hue. From this it very

naturally follows that, if a normal spectrum is cast on a white wall in a room not carefully darkened, scarcely more than the three fundamental colours will be discerned, red, green, and blue-violet; the other tints can with some difficulty be made out, but at first sight they strike the unprejudiced observer simply as the places where the three principal colours blend together. The representatives of the fundamentals among pigments are also those which surpass all others in strength and saturation. One of the fundamental colours, red, is used without much difficulty in painting and decoration; the other two are more difficult to manage, particularly the green. The last colour, even when subdued, is troublesome to handle in painting, and many artists avoid it as far as possible, or admit it into their work only in the form of low olive-greens of various shades. When the tint approaches the fundamental green, and is at the same time bright, it becomes at once harsh and brilliant, and the eye is instantly arrested by it in a disagreeable manner (108 – 22).

15 • JAMES McNEIL WHISTLER
(1834 – 1903)

Whistler was an American painter who was influenced in his youth by Courbet and later by the composition of Japanese prints. He acquired a reputation for sharp-tongued eccentricity, fired by exchanges with Ruskin and Oscar Wilde and by the publication of *The Gentle Art of Making Enemies* (1890), a collection of his early writings.

On facing pages in *The Gentle Art . . . ,* Whistler printed a review by P. G. Hamerton (*Saturday Review,* June 1, 1867), and his own rebuttal regarding color terminology.

From THE GENTLE ART OF MAKING ENEMIES

Critic's Analysis. In the "Symphony in White No. III" by Mr. Whistler there are many dainty varieties of tint, but it is not precisely a symphony in white. One lady has a yellowish dress and brown hair and a bit of blue ribbon, the other has a red fan, and there are flowers and green leaves. There is a girl in white on a white sofa, but even this girl has reddish hair; and of course there is the flesh colour of the complexions.

The Critic's Mind Considered. How pleasing that such profound prattle should inevitably find its place in print! "Not precisely a symphony in white for there is a yellowish dress brown hair, etc. another with reddish hair and of course there is the flesh colour of the complexions."

Bon Dieu! did this wise person expect white hair and chalked faces? And does he then, in his astounding consequence, believe that a symphony in F contains no other note, but shall be a continued repetition of F, F, F.? Fool! (44 – 45).

16 • EMILY NOYES VANDERPOEL
(1842 – 1939)

For Vanderpoel, those who used colors unconventionally were suspect of vice or nervous derangement. This was a fairly common point of view that can be traced to the influence of Goethe, who wrote of the moral associations of colors.

Many early critiques of Impressionism called the painters depraved, insane, or hysterical and warned that a viewer's eyes could be damaged by looking too long at the excessively bright colors. Today, reactions such as these (which were a response to a shift in color use) seem exceedingly overwrought, especially since the colors in Impressionist painting do not impress us as unusually bright.

From COLOR PROBLEMS

Color—Blindness

There are other forms of color-blindness which are less common. Some persons seem to see but red and blue, classing yellow and green with red. A less common defect is that of not seeing violet, while there are a few cases on record where all sensation of color is wanting, everything appearing in differing degrees of grey No doubt some people are born color-blind, but the defect is also brought on by disease, by the excessive use of tobacco, alcohol, and other stimulants, and may or may not prove permanent. Doctor Charcot and his school in Paris have made many examinations into visual disturbances, and through these

examinations much of the peculiar coloring and mannerism of some of the modern painters of the so-called impressionist, tachist, mosaist, gray-in-gray, violet colorist, archaic, vibraist, and color orgiast schools have been explained. The artists tell the truth when they say that nature looks to them as they paint it, but they are suffering from hysteria or from other nervous derangements by which their sight is affected (6–7).

Color – Harmonies

It is said that the use of agreeable and harmonious colors tends to the sanity of the whole body by strengthening the nerves (73).

17 • PAUL GAUGUIN
(1848 – 1903)

Gauguin, the son of a journalist, worked as a stockbroker until the age of thirty-four, then painted in Brittany, Tahiti, and the Marquesas Islands. He was successively associated with the Impressionists (1880 – 82), with a movement he called Synthetism, and with the Symbolist writers (1890). His paintings influenced those of the Fauves and the Nabis.

Gauguin's "Notes on Painting" (probably dating from about 1890), were found in a sketchbook containing studies of Brittany and were published by Henri Mahaut in 1910. In "Notes," Gauguin traces the ironies of color mixing. For example, the method by which two colors are combined effects the result. A physical mixture of red paint and green paint yields brown paint of one shade or another, depending on the exact red and green and the proportions in which mixed. Yet placing "a green next to a red does not result in a reddish brown like the mixture, but in two vibrating tones," each setting off the other.

From NOTES ON PAINTING

On an instrument, you start from one tone. In painting you start from several. Thus, you begin with black and divide up to white—first unit, the easiest and also the most in use, consequently the best understood. But take as many units as there are colours in the rainbow, add those made up by composite colours, and you will have a rather respectable number of units, truly a Chinese puzzle, so that it is not astounding that the colourist's science has been so little investigated by the painters, and so

little understood by the public. On the other hand, what richness of means to attain to an intimate relationship with nature.

They reprove our colours which we put unmixed side by side. In that domain we are perforce victorious, since we are powerfully helped by nature, which does not proceed otherwise.

A green next to a red does not result in a reddish brown like the mixture, but in two vibrating tones. If you put chrome yellow next to this red, you have three tones complementing each other and augmenting the intensity of the first tone: the green.

If, instead of the yellow, you apply blue, you will find three different tones, but vibrating through one another.

If instead of the blue, you apply a violet, the result will again be a single tone, but a composite one, belonging to the reds.

The combinations are unlimited. The mixture of colours results in a dirty tone. One colour alone is a crudity and does not exist in nature. They only exist in an apparent rainbow, but how well rich nature took care to show them to you side by side in an arbitrary and unalterable order as if each colour was born out of another!

Now, you have fewer means than nature, and you condemn yourselves of all those which it puts at your disposal. Will you ever have as much light as nature, as much heat as the sun? And you speak of exaggeration, but how can you be exaggerating, since you remain below nature?

Ah! If you mean by exaggerated any badly balanced work, then you are right in that respect. But I must draw your attention to the fact that, even if your work be timid and pale, it will be considered exaggerated, if there is a mistake of harmony in it.

Is there then a science of harmony? Yes.

And in that respect, the feeling of the colourist is exactly the natural harmony. Like singers, painters sometimes sing out of tune, and their eyes have no harmony.

Later there will be, through studies, an entire method of harmony, unless people omit to study it, in the academies and in the majority of the studios. In fact, the study of painting has been divided into two categories. One learns to draw and then to paint, meaning that one colours inside of a ready-made contour, very much as a statue might be painted afterwards.

I admit that, so far I have understood only one thing about this practice, and that is that the colour is nothing but an accessory. "Sir, you must draw properly before painting," this is said in a professorial manner; the greatest stupidities are always said that way.

Do you put on your shoes like your gloves? Can you really make me believe that drawing does not derive from colour and vice versa? And to prove it, I commit myself to reduce or enlarge one and the same drawing,

according to the colour which I use to fill it up. Try to draw a head of Rembrandt in exactly the same proportions, and then put on it the colours of Rubens, and you will see what a misshapen thing you will have, and at the same time, the colour will have become unharmonious (162–63).

18 • VINCENT VAN GOGH
(1853 – 1890)

Van Gogh sold one painting during a troubled life that ended in suicide at the age of thirty-seven. Within a hundred years of his death, this tragic artist has been radically reevaluated, and his paintings bring record-breaking prices at auction. The letters Van Gogh wrote to his brother, Theo, often discussed paintings in progress. Black, ignored or spurned in Impressionist color theory because black objects can be painted with dark shades of other colors, returned to favor with Van Gogh, Gauguin, and other post-Impressionists.

From THE LETTERS OF VINCENT VAN GOGH

[Neunen, late October 1885]

Dear Theo,

I read your letter about black with great pleasure, and it convinces me that you have no prejudice against black.

Your description of Manet's study, "The Dead Toreador," was well analyzed. And the whole letter proves the same as your sketch of Paris suggested to me at the time, that if you put yourself to it, you can paint a thing in words.

It is a fact that by studying the laws of the colours, one can move from instinctive belief in the great masters to the analysis of why one admires—what one admires—and that indeed is necessary nowadays,

when one realizes how terribly arbitrary and superficially people criticize. . . .

Just now my palette is thawing and the frigidness of the first beginning has disappeared.

It is true, I often blunder still when I undertake a thing, but the colours follow of their own accord, and taking one colour as a starting-point, I have clearly before my mind what must follow, and how to get life into it.

Jules Dupré is in landscape rather like Delacroix, for what enormous variety of mood did he express in symphonies of colour.

Now a marine, with the most delicate blue-greens and broken blue and all kinds of pearly tones, then again an autumn landscape, with a foliage from deep wine-red to vivid green, from bright orange to dark havana, with other colours again in the sky, in greys, lilacs, blues, whites, forming a further contrast with the yellow leaves.

Then again a sunset in black, in violet, in fiery red.

Then again, more fantastic, what I once saw, a corner of a garden by him, which I have never forgotten: black in the shadow, white in the sun, vivid green, a fiery red and then again a dark blue, a bituminous greenish brown, and a light brown-yellow. Colours that indeed have something to say for themselves.

I have always been very fond of Jules Dupré, and he will become still more appreciated than he is. For he is a real colourist, always interesting, and so powerful and dramatic.

Yes, he is indeed a brother to Delacroix.

As I told you, I think your letter about black is very good, and what you say about not painting local colour is also quite correct. But it doesn't satisfy me. In my opinion there is much more behind that [sic] not painting local colour.

"Les vrais peintres sont ceux qui ne font pas la couleur locale" ["The true painters are those who do not render local colour"]—that was what Blanc and Delacroix discussed once.

May I not boldly take it to mean that a painter does better to start from the colours on his palette than from the colours in nature? I mean, when one wants to paint, for instance, a head, and sharply observes the reality one has before one, then one may think: that head is a harmony of red-brown, violet, yellow, all of them broken—I will put a violet and a yellow and a red-brown on my palette and these will break each other.

I retain from nature a certain sequence and a certain correctness in placing the tones, I study nature, so as not to do foolish things, to remain reasonable—however, I don't mind so much whether my colour

corresponds exactly, as long as it looks beautiful on my canvas, as beautiful as it looks in nature.

Far more true is a portrait by Courbet, manly, free, painted in all kinds of beautiful deep tones of red-brown, of gold, of colder violet in the shadow with black as repoussoir, with a little bit of tinted white linen as a repose to the eye—finer than a portrait by whomever you like, who has imitated the colour of the face with horribly close precision.

A man's head or a woman's head, well contemplated and at leisure, is divinely beautiful, isn't it? Well, that *general harmony* of tones in nature, one loses it by painfully exact imitation, one keeps it by recreating in an equivalent colour range, that may be not exactly or far from exactly like the model.

Always and intelligently to make use of the beautiful tones which the colours form of their own accord, when one breaks them on the palette, I repeat—to start from one's palette, from one's knowledge of colour-harmony, is quite different from following nature mechanically and obsequiously.

Here is another example: suppose I have to paint an autumn landscape, trees with yellow leaves. All right—when I conceive it as a symphony in yellow, what does it matter whether the fundamental colour of yellow is the same as that of the leaves or not? It matters *very little*.

Much, everything depends on my perception of the infinite variety of tones of one and the *same family.*

Do you call this a dangerous inclination towards romanticism, an infidelity to "realism," a "peindre de chic," ["painting without copying reality"] a caring more for the palette of the colourist than for nature? Well, que soit. Delacroix, Millet, Corot, Dupré, Daubigny, Breton, thirty names more, are they not the heart and soul of the art of painting of this century, and are they not all rooted in romanticism, though they *surpassed* romanticism?

Romance and romanticism are of our time, and painters must have imagination and sentiment. Luckily realism and naturalism are not free from it. Zola creates, but does not hold up a *mirror* to things, he creates *wonderfully*, but *creates, poetises*, that is why it is so beautiful. So much for naturalism and realism, which nonetheless stand in connection to romanticism.

And I repeat that I am touched when I see a picture about the years '30–'48, a Paul Huet, an old Israëls, like the "Fisherman of Zandvoort," a Cabat, an Isabey.

But I find so much truth in that saying: "ne pas peindre le ton local," ["do not paint local tone"] that I far prefer a picture in a lower tonal scale than nature to one which is exactly like nature.

Rather a water-colour that is somewhat vague and unfinished than one which is worked up to simulate reality.

That saying: "ne pas peindre le ton local," has a broad meaning, and it leaves the painter free to seek for colours which form a whole and harmonize, which stand out the more in contrast to another combination.

What do I care whether the portrait of an honourable citizen tells me exactly the milk-and-watery bluish, insipid colour of that pious man's face—which I would never have noticed. But the citizens of the small town, where the above-mentioned individual has rendered himself so meritorious that he thought himself obliged to impress his physiognomy on posterity, are highly edified by the correct exactness.

Colour expresses something by itself, one cannot do without this, one must use it; that which is beautiful, really beautiful—is also correct; when Veronese had painted the portraits of his beau-monde in the "Marriage at Cana," he had spent on it all the richness of his palette in sombre violets, in splendid golden tones. Then—he thought still of a faint azure and a pearly-white—which does not appear in the foreground. He detonated it on in the background—and it was right, spontaneously it changes into the ambience of marble palaces and sky, which characteristically consummates the ordering of the figures.

So beautiful is that background that it arose spontaneously from a calculation of colours.

Am I wrong in this?

Is it not painted *differently* than somebody would do it who had thought at the same time of the palace *and* of the figures as one whole?

All that architecture and sky is conventional and subordinate to the figures, it is calculated to make the figures stand out beautifully.

Surely *that is* real painting, and the result is more beautiful than the exact imitation of the things themselves. To think of one thing and to let the surroundings belong to it and proceed from it.

To study from nature, to wrestle with reality—I don't want to do away with it, for years and years I myself have been so engaged, almost fruitlessly and with all kinds of sad results.

I should not like to have missed that *error.*

I mean that it would be foolish and stupid always to go on in that same way, but *not* that all the pains I took should be absolutely dismissed.

"On commence par tuer, on finit par guérir," ["One begins by killing, one ends by healing"] is a doctor's saying. One starts with a hopeless struggle to follow nature, and everything goes wrong; one ends by calmly creating from one's palette, and nature agrees with it, and follows. But these two contracts are not separable from one another. The

drudging, though it may seem in vain, gives an intimacy with nature, a sounder knowledge of things. And a beautiful saying by Doré (who sometimes is so clever!) is: *je me souviens* ["I remember"]. Though I believe that the best pictures are more or less freely painted by heart, still I *cannot* divorce the principle that one can never study and toil too much from nature. The greatest, most powerful imaginations have at the same time made things directly from nature which strike one dumb.

In answer to your description of the study by Manet, I send you a still-life of an open—so a broken white—Bible bound in leather, against a black background, with a yellow-brown foreground, with a touch of citron yellow.

I painted that in *one rush*, during a single day.

This is to show you that when I say that I have perhaps not plodded completely in vain, I dare say this, because at present it comes quite easily to me to paint a given subject unhesitatingly, whatever its form or colour may be. Recently I painted a few studies out of doors, of the autumn landscape. I shall write again soon, and send this letter in haste to tell you that I was quite pleased with what you say about black.

Goodbye,

Yours,

Vincent (239 – 44).

19 • WILHELM OSTWALD
(1853 – 1932)

Wilhelm Ostwald, a major physical chemist who taught at the University of Leipzig, was also an amateur painter and an influential color theorist. In 1909, he received the Nobel Prize in Chemistry for discovering how to oxidize ammonia to yield oxides of nitrogen.

Retirement to Saxony in 1906 enabled Ostwald to devote his time to the study of color and natural philosophy. *Letters to a Painter* appeared in that year. A series of books expounding his system for cataloguing colors began with *Die Farbenfibel (Color Primer)* in 1916, followed by *Die Harmonie Der Farben (Color Harmony)* in 1918. Among many following publications by Ostwald and his followers, one of the most noteworthy is *The Color Harmony Manual,* a set of standards based on Ostwald's theories and produced by the Container Corporation of America under the supervision of Egbert Jacobson.

Ostwald was influenced by the psychologist Gustav Fechner and the American color theorist Albert H. Munsell, whom he met during a visit to the United States in 1905. The Ostwald system is essentially an adaptation of Munsell's, though based on eight major hues instead of ten and fine-tuned to create what has been called a superior system for its better-adjusted visual balance.

Ostwald's aesthetic ideas are less satisfying, either because he remained rooted in the nineteenth century or because he had not originally been trained in the visual arts. He hoped to "raise" color harmony, aesthetics, and the arts to the level of the sciences by demonstrating that they rested on a mathematical foundation—an effort which implies that the arts are less worthy than the sciences, and based on an inferior set of rules.

From LETTERS TO A PAINTER ON
THE THEORY AND PRACTICE
OF PAINTING

Take a piece of colored glass in your hand, . . . choosing preferably a rather bright color (green or orange, for instance), and look at the image of the window formed when you turn your back to it and hold the glass against a dark background. The image produced at the front side of the glass you already know about; it shows the natural colors of objects, since it is formed by light which is reflected unchanged from this surface. Now look for the other image,—the one formed by reflection from the *back surface* of the plate of glass. It is slightly displaced with respect to the first image and therefore easy to recognize, and it will become still plainer if you turn at a slight angle to the window. This image has the color of the glass, and you will readily see that this must be the case, for when the colorless daylight passes through the glass it becomes colored. This is the most important property of colored glass. In this case the light has not merely passed through a single thickness of glass, as would be the case if you looked at the window through it, but it has been reflected at the back surface and has passed back through the glass again before coming out in front. It is therefore as strongly coloured as would be the case if it had passed through two plates of glass of the same kind. The whole effect of pigments depends on this phenomena, for they are substances similar in their properties to the colored glass. They allow light to pass, but give it color at the same time. While a colorless, transparent substance in a fine state of division reflects light unchanged, that is as white light, a colored pigment reflects colored light, and covers well when it has great refractive power and is in a fine state of division.

Your first question will be, How does the pigment *color* the light? The answer is, By taking away or destroying a part of the white light. We learn in optics that white light can be decomposed into light of a great many different colors by allowing it to pass through a glass prism. If these different colors are all recombined, we get white light again, but if a part of the colored light is removed, the remainder will also be colored after it is collected. Colored bodies have the power of destroying a part of the light that passes through them. They change it into heat, when of course it ceases to exist as light, so the remainder of the light is colored when it emerges.

A pair of colors always belong together under these circumstances,— the one which is absorbed and the one which remains. If red is removed, the remainder will be green after it is collected again, and vice versa. Such pairs of colors are called *complementary* colors. Red and blue green, golden yellow and blue, green yellow and violet, are examples, and there is of course an infinite number of them, since any part can be removed from the total which makes white light with the production of a complementary color. Each pair is reciprocal; that is, if red is removed blue green remains, if blue green is removed red remains, etc.

This will be, for the time being, explanation enough to enable you to understand the simple phenomena in the technique of pastel. Ultramarine has the property of taking away part of the white light so that the remainder consists principally of blue, mixed with some violet and red. The white light passes into the heaped-up particles of pigment and is reflected from their back surfaces, reaching the eye as blue light. Not all the light which reaches the eye is blue, for white surface light from the surface of the outside row of pigment grains is mingled with the body color. This is, however, smaller in proportion as the pigment granules are smaller, its amount being very small indeed in the case of finely ground colors.

You will probably have noticed that the Ultramarine which you mixed with water and gum in making pastel was a very much darker blue than the dry powdered pigment in the finished pastels, and you know that in general dry pigments always look much lighter in hue than wet ones, whether mixed with water, oil, varnish, or any other liquid. . . . If the interstices between the granules are filled with a substance of greater refractive power than air (and all liquids show much greater refraction than air), the reflection from the back surfaces of the pigment granules is weak. The light must therefore pass through many granules one after the other before it is reflected to any extent, becoming much more deeply colored. Under these conditions a larger proportion of the light is absorbed, and the color is therefore purer as well as deeper.

The lightening produced in pastels by the addition of chalk is now a simple enough matter to understand. The white chalk particles in the mixture lie between the blue-producing granules of Ultramarine and they send back white light practically unchanged, so that the reflected light contains blue and white mingled together. The granules are so small that we cannot distinguish between them, and we get the effect of a light blue, that is a blue color containing a good deal of white. Such mixtures also appear deeper in color when wet, for here too the light penetrates deeply into the wet mixture and is affected by more Ultramarine granules than when the mass is dry.

Now remember that the application of a fixative produces the same optical effect as the presence of moisture but in less degree, and you will easily see why a pastel picture remains a little deeper in color after fixation. You now have the most important points in the optics of pastel work, with the exception of the part which applies to *mixtures*. . . .

Suppose that various regions of colored light are removed from average white light . . . the remainder being then emitted to form the complementary color. This will give an infinite series of colors connected in pairs. Now you may vary each color in either of two ways. First, you may suppose the color to change so that it gets brighter and brighter or weaker and weaker, without ceasing to be the same color. A green, a blue green for instance, may be changed from the weakest to the brightest blue green, and the differences we call differences in the *intensity* of the color. We may, on the other hand, without changing the intensity of the color, cause it to become less and less green until it finally becomes merely a gray, and the differences in this case are called differences in the *saturation* of the color. The intensity depends on the total quantity of light which reaches the eye, the saturation on the proportion of colored and colorless light which reaches us. A layer of color is bright when the surface light is acting, but it is at the same time less saturated as more surface light is mixed with the body color.

If we examine any colored light by decomposing it into its constituents, the light from a saturated color would be characterized by the fact that it contains only a comparatively small region of color, all the rest being absent. A saturated blue green would show, when analyzed with a prism, only a blue-green light and nothing else. As a color becomes less and less saturated it contains light of more and more colors, and in a neutral gray all colors are present in the same proportion as in white but in less intensity.

Now what happens when two colors are mixed? To arrive at the right answer to this question it must be kept in mind that there are two fundamentally different ways of mixing two or more colors,—by *addition* and by *subtraction*.

If green light and yellow light are thrown together on a white screen by two projection lanterns, the eye receives the sum of the two lights and addition has been the result. But if the yellow glass is put in the path of the beam from the projector which is already provided with a green glass, it removes from the green light (in which especially the red of the spectrum is lacking) the colors (especially blue violet) which when taken from white light leave yellow, and the resulting beam will be lacking in *both* these regions. Helmholtz showed many striking examples of the very great and fundamental difference in these two ways of mixing colors. Green is formed from blue and yellow by sub-

traction, but when these two colors are added white is the result, and of course additive light is brighter than subtractive, other things being equal.

The phenomena of subtraction are by far the most frequent and important in the ordinary mixing of colors, and we are accustomed to make green by mixing blue and yellow, but it is also possible to produce additive effects in painting. To attain them the colors to be added are laid on side by side in points or spots which are kept as small as possible, instead of laying on the colors over each other. If, then, the eye of the observer is far enough away so that the individual points can no longer be distinguished, the retina receives an impression corresponding to a superposition or addition of the two colors. The Pointillists or Neo-impressionists make use of this method.

It will be evident, from what has been already said, that a color effect of this kind fits into the arrangement of colors according to intensity and saturation just as well as an effect produced by subtraction. But in the two cases different relations of colored pigments and white must be chosen to produce the same effect. It is also evident that no results of a fundamentally different or more far-reaching nature, either as regards intensity, depth, fire, or whatever the color effect may be called, can be produced by the additive method of mixing colors which cannot be produced by the ordinary subtractive method of mixing. In either case one has the same scale, from the whitest white to the blackest black, which pigments are capable of giving, but the method of attaining a given color effect is different in the two cases. A further difference arises from the necessity—a purely technical one, of course—of giving to the individual spots of color a considerable size as they are laid down side by side in the additive process. This makes fine drawing difficult. But when the spots of color are almost indistinguishable there is produced a psychophysical secondary impression, a *flickering*, which is unattainable with a smooth coat of color, and in this there is to be found the technical advantage of this particular method. It is immediately evident that for the production of certain effects such a means may be of great value, while there are numberless other effects which must be produced to which this special optical method is not applicable (52–61).

20 • DENMAN WALDO ROSS
(1853 – 1935)

Music has many mathematical relationships, such as that between the frequency of a vibrating string and the note produced by that string. A hope that similar relationships could be found among colors led to many attempts to correlate hues with musical notes. The roots of the association between musical notes and colors extend back to Plato's belief that a musical note extended in time and a color tone extended in space were both examples of unity, and therefore of ideal beauty.

Ross was an American painter who wrote on color, painting, and drawing for an audience of painters and painting students. Though superficially similar, his ideas differ from Benson's, whose remarks were more immediately directed to artisans and industry workers.

From THE PAINTER'S PALETTE:
A THEORY OF TONE RELATIONS,
AN INSTRUMENT OF EXPRESSION

The Scale of Colors

R RO O OY Y YG G GB BV V VR

The Scale of Colors appears in the Spectrum Band. The colors appear also in pigments of high intensity: in English Vermilion, Orange Vermilion, Cadmium Orange, Cadmium Yellow, Lemon Yellow, Vert Emeraude, Cerulean Blue, Cobalt Blue, and French Ultramarine, in Madder and Alizarin reds. They appear, also, in natural objects of high color-inten-

sity,—in minerals and in precious stones, in leaves and flowers, in the
wings of butterflies, and in the feathers of birds.

Any one of the twelve colors may be more or less neutralized or even
completely neutralized by its complementary. The complete neutralization
of any color gives us what we call Neutrality (N). The complementaries
which neutralize and consequently balance one another are, ap-
proximately, Red and Green, Red-Orange and Green-Blue, Orange and
Blue, Orange-Yellow and Blue-Violet, Yellow and Violet, Yellow-Green and
Violet-Red, Green and Red, Green-Blue and Red-Orange, Blue and
Orange, Blue-Violet and Orange-Yellow, Violet and Yellow, Violet-Red and
Yellow-Green. These are the colors which, being mixed together, give us
neutralizations and Neutrality. Complementary colors occur in the Scale of
Colors at the interval of the seventh, approximately.

Complementary Colors at the Interval of the Seventh

V VR R RO O OY Y YG G GB B BV V

In saying that certain colors, Red and Green for example, are
complementaries we must recognize the fact that these colors are variable
under their terms or names. In pigments and on palettes, for instance, the
complementaries are a particular red and a particular green which, being
mixed, produce a colorless gray. As the Red varies towards Orange, the
Green, to be a true complementary, must vary towards Blue. As the
Green varies towards Yellow the Red must vary towards Violet. It follows
that, having established on the palette a certain Red; the complementary
will be the particular Green which will neutralize it; or having established
on the palette a certain Green, its complementary will be the particular
Red which will neutralize it; whatever that Red may be. The same is true
of all complementaries: they must neutralize and so balance one another
perfectly. We must be careful not to be influenced by the words or names
we use and the effects which may be associated in our minds with those
words or names. If, thinking of Red as the effect of English Vermilion and
of Green as the color of green grass, we produce tones to express these
ideas, we shall produce a Red and a Green which will not be
complementaries. The mixture of a hot Red and a relatively warm

Grass-Green will give us, not a colorless gray, but a red-brown or a green-brown, as we use more of the Red or more of the Green in the mixture. No colors are complementary on the Palette which do not, when mixed together, produce a perfect neutral. When the complementaries are unequally intense, one being stronger in color than the other, the neutral will be obtained by an unequal mixture: more Red than Green, for example, or more Green than Red.

Hot and Cold Colors

Considering the different colors produced by pigments and pigment-mixtures we feel that some of them are relatively Hot (H) and others relatively Cold (C); that between the extremes there are colors which are half-hot and half-cold (H $1/2$ C). The hottest of all colors is a Red-Orange, when it is pure and intense; as intense as possible. The coldest of all colors is a Green-Blue when it is as pure and as intense as possible. Violet is relatively half-hot and half-cold; Yellow is relatively half-hot and half-cold. Violet-Red and Orange-Yellow are, accordingly, in the first degree of heat; Yellow-Green and Blue-Violet in the first degree of cold. Red and Orange are in the second degree of heat; Green and Blue in the second degree of cold. Red-Orange, the hottest of all the colors, is in the third degree of heat and Green-Blue, the coldest of all colors, is in the third degree of cold. Neutrality, the result of mixing complementaries, is half-hot and half-cold, like Violet and like Yellow (3–5).

21 • ALBERT H. MUNSELL
(1858 – 1918)

Munsell and Ostwald were the most influential color theorists of the early twentieth century, though Munsell has not received his due as the more original thinker. He was trained as an art educator and taught at the Normal Art School in Boston until 1915. He encountered Maxwell's ideas through Rood's *Modern Chromatics,* which he read at the age of twenty-one. Twenty-five years later, in *A Color Notation* (1905) Munsell outlined his system for standardizing color names, ensuring good taste in color use, and arranging color swatches in a three-dimensional "tree" that illustrated relationships among the colors.

Newton is said to have made the first color wheel, and many theorists had devised methods for arranging the principal and intermediary colors in triangles, circles, spheres, and other geometric shapes. Munsell's system is the most comprehensive. It is based on five principal colors and five intermediary colors, and identifies the main attributes of color as hue, value, and chroma. The corresponding parameters in the Ostwald system (with eight principal colors and sixteen intermediary colors) are hue content, black content, and white content.

From A COLOR NOTATION . . .

CHAOS—Misnomers for Color
Writing from Samoa on Oct. 8, 1892, to Sidney Colvin in London, [Robert Louis] Stevenson says: "Perhaps in the same way it might amuse you to send us any pattern of wall paper that might strike you as cheap, pretty

and suitable for a room in a hot and extremely bright climate. It should be borne in mind that our climate can be extremely dark, too. Our sitting room is to be in varnished wood. The room I have particularly in mind is a sort of bed and sitting room, pretty large, lit on three sides, and the colour in favor of its proprietor at present is a topazy yellow. But then with what colour to relieve it? For a little work-room of my own at the back, I should rather like to see some patterns of unglossy—well, I'll be hanged if I can describe this red—it's not Turkish and it's not Roman and it's not Indian, but it seems to partake of the two last, and yet it can't be either of them because it ought to be able to go with vermilion. Ah, what a tangled web we weave—anyway, with what brains you have left choose me and send some—many—patterns of this exact shade."

Where could be found a more delightful cry for some rational way to describe color? He wants "A topazy yellow" and a red that is not Turkish nor Roman nor Indian, but that "seems to partake of the two last, and yet it can't be either of them." As a cap to the climax comes his demand for "patterns of this exact shade." Thus one of the clearest and most forceful writers of English finds himself unable to describe the color he wants. And why? Simply because popular color terms convey different ideas to different persons.

When used inappropriately they invite mistakes and disappointments, for they do not clearly state a single one of the three qualities united in every color, which must be known to convey one person's color conceptions to another.

Music is equipped with a system by which it defines each sound in terms of its pitch, intensity, and duration, without allusions to the endless varying sounds of nature. So should color be supplied with an appropriate system.

It would, of course, be a waste of time to attempt the naming of every kind and degree of color, but there is a clue to this labyrinth if one will approach the problem with "a clear mind, a good eye, and a fair supply of patience."

ORDER—Visual qualities of Color
A child gathers flowers, hoards colored beads, chases butterflies and begs for the gaudiest painted toys. At first his strong color sensations are sufficiently described by the simple term of red, yellow, green, blue, and purple. But he soon sees that some are light, while others are dark, and later comes to perceive that each hue has many grayer degrees. Thus he early recognizes three ways in which colors differ.

Consciously or not, all skillful use of color must reckon with these simple but important facts.

Every color sensation unites three distinct qualities, defined as hue,

value and chroma. One quality may be varied without disturbing the other. Thus a color may be weakened or strengthened in Chroma without changing its Value or Hue. Or its Hue may be modified without changing its Value or Chroma. Finally, its Value may be changed without affecting its Hue or Chroma.

A single term or name cannot define changes in this tri-dimensional balance which to the eye is a single color, as for instance, the difference between the two sides of a red cloth, one of which has been faded by exposure to the sun. Let us here define more explicitly the three terms which can describe these changes.

It may sound strange to say that color has three dimensions, but it is easily proved by the fact that each of them can be measured separately. Thus, in the case of the faded cloth; its redness or Hue, the amount of light or its Value, and its departure from gray of the same Value or its Chroma, can each be measured independently.

Hue is the name of a Color
It is that quality by which we distinguish one *color family from another*, as red from yellow, or green from blue or purple. It is specifically and technically that distinctive quality of color in an object or on a surface; the respect in which red, yellow, green, blue, and purple differ from one another; that quality in which colors of equal luminosity and chroma may differ. Science attributes this quality to difference in length of ether waves impinging on the retina, which causes the sensation of color.

Value is the lightness of a Color
It is that quality by which we distinguish a *light color from a dark one*. Color values are loosely called tints and shades, but these terms are frequently misapplied. A tint should be a light Value, and a shade a dark Value, but the word shade has become a general term for any type of color so that a shade of yellow may prove to be lighter than a tint of blue.

Chroma is the strength of a Color
It is that quality of color by which we distinguish a strong color from a weak one; the degree of departure of a color sensation from that of white or gray; the intensity of a distinctive Hue; color intensity.

The omission of one of these attributes leaves us in doubt as to the character of a color, just as surely as the character of a room would remain undefined if the length were omitted and we described it as 22 feet wide by 14 feet high. The imagination would be free to ascribe any

length it chose. This length might be differently conceived by every individual who tried to supply the missing factor.

Much of the popular misunderstanding of color is caused by ignorance of those three dimensions or by an attempt to make two dimensions do the work of three (13–16).

22 • MAX PLANCK
(1858 – 1947)

Planck, professor of physics at the universities of Kiel, Munich, and Berlin, introduced quantum theory, an achievement for which he received the Nobel Prize in Physics in 1918. He frowned on Goethe's rejection of Newton's theories about color, and in support of Newton, Planck argued that knowledge acquired through the reasoning of the physical sciences was pure knowledge and thus superior to, or significantly different from, knowledge acquired by other routes. The implication was that pure knowledge is revealed only to pure scientists and, as Goethe was not a scientist, his importance could be greatly diminished. (Rudolph Carnap was more blunt in his *Philosophical Foundations of Physics*, in which he stated that Goethe's ideas led only "to commonplaces known to interior decorators.")

Planck, of course, is wrong, as is Carnap. The knowledge of the physical sciences—about color and light or anything else—is neither "pure," special, elevated, nor even necessarily objective. The explanation of color in the physical sciences is especially weak, perhaps because, as Russell points out, attempting to develop an "objective" explanation of a subjective phenomenon is inconsistent on logical grounds.

The final word is not in on Goethe and Newton, and labeling one subjective and the other objective is an extremely superficial assessment. For example, we need more insight into how Newton developed his ideas, which may have been outgrowths of his fascination with the mystical and the occult rather than pure or objective in any sense that Planck could have meant. We know only that Newton, who may have suffered a nervous breakdown in middle age, and who was keenly interested in numerology, left unpublished papers hidden from his contemporaries that are still largely unassessed. Some of these papers record secret experiments in alchemy, which may have occupied more of Newton's time than his work in the natural sciences. Others, on religious mysticism and theology, led

John Maynard Keynes to characterize Newton as "a Judaic monotheist of the school of Maimonides," a man who combined his fervent faith with esoteric and highly unorthodox religious views.

From A SURVEY OF PHYSICS

The Nature of Light

The first problem of physical optics, the condition necessary for the possibility of a true physical theory of light, is the analysis of all the complex phenomena connected with light, into objective and subjective parts. The first deals with those phenomena which are outside, and independent of, the organ of sight, the eye. It is the so-called light rays which constitute the domain of physical research. The second part embraces the inner phenomena, from eye to brain, and this leads us into the realms of physiology and psychology. It is not at all self-evident, from first principles, that the objective light rays can be completely separated from the sight sense, and that such a fundamental separation involves very difficult thinking can not better be proved than by the following fact. Johann Wolfgang von Goethe was gifted with a very scientific mind (though little inclined to consider analytical methods), and would never see a detail without considering the whole, yet he definitely refused, a hundred years ago, to recognize this difference. Indeed, what assertion could give a greater impression of certainty to the unprejudiced than to say that light without the perceptive organ is inconceivable? But, the meaning of the word light in this connection, to give it an interpretation that is unassailable, is quite different from the light ray of the physicist. Though the name has been retained for simplicity, the physical theory of light or optics, in its most general sense, has as little to do with the eye and light perceptions as the theory of the pendulum has to do with sound perception. This ignoring of the sense-perceptions, this restricting to objective real phenomena, which doubtless, from the point of view of immediate interest, means a considerable sacrifice made to pure knowledge, has prepared a way for a great extension of the theory. This theory has surpassed all expectations, and yielded important results for the practical needs of mankind (139–41).

23 • GEORGES SEURAT
(1859 – 1891)

Line is not an important element in Impressionist paintings, which generally look soft, blurred, or hazy. The technique of applying paint in small spots of various colors (broken color) made it difficult or impossible to maintain a strong sense of line or clearly defined edges. Also, the spots of color gave an impression of floating on a flat plane—the picture plane. This limited the sense of three-dimensionality that earlier artists had achieved by modeling with light and shadow.

The neo-Impressionists and the post-Impressionists regarded these characteristics as weaknesses in Impressionist painting, to be addressed by fine-tuning theory and technique. The three major post-Impressionist painters tried a variety of methods. Gauguin returned to traditional techniques for modeling in light and shadow and reintroduced the use of black in shadows, a color the Impressionists had banned. Van Gogh and Cézanne experimented with a new way of modeling, by giving a definite direction to the spots of color, and with drawing thick, thin, continuous, or broken outlines around objects, a method for restoring a stronger sense of line.

The neo-Impressionist solution, exemplified by the paintings and theories of Seurat, was different from any of these. Like Cézanne, Seurat sought to impose a higher degree of order on Impressionism. His method for accomplishing this focused on reducing the spots of many colors to tiny points or dots arranged in a methodical manner (Pointillism). The smaller size promoted optical mixture and allowed sharp or definite edges to be created. But the technique was excruciatingly slow. Seurat, by report, often spent an entire day neatly dotting a few square inches of canvas.

Because the Pointillist technique was slow, and did not lend itself to making changes or reworking, Seurat made many preparatory drawings and sketches in oil, planning each detail before the final painting was executed. His return to a method in which paintings were planned in advance,

and were not necessarily executed at the scene, was a return to the methods of the Renaissance and turned Impressionist theory upside down. The Impressionists believed that an artist ought to look at a scene while painting it, in order to be aware of small nuances in illumination that could not be easily remembered.

As with many attempts to order the elements of painting, Seurat's assessment of color begins by pairing opposites (dark and light, warm and cool, and so forth). It moves on to suggest how the opposites can be balanced against one another or reconciled, and how all other categories can be derived from the original set of polarities.

From FROM THE CLASSICISTS TO THE IMPRESSIONISTS

Excerpt of Letter to Maurice Beaubourg

August 28, 1890

ESTHETIC

Art is harmony.

Harmony is the analogy of opposites, the analogy of similar elements, of *value, hue, and line*, considered according to their dominants, and under the influence of lighting, in gay, calm, or sad combinations.

The opposites are:

For value, a more {luminous} for a darker one.
 {light}

For hue, the complementaries, i.e., a certain red opposed to its complementary, etc.

 {red-green}
 {orange-blue}
 {yellow-violet}

For line, those forming a right angle.

Gaiety of value is the light dominant; of *hue,* the warm dominant; of *line,* lines above the horizontal.

Calmness of value is the equality of dark and light; of hue, of warm and cool; and the horizontal for line.

Sadness of value is the dark dominant; of hue, the cool dominant; and of line, downward directions.

TECHNIQUE

Granting the phenomena of the duration of the light-impression on the retina, synthesis necessarily follows as a resultant. The means of expression is the optical mixture of values, of hues (of the local color and the color of the illuminating light: sun, oil, lamp, gas, etc.), that is to say, of the lights and their reactions (shadows), in accordance with the laws of *contrast*, gradation and irradiation.

The frame is in a harmony opposed to that of the values, hues, and lines of the picture (470–71).

24 • ROLAND ROOD
(1863 – 1927)

Roland Rood, the son of Ogden Nicholas Rood, worked as an assistant to his father and after 1887 was active as a landscape and portrait painter. Rood published several articles on photography and at the time of his death had been working for 15 years on a book about color and painting. The book, edited and completed by G. L. Stout, was published posthumously as *Color and Light in Painting*.

From COLOR AND LIGHT IN PAINTING

Whiteness and Neutrality

When we look at nature we find (in physical terminology) that every object is colored, even if only very slightly. All the objects and various parts of the objects send to our eyes different quantities of light. Nature has a color element and a light-dark element, and these two elements are, with astonishing ease, separated in mind, the one from the other. So easily is this separation made that it is consciously, as well as unconsciously, effected by everybody many times a day. To separate the lights from the shadows seems logical because that is differentiating between very apparent quantities, but unconsciously to divorce the light-dark element from the color itself means disentangling a compound sensation without effort of thought. The singularity of our ability to differentiate between the color and the light-dark only becomes evident after reflection, and then leads to the suspicion that somehow consciousness always has two

indubitable. But both Leonardo and Helmholtz state clearly that black is the absence of all light. Both Leonardo and Hering as well as Helmholtz are right. The question simply resolves itself into: how can nothing produce a sensation? Very easily. Nothing produces a sensation more easily than *nothing*.

Black produces a sensation but not the one psychology has been looking for—it produces the sensation of astonishment at the unexpected, at suddenly finding an *area of nothing* in a space that is all filled in with stimuli producing color. This astonishment is only experienced when the black area makes its appearance in a group of illuminated objects which we feel should logically all be illuminated. Nor do we usually experience astonishment when looking at very dark shadows, nor in the night, nor when we close our eyes, for then, expecting blackness, we cannot be astonished. But when I look at black velvet and suddenly see nothing, or when I look around my room and my eye falls on a piece of black lacquer so placed as to reflect no light, I experience a strong sensation. It is the nonfulfillment of confident expectancy that is astonishing. And this nonfulfillment upsets the judgment and there results a commotion in consciousness.

Also, black to produce a sensation must be adulterated with as little white as possible. White takes the edge off the phenomenon with great rapidity. A blue-gray, half color and half white, is still a strong stimulus, but such a mixture of black and white is like well-watered milk. Black diluted with only as much white as is always contained in chrome yellow no longer acts as black. Every painter knows this. And the reason is that nothing ceases very quickly to be nothing if something is added to it. A very small quantity of white in black causes the mixture to be measured by mind as so-and-so much white—the void has lost its spell. This is why grays produce lukewarm sensations, as every tailor knows. There is next door to no potency in dark gray: it does not astonish, nor is the quantity of white in it sufficient to stimulate strongly.

But, it will be asked, is not the sensation of astonishment so different from the sensation of color that we should instantly detect the disparity? In the first place black, as we have seen, only produces its peculiar sensation when pure or almost so, that is, when it is what we call "vivid." We have reason to believe that all vivid colors affect consciousness in such a manner that it acts emotionally—vivid red, vivid green, vivid black, are felt emotionally. And when sensations are felt emotionally they become very difficult to analyze. Secondly, I have often and distinctly felt the shock of astonishment when suddenly coming upon a large area of black, astonishment which I have never felt in the presence of colors. What holds for large areas holds for small, and I believe that if others introspect themselves they will get the same answer.

Hering—I believe it was Hering—in his classification of color elements tabulates them into three sets: the red-green, the blue-yellow, the black-white. This, altogether apart from my argument above, is necessarily fallacious. If we place a piece of black paper in sunlight and close by in the shadow a piece of white, it will be observed that the black scrap becomes whiter than the white one, and it is not difficult to juggle them around in lights and shadows of different strengths so as to get them to appear identical. But no amount of juggling in lights and shadows will ever make blue turn yellow or red turn green. The black-white belongs to a totally different category from the color elements. Leonardo had it right. White is all colors, black none; but having no psychological interest, he carried it no further.

Painters, although they look at black as a color and use large and small areas of it in a nearly pure state to enrich the color scheme of their pictures, soon find something "weird" about it. When a man dressed in a coat of very black quality is placed in a studio side light of medium strength against a not very dark but shadowed background, it can be so arranged that the shaded side of the coat is darker than the background and the illuminated side lighter—which is quite normal and in nowise unpleasant to look at. But when the painter paints what he sees, taking due precautions to retain the true relations of light and dark, the whole thing will usually come out "all wrong"; the very quality the whole thing was done for, the richness, blackness of the coat, will all be gone, and in place there will be a coat with black enough shadows, but with chalky and offensively gray lights. The reason is that the painter's blackest black is the black on his palette, whereas the coat's blackest black is this same black blackened still more by being in shadow, namely many shades darker than the palette can go. But the painter can do no better than use his black pigment to copy the greater black of nature, and perforce must mix a fair amount of white with the black on his palette to obtain the light and half-light. It is this white which kills the sensation of nothingness in the painted coat. But no such thing ever happens when the coat or object is colored, for the simple reason that colors depend upon the color stimuli to produce their sensations and when the color is weakened too much by excessive white it is in large part replaced by the very white which weakens it, whereas the quantity of white sufficient to destroy the nothingness of black is no more than sufficient to produce a very weak, lukewarm sensation. Lukewarmness, although very agreeable in certain places, is exactly the opposite from what we expect of black, and we are disappointed and disgusted.

It appears to have been Hering's fallacy that he mistook the subjective effect of contrast for an objective quality. A few experiments, tried thousands of times by others, may illustrate this. In my room, around the

corner from the window, I hung a piece of black velvet a few feet in front of me so that it received no direct light. Shielding my eyes from the light, I looked at the velvet. It looked impenetrably dark. But as I continued to gaze, it lightened a little and I became aware of a few folds in the cloth and these became evident not because they darkened but because the rest lightened, owing to the expanding and accommodation of the pupils of my eyes to the general darkness. Then, in my direct line of vision over the middle of the velvet, but a foot nearer to myself, I introduced a square of white paper held at such an angle as to let it receive direct light. This was easy to accomplish owing to the positions of the velvet and myself. I stared at the white. Instantly, like a descending wave, the velvet darkened still more, simply because of the accommodation of the pupil to the white. I continued to stare. The white dulled a little and the black lightened a little, unquestionably due to fatigue. Suddenly I removed the white paper, holding my eyes steady, and in a second or two saw an astonishingly black square on the velvet. A few trials however made it evident that the square was not so black in itself, but that the velvet around the square had lightened materially; it even looked gray, and it was this contrast which made the spectral image of the white square look so dark. In fact, the truly astonishing thing in this experiment is not the darkness of the afterimage of the white, but the lightness of the black surrounding the afterimage. Why should this lightness of the black occur? The dilation of the pupil on the removal of the white square would account for it only to a slight extent, but the gray disappears and darkens again when the effect of the afterimage has worn off. So it cannot be due to the dilation of the pupil and it cannot be due to successive contrast, because the same stimulus (or lack of stimulus), the black, is still acting on the same portion of the retina surrounding the spectral image, the conditions of the experiment being, as I have said, that the eyes shall not be moved. It must therefore be simultaneous contrast—that is, inducted contrast—and I believe the whole of this resolves itself into a question of contrast.

As a next experiment, gazing into the dark velvet as before, I drew it to myself. It grew darker and darker, and as it almost touched my eyes I realized that the darkness was greater than any afterimage had been. I threw it over my head, and a greater blackness than all swept over my consciousness. As I sat there with the velvet pressed to my eyes a singular phenomenon took place. Everything remained the same. The blackness neither lightened nor darkened, but my opinion, my judgment regarding its blackness, altered materially, and I decided it was not so very dark after all and wondered why I had thought so. What had happened was this: mind judges the strength of a sensation by its vividness, and vividness is produced by the passing from one sensation to another. The greater the shock of the contrast of the sensations, the greater the vividness. But as in

utter blackness there is no objective contrast, and as the memory image of daylight begins rapidly to fade, thus even eliminating the contrast between an image of mind and an objective fact, then consciousness, finding itself in a state where all possibility of the production of vividness is denied it, judges that the sensation is not so strong after all. It is for this reason that when the absolute blackness of the closed and shielded eyes is presented to vision, we deem it lighter than the gray-black of nature.

But, it may be asked, how do I know that the darkness I experienced when first I threw the velvet over my head did not lighten? Because consciousness feels the weakening and strengthening of a sensation keenly. It is a psychological commonplace that a much smaller difference of sensation registers in consciousness when the sensation itself is changing than when it is successively compared with another sensation.

Therefore black, as Leonardo and Helmholtz claim, is nothing, and white is everything. But from this we must not falsely conclude that black and white are the opposites of each other as is constantly premised. Everything and minus everything are opposites; and plus a billion dollars and minus a billion dollars are opposites; but a billion is not the opposite of nothing, namely zero. Opposites destroy each other and leave nothing, but white added to black only changes the sensation from one category to another, a thing that has no connection with annihilation as implied in opposites.

In case the reason stated above as to why black produces a sensation may be objected to, I am giving the following physiological . . . explanation. When we look at a patch of color, we experience a sensation which, however, continues to weaken as we continue to look. When we suddenly turn from the patch to another of a different color, we experience a sensation which is particularly strong at the instant of making the change. Our attitude, or what psychology calls our attitude of attention, suddenly changes from one state of adjustment to another, and the change requires an effort. This effort is felt in consciousness as a shock, and the greater the contrast between the two patches of color, the greater the necessary change in the attentive attitude, and the greater the shock. The shock when strong produces upon us the sensation of what we call vividness. Vividness is merely the effect produced by the sudden and violent adjustment of the attention to something new and different. Now the greatest possible change in attention that color can produce is caused by looking from bright light into blackness, from white paper onto black paper, and when we do so we feel that the black paper is producing the sensation, whereas in truth the sensation of vividness apparently effected by the black has not really been effected by the black itself but by the shock of changing the attentive attitude. The fallacy in everyday reasoning about sensation is the assumption that sensation can only be effected by

stimulus. Sensation is usually effected by stimulus, but it is often effected by the change of action of the attentive apparatus, independently of stimulus. That black in itself is incapable of producing any sensation is demonstrated by closing the eyes and shielding them under a black cloth. When this is done suddenly a shock is felt for an instant, and then all sensation dies out. And the reason we do not experience any sensation after the first adjustment is that the attention is no longer called into play simply because the blackness under the closed eyelid is *all black* and there is no possibility of a change of attitude.

Therefore I conclude that the shock or sensation produced by black is the effect of the change of attentive adjustment from a stimulus to absence of all stimulus. I place more faith in this explanation than in the astonishment explanation (22–31).

25 • PAUL SIGNAC
(1863 – 1935)

The neo-Impressionist painter Signac, author of *From Eugène Delacroix to Neo-Impressionism* (1899), worked with Seurat on the development and perfection of Pointillism—a further development of the technique the Impressionists used in applying color. Impressionist broken color was applied in small irregular spots of many colors that in theory should have blended in the eye (optical mixture). The neo-Impressionists reduced the color spots to tiny regular dots or points (hence, Pointillism). The tendency of the dots to blend increases as their size is reduced. The following excerpt, taken from Rewald's *Georges Seurat*, contains Signac's comments about Delacroix and his use of color.

From GEORGES SEURAT

Signac on Delacroix

Delacroix has proved the advantages of an informed technique; he has shown that logic and method, far from limiting the passion of the painter, strengthen it.

He revealed the secret laws which govern color: the accord of like colors, the analogies between contrasting colors.

He showed how inferior a dull and uniform coloration is to the shades produced by the vibrations of various elements when they are combined.

He indicated the potentialities of optical mixture which makes possible the creation of new tints.

He advised colorists to use as little as possible colors dark, dim or dirty.

He taught that one can modify and tone down a shade without dirtying it by mixing on the palette.

He pointed out the moral influence which color adds to the effect of the picture: he explained the aesthetic language of tints and tones.

He incited painters to dare everything and not fear that a harmony can be too brightly colored (16).

26 • ROBERT HENRI
(1865 – 1929)

Henri, an influential portrait painter and respected teacher, was a leader of the Ash Can school (an early twentieth-century school of American artists who worked to depict genre scenes of city life realistically) and member of The Eight (a group of American artists formed by Henri for the purpose of independent exhibition after his breach with the National Academy of Design in 1907). Henri studied at the Pennsylvania Academy of the Arts and taught at the Women's School of Design (Philadelphia) and the Art Students' League (New York). Like Matisse, his students collected notes reporting what he said in class.

In use of color, Henri stressed the importance of large masses, and of the general tonality of a painting, which he described as a "super color that envelops all others."

From THE ART SPIRIT

Color

The possibilities of color are wonderful. A study entrancingly interesting and unlimited. It is a wise student who has a perfectly clean, well-kept palette—glass over a warm white paper on a good-sized table, always clean—and uses such a palette to make continual essays with color—thousands of little notes, color combinations, juxtapositions of all the possible intensities of a well-selected spectrum palette. Many artists just paint along, repeat over and over again the same phrases, little knowing

the resources of the materials before them, and in many cases simply deadening their natural sense of color instead of developing it.

The backgrounds that are dark are very difficult to paint. That is, to make them seem like fine, breathable air. Of course it is easy to get away with a dark background, and it by its nature cannot be crude, but it can be heavy, snuffy, black.

The effect of brilliancy is to be obtained principally from the oppositions of cool colors with warm colors, and the oppositions of grave colors with bright colors. If all the colors are bright there is no brightness.

However much you may use "broken color," hold on to the few simple larger masses of your composition, and value as most important the beauty and design of these larger masses, or forms, or movements. Do not let beauty in the subdivisions destroy the beauty or the power of the major divisions.

Whatever you feel or think, your exact state at the exact moment of your brush touching the canvas is in some way registered in that stroke. If there is interesting or reasonable sequence in your thoughts and feelings, if there is order in your progressive states of being as the paint is applied, this will show, and nothing in the world can help it from showing.

There is a super color which envelops all the colors. It is this super color—this color of the whole, which is most important.

Dirty brushes and a sloppy palette have dictated the color-tone and key of many a painting. The painter abdicates and the palette becomes master.

Employ such colors as produce immensity in a small space. Do not be interested in light for light's sake or in color for color's sake, but in each as a medium of expression.

There is a color over all colors which unites them and which is more important than the individual colors. At sunset the sun glows. The color of the grasses, figures and houses may be lighter or darker or different, but over each there is the sunset glow.

A human body bathed in the color of the atmosphere surrounding it, luminous and warm in its own color.

The color of a background is not as it is, but as it appears when the artist is most deeply engaged with the figure in front of it. It is not seen with a direct eye.

If you look past the model at the background it responds to your appeal and comes forward. It is no longer a background.

Get a right height of chair and sit at your painting table. Take as true a Red, Yellow and Blue as you can choose. Mix neighbor with neighbor until you have three new notes, Orange, Green, Purple. Set all six in a line and mix neighbor with neighbor until you have six more—RO. OY. YG. GB. BP. PR. You have now before you a homogeneous palette, analogous to the spectrum band. They are PR. R. RO. O. OY. Y. YG. G. GB. B. BP. P.

This is a first step taken in the direction of an acquaintance with the possibilities of pigment colors.

You can make hundreds of experiments on the glass of your palette the memories of which will sink into you to come into service in cases of actual need when at the work of painting.

The studies H. G. Maratta has made in the formation of palettes and generally in the science of color are of a decided educational value. Many of us have benefited greatly through his work. He told me many years ago that his first intention was to write a book, but decided, upon consideration, that a practical demonstration with colors instead of the names of the colors would be better. So he made the colors and they were his book. Many artists bought his colors and opened the box thinking the magic of picture-painting would jump out. Others bought them knowing that they would have to dig, and they dug. It was mighty well worth while.

The works of such men are available to the student and the wise student will be keen to know what is going on in the world.

Such works are really gifts, for the making of them represents much study and is certainly not a commercial proceeding.

If you have not read, and studied, for here again you must dig, the works of Denman Ross, get them by all means, for you must want to get the wisdom and the practical advice they contain, and what they suggest.

Understand that in no work will you find the final word, nor will you find a receipt that will just fit you. The fun of living is that we have to make ourselves, after all.

It is a splendid thing to live in the environment of great students. To have them about you in person if you can. If not in person, in their works. To live with them. Great students agree and disagree. They stir the waters.

Many things that come into the world are not looked into. The individual says "My crowd doesn't run that way." I say, don't run with crowds.

I suggest many other books. There are many theories on color. Look them up. Get acquainted. There may be something you want to know.

Personal experimentation is revealing, and, once you get into it, immensely engaging.

Remember that pigment is one thing and light is another. A palette is set in accord with the spectrum band. But combinations of light and combinations of pigments produce differing results.

Signac's book "Néo-Impressionnisme" is a book that should interest any student. It is a pity it has not been translated into English. But if you know French it will be good to read. It is an argument in favor of the total division of color in painting, but that does not matter. In making his argument he tells in a simple way many valuable things.

I think the true Yellow is rather more green than the yellow generally accepted as "true." I am speaking of paint and I am thinking of the functioning power of the pigment.

Black is always thought of as a neutralizer of color. It should be better remembered that white is also a neutralizer of color, except perhaps in its effect on a very deep blue, blue purple, purple or purple red, so deep that their color cannot be appreciated. In such cases the neutralizing white has a reverse effect when only a slight quantity is added. It serves to bring the color up out of the depths. Except for this service white is a neutralizer.

In the painting of light, in modeling form, keep as deep down in color as you can. It is color that makes the sensation of light. Play from warm to cold, not from white to black.

The tendency to put in more and more white is so usual that it would be well to restrict the white. Keep it off the palette. Allow only so much of it in the pigments which must have it, and allow them much less than you think they should have.

A set palette may look quite impossible for its want of white in comparison with the subject before you. It certainly is, any paint is, if you expect to *reproduce* the thing in nature. But your work is not, and cannot be, a reproduction. Nature has its laws. Your pigments and your flat canvas have other laws. You must work within the laws of your material.

Your palette may look impossible but it may be that by adding more white you will make it more impossible. The pictures that produce the sensation of light and form are really deep in color. Try something white against them. The pictures which are overcharged with white paint look whiter but they do not have the look of light.

Form can be modeled in black and white, but there are infinitely greater possibilities in modeling through the warmth and coolness of color.

There are three methods. The first is black and white modeling. This was largely practiced by the old masters who relieved themselves of a double difficulty by building their pictures up in monochrome and later applying glazes of transparent color. Form was almost wholly dependent on the monochrome substructure.

The second method is color modeling to the exclusion of black and white monochrome. Many have professed this method, but few have practiced it.

The third method is the union of the first and the second. In this method there is a recognition of advantages to be derived from both, requiring a wise proportioning and selection in order that the two methods may amalgamate in such a way as to strengthen each.

For the motives of the old masters their choice of technique was undoubtedly well made. Their works evidence it.

For our time other choices may be necessary, for we are different. We

may be better or worse in being different, but so we are, and our methods must be suited to our needs.

As an example let us take a hand. With a great old master the hand becomes a symbol. He made the symbol by making a hand magnificent, monumental, but of such a material definiteness that it is photographically perfect.

The hand made by a true modern will not lend itself so readily to the black and white reproduction. It is made with different agents because it is conceived in a new way.

What the modern man finds of interest in life is not precisely the same as of old, and he makes a new approach, deals in another way because the symbol to be made is not the same.

The old method, great as it was, required a mode of procedure which I believe is rarely practical in these days. It meant a building up in black and white, the design finished in this medium. Then weeks of drying. Then a return to the subject and the color applied. It was a cool and calmly calculated procedure.

It seems to me that the present day man, with all his reverence for the old master, is interested in seizing other qualities, far more fleeting. He must be cool and he must calculate, but his work must be quick.

All his science and all his powers of invention must be brought into practice to capture the vision of an illusive moment. It is as though he were in pursuit of something more real which he knows but has not as yet fully realized, which appears, permits a thrilling appreciation, and is gone in the instant. . . .

For the same reason that I have indicated my preference for the employment of both methods in the matter of color values and black and white values, I prefer the use of pure colors together with grave colors.

There are artists who declare with almost a religious fervor that they only use "pure colors." But generally in seeing their pictures I find that they have more or less degraded these colors in practice.

I believe that great pictures can be painted with the use of the most pure colors, and that these colors can be so transformed to our vision that they will seem to have gradations which do not actually exist in them. This will be brought about by a science of juxtaposition and an employment of areas that will be extraordinary.

But even so, there is a power in the palette which is composed of both pure and grave colors that makes it wonderfully practical and which presents possibilities unique to itself.

In paintings made with such a palette, if used with great success, we find an astounding result. It is the grave colors, which were so dull on the palette that become the living colors in the picture. The brilliant colors are their foil. The brilliant colors remain more in their actual character of bright

paint, are rather static, and it is the grave colours, affected by juxtaposition, which undergo the transformation that warrant my use of the word "living." They seem to move—rise and fall in their intensity, are in perpetual motion—at least, so affect the eye. They are not fixed. They are indefinable and mysterious.

In experimentation I have seen an arrangement of a bright color and a very mud-like neutral pigment present the phenomena of a transference of brilliancy—the neutral presenting for a moment a sizzling complementary brilliance far overpowering the "pure color" with which it was associated.

On a picture, because there are many conflicting associations, such an extreme occurrence could not be possible, but the fact exists and the impression is made on our keener consciousness.

If new colors were made far more brilliant than the present "pure" colors; then the present colors would fall into the rank of neutrals, and when juxtaposed with their superiors, which would be more or less static, the same change might be effected in them.

It would be their turn to make this thing happen in the eye of the observer. For it is an effect on the sensitive eye and a consequent stirring of the imagination which produces the illusion.

The fact is that a picture in any way, in color, form, or in its whole ensemble . . . sends out agents that stimulate a creation which takes place in the consciousness of the observer.

That is the reason association with works of art is enjoyable.

It is also the reason they tire some and irritate others.

Generally in pictures which give the illusion of fine color and form we find one, less often two, areas made up of pure color. This, or these notes are possibly the most obvious and striking notes, but it may be found that however beautiful they are in themselves they are only foils to the mysterious tones they serve to complement. It is these ever-changing mysterious tones which keep up the interest in the picture (49–59).

27 • WASSILY KANDINSKY
(1866 – 1944)

Kandinsky was born in Moscow. In his autobiographical *Backward Glances* (1913), he describes his earliest color memories, going back to the age of two. He recalled sap green, carmine red, ocher yellow, black, and white, but not the objects on which he had seen these colors. Can the origin of non-objective painting be traced to this predilection or quirk of memory? We know only that the paintings from Kandinsky's mature period show a similar ordering of priorities. The objects of the natural world are less important than their colors, which assume a new order of their own.

Before pursuing a career as a painter, Kandinsky studied law, a discipline reflected in his methodical arguing of ideas. But the ambitious scope of his theorizing, and its somewhat mystical nature, also suggest the writings of Gurdjieff, Ouspensky, and others heralded today as the precursors of a new age. They were searching for a different metaphor to simplify a complex world that sometimes seemed incomprehensible.

As a foundation for his theories about color, Kandinsky expanded the set of simple or elemental colors of the ancient Greeks to a set of simple (elementary) phenomena, drawing parallels between basic colors and basic lines, basic sounds, and basic psychological states. Laws of nature or of human psychology followed from these associations.

From POINT AND LINE TO PLANE

Colour: Yellow and Blue

The acentric [sic] free straight lines are the first straight lines to possess a special capacity—a capacity which they share to a degree with the

"colourful" colours, and which distinguishes the latter from black and white. *Yellow* and *blue*, especially, carry within them different tensions—tensions of advancing and retreating. The purely schematic straight lines (horizontals, verticals and diagonals—but especially the first two), develop their tensions *on* the plane and exhibit no inclination to leave it. In the case of free straight lines and, above all, the acentric ones, we observe a loose relationship to the plane: they are less completely fused with the plane and seem to pierce it occasionally. These lines are farthest removed from the point, which claws itself into the plane, since they especially have abandoned the element of rest.

In the case of the *bounded plane,* this loose relationship is possible only when the line lies freely on it; that is, when it does not touch its outside boundaries. . . .

. . . [T]here is a certain relationship in the tensions of the acentric free straight lines and those of the "colourful" colours. The natural connections between the "graphic" and the "pictorial" elements, which we can to some extent recognize today, are of immeasurable importance to the future theory of composition. Only in this direction, can planned exact experiments in construction be made in our laboratory work, and the mischievous fog in which we are today condemned to wander, will certainly become more transparent and less suffocating.

Black and White

When the typical straight lines, principally the horizontals and verticals, are tested for their colour characteristics, a comparison with *black* and *white* forces itself, logically enough, upon our attention. Just as both of these colours (which until recently were called "non-colours" and which today are somewhat ineptly termed "colourless" colours) are silent colours, both of the above mentioned straight lines are, in the same manner, silent lines. Here and there, the sound is reduced to a minimum: silence or, rather, scarcely audible whispering and stillness. Black and white lie outside of the colour wheel. . . . Horizontals and verticals occupy a special place among lines because, when in a central position, they cannot be repeated and are, therefore, solitary. If we examine black and white from the standpoint of temperature, we find white more apt to be warm than black and that absolute black is inwardly unquestionably cold. It is not without reason that the horizontal scale of colours runs from white to black. . . .

"Today" human beings are completely absorbed with the external; the inner is dead for them. This is the last step of the descent, the end of the blind alley. In former times, such places were called "abysses;" today the modest expression "blind alley" suffices. The "modern" individual seeks inner tranquility because he is deafened from outside, and believes this

quiet to be found in inner silence. Out of this, in our case, has come the exclusive preference for the horizontal-vertical. The further logical consequence would be the exclusive preference for black and white, indications of which have already appeared several times in painting. But the exclusive association of the horizontal-vertical with black and white has still to take place; then everything will be immersed in inner silence, and only external noises will shake the world. . . .

These relationships [between black and white], which are not to be understood as wholly equivalent values but, rather, as inner parallels, may be arranged in the form of a table such as [in Fig. 1].

Fig. 1

Graphic Form	Pictorial Form
Straight Line:	Primary Colours:
1. horizontal,	black,
2. vertical,	white,
3. diagonal,	red (or grey, or green),
4. free straight line.	yellow and blue.

Red

. . . [R]ed . . . is distinguished from yellow and blue by its characteristic of lying firmly on the plane, and from black and white by an intensive inner seething—a tension within it. The diagonal reveals this difference from free straight lines: that it lies firmly on the plane; and this difference from horizontals and verticals: that it has a greater inner tension. . . (62–65).

Angular Lines and Colour

. . . The cold-warm of the square and its definite plane-like nature, immediately become signposts pointing to *red,* which represents a midway point between yellow and blue and carries within it cold-warm characteristics. . . . Not without reason has the red square appeared so often of late. It is not, therefore, completely without justification that the *right angle* is placed on a parallel with *red.* . . .

[I]t is necessary to emphasize a special angle which lies between the right and acute angles—an angle of 60 degrees (right angle minus 30 degrees and acute plus 15 degrees). When the openings of two such angles are brought together, they produce an equilateral triangle—three sharp, active angles—and become the sign-post to yellow. . . . Thus, the *acute angle* has a yellow colour within.

The obtuse angle increasingly loses its aggression, its piercing quality, its warmth, and is, thereby, distantly related to a line without angles which . . . constitutes the third primary, typical form of the plane—the circle. The passiveness in the *obtuse angle*, the almost missing forward tension, gives this angle a light *blue* tone.

In addition, further relationships can be indicated: the acuter the angle, the closer it approaches sharp warmth and vice versa, the warmth decreases toward the red right angle and inclines more and more to coldness, until the obtuse (150 degree) angle develops; this is a typical blue angle and is a presentiment of the curved line which, in its further course, has the circle as its final goal. . . (72–73).

Method

. . . The methods of art analysis have been, until now, far too haphazard and, frequently, too personal in nature. The coming period demands a more exact and objective way to make collective work in the science of art possible. Preferences and talents remain different here as well as elsewhere, and the work accomplished by each person can be only in accordance with his powers. For this very reason, a work program accepted by many is of especial importance. Here and there arises the idea of art institutes working in a systematic way—an idea which will surely soon be realized in various countries. It can be maintained altogether without exaggeration, that a science of art erected on a broad foundation must be international in character: It is interesting, but certainly not sufficient, to create an exclusively European art theory. Geographic and other external conditions are not the important ones in this connection (at least not the only ones) but, rather, it is the differences in inner content of the "nations"—particularly in the field of art—which are, in the first instance, the deciding factor. A sufficient example of this is our black mourning and the white mourning of the Chinese. . . . There can be no greater contrast in feeling for colour—"black and white" is quite as customary with us as "heaven and earth." Yet out of this, a deep-lying, and consequently not immediately recognizable, relationship of the two colours can be discovered: both are silence. This example, therefore, perhaps sheds an especially strong light upon the difference between the inner nature of Chinese and Europeans. After thousands of years of Christianity, we Christians experience death as a final silence, or, according to my characterization, as a "bottomless pit," whereas the . . . Chinese look upon silence as a first step to the new language, or, in my way of putting it, as "birth" (76–77).

28 • CLAUDE BRAGDON
(1866 – 1946)

Bragdon, a respected and articulate theorist, argued that although principles of color theory could be taught, great colorists were born and not made. The idea, though it may seem self-contradictory, is simple and applicable to all areas of endeavor. Most good painters are reasonably good colorists, but few rise to the level of a Matisse or a Rembrandt. Similarly, every physicist is not an Einstein, every singer is not a Caruso, and every writer is not a Shakespeare, Dante, or Milton. Humans can be taught a skill only to a certain point, after which their talent must carry them.

Bragdon felt that musical analogies were of limited use in understanding color, because adjusting color combinations requires attention to value and area, qualities that have no correspondence in music. Beginners, he concluded, are best advised to study the complementary (or "opposite") colors, as Pissarro had urged. The relationship between any color and its complementary could be compared to that between a number and its reciprocal, the reciprocal being the inversion of that particular number. For example, the reciprocal of 2—or 2/1—is 1/2. Bragdon, like others, pointed to this relationship because the product of any number and its reciprocal is 1 or unity, which Plato identified as inherently beautiful.

Though we might reasonably ask how one number can be more beautiful than another, Bragdon, Ostwald, and other theorists relied on the connection as a foundation for often-complicated arithmetical arguments. If a combination of colors (or the method by which that combination was chosen) could be shown to be associated with 1 or unity, this would suffice to show that the combination was harmonious or beautiful.

Bragdon's argument about reciprocals implies that any color (as other theorists had also said) is beautiful when combined with its complementary color, and, therefore, anyone can select beautiful combinations. An academic truism, however, explains why anyone cannot, and sustains the

argument that great colorists are born and not made. Anyone, 'tis said, can choose two colors that look well together, but only the innately gifted colorist can choose three.

From THE FROZEN FOUNTAIN

Color

Ruskin was right when he said that anyone could learn to draw—he was himself an admirable draughtsman—but only those who were to the manner born could become colorists. For the color sense, like the musical sense, appears to be a *gift*, and though amenable to training and development in everyone, it is so only within limits which the born colorist—like the born composer in the field of music—will easily overpass.

No book purporting to deal, . . . with the elements of decorative design as applied particularly to architecture, can omit some discussion of color, for polychromy is entering into architecture more and more, but color cannot be *taught*, effectively—least of all from books. That is to say, no amount of instruction will make a person a *good* colorist; the most that it can do is to prevent him from being a bad one. All that I shall attempt to do, therefore, is to present a few fundamental facts and ideas which, like a knowledge of dynamic symmetry, should be part of the equipment of every designer. Everything beyond this one must learn by actual experimentation—if one can and as one can.

The first thing is to become aware of the inevitable bisection of the color spectrum into cold colors and warm—electric and thermal. Roughly, the colors of higher vibration—from green to violet—belong to the first category, and those of the lower vibration—from red to green—to the second. But any color, from either segment, may itself be warm or cold to the contrasted aspect of itself. That is to say, there can be a cold violet and a warm violet; a cold (greenish) yellow and a warm—there can even be a cold red relatively to another red. Some of the most satisfactory color combinations consist of the cold and warm of a single color, with just enough of the complementary to make them "live more abundantly."

The next thing is to become aware of complementaries. The complementary of a color may be compared to the reciprocal of a number; for just as in mathematics a reciprocal is a function or expression so related to another that their product is unity, the complementary of any given color is such another color from the opposite part of the spectrum that, when combined with it, cancels it, so to speak; yielding, in pigment, neutral grey; in light, white.

Because the secret of color harmony and color brilliance dwells in nothing so much as in the right application of the law of complementaries, the student should make it his first business to know what colors are complementary to each other. He finds this out most amusingly—as one finds out lovers—by bringing them together and observing how they act and react. For complementaries *are* lovers, longing for union, shining brightest when in juxtaposition, supplementing and completing each other. Complementary colors should be learned and committed to memory, just as a musician recognizes and remembers consonant musical tones. This can be done in several different ways; one is by the manipulation of pigments; another and a better, by experimenting with colored light. One learns by these means, for example, that the color of the shadow of an object—on white—will always be the complementary of the color of the light which casts the shadow. But lacking the necessary paraphernalia for this order of experimentation, there is another which is simplicity itself . . . :

Assemble a number of brightly tinted squares of paper or silk of different colors—including the primaries—and in a strong natural light lay them, one after another, in the middle of a sheet of white paper, gazing at each one fixedly until the eye experiences retinal fatigue. After a time a fringe or nimbus of the complementary color will begin to appear around the edge of the colored bit, and if this then be removed quickly, the place it occupied will seem to be suffused by the complementary, which will slowly grow paler and finally disappear. The combinations discovered in this way should be noted and memorized and the experiments repeated until one can tell beforehand, in any given case, what color will appear. The preconceived mental image and the perceived optical image should then be compared and the former corrected by the latter.

Another exercise to the same end is the manipulation of colored gelatines or bits of stained glass against the light, superimposing one over another and noting the colors which result from these combinations. When that result is a perfectly neutral grey, the two colors which produced it are complementaries. Van Deering Perrine, the landscape-painter—a great colorist—used to amuse himself after this fashion with a toy of his own devising. It consisted of two cylindrical pasteboard containers, one within the other, in the sides of which he had cut round holes, similarly located and spaced. These holes, four in each cylinder, he had then covered with a silk dyed red, blue, green, and yellow. Into the center of this contraption he dropped a small electric light, and by turning the outer container about he brought the different colors opposite one another, thus forming others. He used to sit for hours in the dark with this instrument in his hands, as charmed by the beauty of his color-music as a musician at the keyboard of an organ.

Having used the word "color-music," this is perhaps the place to say a little something on the much-discussed analogy between color and sound—the rainbow hues and the musical scale. Within limits clear and inescapable, this analogy is true only in a limited way and up to a certain point; if pressed too far it is full of pitfalls for the artist. It provides an excellent approach however, to the study of color: of little use to the master, it is of service to the neophyte because by means of it he may learn about color in an orderly way.

The solar spectrum, proceeding by an infinite number of gradations from red at one end and violet at the other, may be compared to the sound of a siren which begins on one note and ascends to its octave. The color-band and this sound are equally capable of being artificially subdivided. The so-called chromatic scale in music represents a twelvefold subdivision of the sound-octave, and if the color-octave be similarly dealt with, it is clear that there would be a color to correspond with every note of the chromatic scale. In this splitting-up of the spectrum, however an *equal* subdivision cannot be adhered to—the color-band must be more or less arbitrarily dealt with. By reason of this fact (among other) the various color-scales which have been suggested differ in detail from one another, though most of them make red correspond to the tonic, or middle C, and the deviations from one another of the other color "notes" do not as a rule amount to more than what in music would be a semitone.

Of these color scales—Rimington's, Taylor's, and others—the so-called "ophthalmic color scale" developed by Mr. Louis Wilson, is the most useful, since it embraces a greater range of purples, a color indispensable to the artist. Mr. Wilson makes "royal purple"—which is a deep sanguine, or blood-color, not a violet—the tonic of his scale (although of course, as in music, every color is the tonic of a scale of its own). He omits orange-yellow and violet-purple from his twelvefold subdivision, which makes his scale correspond more exactly with the major diatonic scale of two tetrachords, in which there is a difference of only a semitone between the next to the last note (E and F, and B and C, in the scale of C major). The scale has also the great merit that when its twelve colors are arranged in the form of a circle, the complementaries occupy positions exactly or very nearly opposite to each other. . . . [See] Wilson's scale with its musical correlatives [Fig. 1].

It is evident that by the use of this scale some sort of translation of musical chords—and indeed of entire compositions—into their color correlatives is rendered possible. The thing has been done—I have done it myself—and the results are interesting and instructive; they are also beautiful, for colored light is seldom unbeautiful, but not more so than could be arrived at by means more direct. For the beauty of any given color combination depends almost entirely upon the right adjustment of relative

Fig. 1

Purple	C, B sharp
Purple-red	C sharp, D flat
Red	D
Red-orange	D sharp, E flat
Orange	E, F flat
Yellow	F, E sharp
Yellow-Green	F sharp, G flat
Green	G
Green-blue	G sharp, A flat
Blue	A
Blue-violet	A sharp, B flat
Violet	B, C flat

areas and relative *values*, things unrelated to music, to the determination of which therefore the musical parallel can give no help. In color-translation musical consonances are often found to be less satisfactory than dissonances, and there are color combinations of extraordinary beauty of which a correlative musical expression gives no hint—like a passage from warm to cold of a given color together with its complementary (purple, purple-red, red, red-orange, orange, and green-blue, for example): in music all this would amount to would be a chromatic run of five notes and the fourth of the middle one of them.

As a matter of fact there are *no* ugly color combinations if they are dealt with in a manner which gives due regard to areas and values. Modern music appears to be built on the same assumption with regard to sound—that all is relative. Be that as it may, the law of complementaries is a better guide and safeguard (in so far as there *is* any guide and safeguard other than an intuitive color sense) than any labored translation of musical chords into color chords. Moreover, an intelligent application of the law of complementaries leads to much the same results but in a more direct way. For example, a color triad based on the law of complementaries would consist in "splitting" a given color and combining these two halves with its complementary (purple, orange, and green-blue, or yellow-green, blue-violet, and red). In our color-wheel these would define an equilateral triangle, and would correspond in music to an augmented triad. Major, minor, and diminished triads, picked out on the color-wheel in this way, also define triangles the vertices of which meet the "rim" never less than three "spokes" apart. Knowing this fact, should one choose to depend upon a mechanical method for obtaining harmonious color combinations, this system of triangulation is easier and more direct than the translation of musical chords into color chords by means of the musical analogy.

Experimentation along these lines is helpful and educative, but it should always be remembered that the law of complementaries is the master-key to the color mystery in so far as there is any key at all. It is one, however, which gives access only to the ante-room of that enchanted castle, for with the three variables of hue, area, and intensity only the born colorist can successfully deal.

Mr. Fritz Trautmann, who starts from the vantage ground of being a born colorist, has for a number of years been studying and experimenting along original lines. The results of his researches he has not formulated as yet, but he has been gracious enough to permit me to transcribe part of a letter containing the core of his theory, from the application of which, in both painting and teaching, he has achieved remarkable results:

The most subtle and penetrating vibrations coming to us from the sun—the so-called ultra-violet ray—is the one that most definitely affects the skin, as is evidenced by sun-tan; and as the eye is the part of the skin most sensitively adapted or tuned to the sun's rays, it would seem that this most sensitive spot should make a natural—or normal—response to violet. We know that when any material is so constituted in its crystalline structure that it absorbs light of a given color, that material takes on an external aspect of all the rest of the light that is turned back—in other words, the complement. Now it is an interesting fact, and I think a significant one, that the physiologists have discovered that the pigmentation of that most sensitive spot on the retina is yellow, and they call it the yellow spot.

This is the underlying basis of my theory: The sun is the affector, the eye is the receptor. All phenomenal aspects occur between the two. It requires both affector and receptor for the conception of white light. So for us who live under the sun, the violet-yellow axis becomes the personal axis or beginning place for all color sensation. I have never had a group of students disagree about the location of these poles on the color-wheel or fail to isolate them from the other hues. Once they have made that judgment, the explanation of color action becomes simple: All the rest of it is a sort of emotional tremor imparted to the personal axis. I drive two tacks in a screen, one some distance above the other, and over these I stretch a rubber band. The top tack is yellow—the light of the eye: bright, luminous, revealing. The bottom tack is violet—helios, the sun—profound, deep, penetrating. If I grasp one half of the band—midway between the tacks or not—and stretch it out to the right, the personal axis is distorted or deflected, with the maximum of deflection occurring at the point where my finger happens to be. If I pull the band out to the left, the axis is again disturbed, but the extreme point of the

disturbance is exactly opposite in nature and complementary to the one on the right. I ask the class to identify these extremes on the color wheel, and I give appropriate names to designate their emotional appeal. Here, again, I have never had a group fail to agree on their location, even to a surprising degree of precision, and there is never any doubt about their feeling that one side is hot and the other cold. When it comes to color notation I find that there is usually some difference of opinion as to what these extreme places should be called. Almost everyone will agree on *red* as the name of the hot extreme, but *blue* is a name so long associated with a color containing a large dose of violet that many object to it as applied to the cold extreme. On the other hand, they also reject the term *blue-green* because the green part of the term implies a content of yellow, and they are quick to discern that the disturbance of the personal axis equally affects both poles and that no point can be considered extreme so long as it contains an element of either yellow or violet. Strange to say, however, the terms *redness* and *blueness* seem to satisfy the majority of any group, so I let it go at that and impress upon them that the name is really of little importance so long as they are sure of the quality.

This should be enough to give you the kernel of my whole idea. All of the intervening colors between these four critical points are considered as the two primary personal poles (yellow and violet), merely being cooled or warmed to succeeding degrees. White and black to me are neutrals, always secondary effects, the result of complementaries acting together—interacting. Dodge McKnight paints the whitest of snow with red and blue pigment. He could as well do it with yellow and violet or any other pair, depending on the time of day—the mood.

This seems to me a better approach to the subject of color than by way of the musical parallel, although the conclusions and results may prove to be identical. A graphic expression of Mr. Trautmann's idea would consist of a cross of which the vertical axis would have yellow at the top and violet at the bottom, and the horizontal axis "redness" at the left and "blueness" at the right. . . . Comparing this with the Wilson color-wheel, it will be seen that these colors occupy the same relative position and that there is no essential contradiction between them. In Trautmann's cross the intermediate spaces between his four "primaries" may be bisected, yielding the "secondaries" . . . orange, green, indigo, and purple, a color scale of eight notes: or trisected, yielding a scale of twelve, in all essentials like the Wilson scale. If a more minute subdivision be required, the total may be increased to sixteen, in which case it would read as [in Fig. 2].

Fig. 2

Violet	Yellow
Violet-purple	Yellow-green
Purple	Green
Purple-red	Green-blue
Red	Blue
Red-orange	Blue-indigo
Orange	Indigo
Orange-Yellow	Indigo-violet

It would be well for the student of color to use this scale, which is both adequate and orderly; and to adopt also this terminology, abandoning the ridiculous practice of referring to colors by those arbitrary and meaningless names by which they are currently known. But in so doing one should keep clearly and constantly in mind what I have said about it, and particularly the "color-cross"—as a mariner keeps in mind the cardinal points of the compass.

The color-world is *par excellence* a world of relativity: colors alter their appearance in changed relations and proportions and under different conditions of atmosphere and illumination. A color may be made to appear warm or cold, to advance or to retreat, by an alteration of adjacent colors, and it in turn affects them. In this, more than in any other department of the fine arts, each must work out his own salvation with relatively little outside aid. Belonging as it does to the domain of feeling rather than of thinking, the intuition rather than the reason should be one's guide. Over and above what I have already said, perhaps the only further instruction which can be given is summarized in the words: *observe, reflect, feel, and experiment* (116–25).

29 • WILLIAM BENSON
(19th Century?)

Benson was an insufficiently appreciated nineteenth-century color theorist, far in advance of his day. He believed that red, yellow, and blue (the simple or primary colors) were beautiful in any instance: by themselves, in combination with one another, or when muted. He felt that "there can be no discord in colours," in short, that anything worked or could work in the appropriate circumstances.

The more radical implications of Benson's conclusions were not explored until the twentieth century, when artists began to experiment with more unusual color combinations. The most interesting combinations of colors are those that surprise us and cure us of irrational prejudices about which colors ought to be combined with which. We rarely expect dark green to look interesting next to dark gray. A peach color that suggests Grandmother's nightgown is not expected to be interesting alongside a yellow-green suggesting pea soup. Yet the Abstract-Expressionist painter Willem de Kooning has been praised for exactly these combinations—because we did not expect these colors to look interesting, but somehow they did. Although yet another comparison between color and music is frustrating, we need to look past this with Benson.

From PRINCIPLES OF THE SCIENCE OF COLOUR CONCISELY STATED . . .

The Harmony of Colours

If the harmony of colours is proved by the pleasure which they give when viewed in succession, or side by side, and when viewed in combination,

then the three simple colours must be considered as eminently harmonious. Each of them separately is beautiful, pleasing the eye especially on its first appearance after darkness, but their beauty is increased and lasts longer when they are presented in couples one after another, as when the Red and the Green, the Green and the Blue, or the Blue and the Red prismatic rays are caused to enter the eye side by side without the rest, and the eye is rapidly directed from one to the other; and they give still greater and more lasting pleasure when all three in like manner are presented side by side or in succession to the eye. When seen in conjunction, again, they are equally beautiful, whether presented in pairs, as in Yellow, Seagreen, or Pink, or altogether, as in pure White; nor is their beauty lost in either case though one is presented in greater strength than another, as in the intermediate hues, and indeed in all colours which are not perfectly neutral, no colour being without some mixture of white. It is also very remarkable that the more nearly neutral the colour is with the same degree of brightness, the longer can the eye contemplate it with pleasure. It would seem as if, there being three kinds of nervous fibres, or three modes of action, one for each simple sensation of colour, alternations of rest and excitement in each of them give pleasure; for such a supposition sufficiently accounts for the principles of the harmony of colour without assuming that the excitement of one sensation creates a desire for the like excitement in the rest.

Whether there is or is not any relation between the periods of the vibrations which most powerfully excite the several simple sensations of colour, similar to that which exists between musical notes in the same octave, has not, it seems, yet been conclusively shown. The wave-periods of those rays which appeared in Mr. Maxwell's experiments to present the deepest Red, Green and Blue, though not forming any harmonical series, do not differ very widely from the series 1, 4/5, 2/3 or that of the musical notes, C, E and G, the simplest and best of any series of three that can be found within an octave. To form that series the extreme terms should be more distant from the mean. But owing to the weakness of the light near the ends of the spectrum, it seems probable that the relative depth of colour in the Red and Blue rays falling outside of those mentioned above is not accurately determined by the experiments, and it is not easy to persuade the eye that the depth of colour is really less in those outer rays. Hence it may yet be possible that the same relation exists between Red, Green, Blue, in color, as between *do, mi, sol*, in music; and it must be admitted that not only the analogy between light and sound, arising from their vibratory nature, but also several circumstances attending the sensations excited by light, make it probable that such a relation does really exist. Moreover there is evidently a greater difference between Red and Green, and between Red and Blue, than there is between Green and

Blue; which corresponds with what is true of the notes C and E, C and G, and E and G. But it does not seem that the sequence of colours in the spectrum can be explained on these principles without supposing that the sensation of Red is also excited in a minor degree by vibrations an octave higher than those of the C, and the sensation of Blue by vibrations an octave lower than those of the G.

If this idea of harmonical relations of colour is true, the eye might be compared to a musical instrument of three strings, tuned to give out those notes only; and that all possible variations of colours correspond to sounds which are symphonies of these notes only, sounded in various degrees of intensity. But in any case, since the three simple sensations, as before stated, are beautiful and pleasant to the eye, both separately and simultaneously, in succession or in combination, it seems clear that (strictly speaking) there can be no discord in colours. . . .

There are, however, different degrees of pleasure derived from different successions or combinations; and though any variation is preferable to unbroken uniformity, some are far more agreeable than others. The chief grounds of excellence will perhaps be found in the following points:—

(1) The due balance of the colours in quantity or strength, or the equivalence of the Red, Green, and Blue contained in the whole composition;

(2) The symmetry, resemblance, or correspondence in nature and extent, of the gradations and contrasts in different parts of the composition;

(3) The variety of the colours, and of the gradations and contrasts presented.

The first of these is carried out with the nearest approach to perfection when every colour is either accompanied with its perfect complementary, or with two or more other colours of such sort that the mean or average of the whole is a neutral Gray: the contrasting colours not being necessarily in juxta-position, but so conveniently arranged as that the eye may readily refresh itself by passing from one to another. If the colours do not quite neutralize each other, an excess of strength in some may be compensated by an increased quantity of others, with the like general effect. But it is not essential that this mean or average, which gives the tone to the whole composition, should be neutral, though it undoubtedly ought to be so for a composition which is to fill the eye for any long continuance. Much of the charm of small compositions, or transient effects, often arises from the predominance of some particular hue. Thus in a landscape, while Red and Green almost universally prevail in the objects below us and immediately around us, they are balanced by the brighter though paler blue light of the heavens and the distance, the tone of the whole being white; while bowers

and rocks in nature, and compartments of dwellings in art, which are visited for a limited time, may owe much of their beauty to the prevalence (not too strong) of particular hues in their colours. Small compositions, again, such as flowering plants in nature, and pictures in art, may have great strength of hue in their general tone, and yet please the more in consequence; but if this effect is to continue, they should be balanced either by the general tone of the surrounding objects, or by other similar objects of an opposite tone at no great distance from them, to which the eye may turn for relief and fresh excitement. In such compositions, again, unity of effect is aided not only by the general prevalence of some hue, but also by giving prominence to some colour on which the eye will naturally rest more than on the others, and which will perform the same office as the key note in a musical composition.

The second point would be perfectly attained where colours change in all directions according to different laws of gradation, each of which continues the same in the same direction; a change which may take place with any degree of slowness down to that which is imperceptible. But the rate of change may be different in different directions; or it may vary in different places, even from nothing to infinity, in which case spaces presenting a uniform colour would adjoin to others presenting other uniform colours, and there would be contrast and no gradation. But it is not essential that every part of a composition should exhibit the same sort of changes; on the contrary, if there are parts on which the eye is to dwell, and which give a character to the whole, they ought to be marked with peculiar changes in the gradations, or something singular in the contrasts. To the head, chiefly, belongs the beauty arising from evenness of colour and truth of gradation; also that arising from unity of design, which gives a character to the whole composition, as well as that arising from the distribution of light and shade, and of various hues, in such a manner as to make them naturally inhance [sic] each other's value, and increase the effect of the whole. In nature the principal gradations and contrasts are made in light and shade; and the important bearing which the disposition of these has upon the beauty of the scene is evident.

The third point, the variety of the colours' gradations and contrasts presented, inhances the richness and charm of a composition, though it increases the difficulty of securing the satisfactory attainment of the two former points. Variety of colours involves first the distance of the extreme colours from each other, or from the mean or average colours; and its attainment in the highest degree requires the utmost possible depth and clearness in the extreme colours, as well as the greatest number of changes. Variety of gradations and contrasts involves not only the

exhibition of gradations and contrasts between different colours, but also the exhibition of gradations of various degrees of quickness, from that which is imperceptibly slow, or the continuation of uniform colour, to that which is infinitely quick, or the juxta-position of different colors (38–41).

30 • WALTER SARGENT
(1868 – 1927)

Sargent, a landscape painter, taught at the School of Education of the University of Chicago. His *Enjoyment and Use of Color* (1923) was a popular text that became a standard, remaining in print for many years.

The physical sciences were only providing, at best, partial explanations for many of the phenomena that were of concern to artists—such as "the character of the play of light." Sargent had a graceful ability to overlook science's shortcomings and he could appreciate these ill-explained phenomena, yet still respect the authority of the physical sciences.

From THE ENJOYMENT AND USE OF COLOR

Under ordinary conditions pure white paint is about fifty times brighter than black paint, but light-colored objects in sunshine are often several hundred times brighter than deep shadows. Of course the specular reflection of sun on water or on polished objects is still brighter. All that the painter can do in representing nature's intervals of light and shadow is to make his intervals between the narrower range of black and white, proportionate to nature's greater steps between the illumination of sunlight and the gloom of shadow. The designer in stained glass can more nearly approach nature's scale of values because light can actually shine through his colors. . . .

The beginner in color is likely to regard black and white as negative in comparison with color. In reality, however, each is a distinctly positive element in a design, and an area of either is far from being a space of silence and emptiness. Pure white or black has a decorative effect in

a design which seems to differ essentially from that of any color however near the color may approach to black or white. Besides its own individual quality each affects the colors near which it is placed, by enhancing them, and in return each is modified by the reflections or after-images of near-by hues.

White light is the most vital thing in nature. When it passes through the prism it is separated into colors the waves of which are constant and regular in their motion, but the waves of white light are irregular and do not repeat themselves. Its stream is tumultuous. The colors which compose it seem hardly to be held in leash or concealed. Their energies are all visible. It pours on, ebullient and effervescing, ready upon meeting any obstacle to be shattered into its many possibilities of hue. In the white of objects this potency is more subdued than in the case of light coming directly from the source of illumination, but it is still evident. The quality varies with the texture of the surface which reflects it. It reverberates from silk differently than from snow. Fine porcelain sends the light graciously to our eyes while cheap china returns harsh glints with knife-like, unmodulated edges. Thus the character of the play of light is often an assurance of the quality of the ware. A student of John La Farge, whose work was criticized because the white flowers in her picture did not take their place behind the frame, said: "I can't help painting very white—and the flowers look very white to me. I don't see how they can be whiter, but I think the frame doesn't suit." Mr. La Farge replied: "It is because they are white-lead color and not white-flower color, which is a very different thing, that they refuse to take their place behind the frame."

. . . Even apart from the effect of reflected hues, blank white seldom occurs in things which we see under ordinary conditions. There are all degrees of selective absorption, so that usually one or more hues are reflected out of proportion to the others, even though to a slight degree. When we collect and compare many examples of what passes for white, feathers, fur, minerals, textiles, the petals of different flowers, we can see the distinctions in hue. Even where the material appears to be very white, but delicate in structure, as in white poppies, we get the impression as in light, of the chromatic vitality of white, as if the different colored rays which compose it jostled one another and were held together only in an unstable equilibrium.

Black stands at the end of the neutral scale, opposite to white. No paint reflects more light than white nor less than black. Consequently, in pigments white is our nearest approach to light, and black is as close as we can come to absolute darkness. Black is theoretically the absence of all color, but an absolute black is seldom found except in total darkness. What we call blacks usually reflect considerable light, and even

color. If we paint a circle as black as paint will make it, and then place it beside a hole of the same size and shape which opens into a fairly large box lined with black, we see how much deeper is the darkness of the aperture than that of the paint (63 – 66).

31 • HENRI MATISSE
(1869 – 1954)

Matisse, one of the most original colorists of the twentieth century, is often identified as a Fauve, but no stylistic label fits comfortably. In the classes he conducted from 1907 to 1911, he advised his students to regard painting as an art of approximation in which the picture plane of the painting was a universe unto itself: the colors in the painting could not precisely match those of the subject, though color relationships in one must parallel those in the other.

Some of the innovations in his paintings were borrowed from Islamic art, which he saw when he visited North Africa. He mixed many patterns in a single painting, used unusual color combinations such as pink, purple and orange, and used large areas of bright color, as in *The Red Studio* (1911).

The American artist Sara Stein (wife of Michael Stein and sister-in-law of Gertrude and Leo Stein), was one of Matisse's original ten students and kept notes on the advice he gave in class.

From MATISSE: HIS ART AND HIS PUBLIC

One must stop from time to time to consider the subject (model, landscape, etc.) in its ensemble. What you are aiming for, above all, is unity.

Order above all, in color. Put three or four touches of color that you have understood, upon the canvas; add another, if you can—if you can't, set this canvas aside and begin again.

Construct by relations of color, close and distant—equivalents of the relations that you see upon the model.

You are representing the model, or any other subject, not copying it;

and there can be no color relations between it and your picture; it is the relation between the colors in your picture which are the equivalent of the relation between the colors in your model that must be considered.

I have always sought to copy the model; often very important considerations have prevented my doing so. In my studies I decided upon a background color and a general color for the model. Naturally these were tempered by demands of atmosphere, harmony of the background and model, and unity in the sculptural quality of the model.

Nature excites the imagination to representation. But one must add to this the spirit of the landscape in order to help its pictorial quality. Your composition should indicate the more or less entire character of these trees, even though the exact number you have chosen would not accurately express the landscape.

STILL LIFE

In still life, painting consists in translating the relations of the objects of the subject by an understanding of the different qualities of colors and their interrelations.

When the eyes become tired and the rapports seem all wrong, just look at an object. "But this brass is yellow!" Frankly put a yellow ochre, for instance on a light spot, and start out from there freshly again to reconcile the various parts.

To copy the objects in a still life is nothing; one must render the emotion they awaken in him. The emotion of the ensemble, the interrelation of the objects, the specific character of every object—modified by its relation to the others—all interlaced like a cord or a serpent.

The tear-like quality of this slender, fat-bellied vase—the generous volume of this copper—must touch you. A still life is as difficult as an antique and the proportions of the various parts as important as the proportions of the head or the hands, for instance, of the antique.

CRITICISM [remarks addressed to individual students]

This manner of yours is a system, a thing of the hand, not of the spirit. Your figure seems bounded by wires. Surely Monet, who called all but the people who worked in dots and commas wire-draughtsmen, would not approve of you—and this time he would be right.

In this instance the dark young Italian model against a steel-gray muslin background suggests in your palette rose against blue. Choose two points: for instance, the darkest and lightest spot of the subject—in this case the model's black hair and the yellow straw of the stool. Consider every additional stroke in addition to these.

This black skirt and white underskirt find their equivalent—in your scheme—in ultramarine blue with dark cobalt violet (as black), and emerald green and white. Now the model is pearly, opalescent color all

over. I should take vermilion and white for this lower thigh, and for this calf—cooler but of the same tone—garance and white. For this prominence of the back of the forearm, cool but very bright, white tinged with emerald green, which you do not see as any particular color now that it is placed.

Your black skirt and red blouse, on the model stand, become an emerald green (pure) and vermilion—not because green is the complementary of red, but because it is sufficiently far away from red to give the required rapport. The hair may also be emerald green, but this green appears quite different from the former.

You must make your color follow the form as your drawing does—therefore your vermilion and white in this light should turn to garance and white in this cooler shadow. For the leg is round, not broken as by a corner.

Thick paint does not give light; you must have the proper color-combination. For instance, do not attempt to strengthen your forms with high lights. It is better to make the background in the proper relation to support them. You need red to make your blue and yellow count. But put it where it helps, not hurts—in the background, perhaps.

In this sketch, commencing with the clash of the black hair, although your entire figure is in gradation from it, you must close your harmony with another chord—say the line of this foot.

There are many ways of painting. You seem to be falling between two stools—one considering color as warm and cool, the other, seeking light through the opposition of colors. Had you not better employ the former method alone? Then your blue background will require a warmer shadow; and this warm, black head against it, a warmer tone than this dark blue you have chosen. Your model stand will take a warmer lighter tone; it looks like pinkish, creamy silk in relation to the greenish wallpaper.

Cézanne used blue to make his yellow tell, but he used it with the discrimination, as he did in all other cases, that no one else has shown.

The Neo-Impressionists took different centers of light—for instance, a yellow and a green—put blue around the yellow, red around the green, and graded the blue into the red through purple, etc.

I express variety of illumination through an understanding of the differences in the values of colors, alone and in relation. In this still life, an understanding of cadmium green and white, emerald green and white, and garance and white, give three different tones which construct the various planes of the table—front, top, and the wall back of it. There is no shadow under this high light; this vase remains in the light, but the high light and the light beneath it must be in the proper color relation (552).

32 • PIET MONDRIAN
(1872 – 1944)

Mondrian was born near Utrecht and studied at the Amsterdam Academy of Fine Arts. He worked in Holland, Paris, England, and New York, and early in his career was influenced by Divisionism (1908) and Cubism (1911). In a series of paintings of trees (c. 1911), Mondrian created an abstract art based on the forms of the natural world. Later, seeking what he called a "pure plastic art," he equated purity with simplification. He gradually reduced his palette to red, yellow, blue, black, and white (the colors we often identify as pure, simple, or primary) and reduced his use of line to verticals and horizontals, eliminating curves and diagonals.

While living in Holland (1915), Mondrian met the Dutch poet and artist Theo van Doesburg, who helped him found the magazine *De Stijl* (first issue October 1917). Mondrian contributed several theoretical articles to *De Stijl,* including "Natural Reality and Abstract Reality," a dialogue in the form of a playscript with seven scenes. The three speakers are: X, a Naturalist painter, Y, an art-lover, and Z, an Abstract-Realist painter.

From PIET MONDRIAN: LIFE AND WORK

Natural Reality and Abstract Reality

SCENE I
Dusk. Flat countryside. Vast Horizon. Far up: the moon

Z The natural value of colors as colors, and as light and shade, is certainly one of the conditions of equilibrium. But all the same, the

relation of color and the relation of proportion are both based on the relation of position.

Y Color as such is already a great delight to me. A yellow all by itself, a simple blue, unfolds before me a whole world of beauty.

Z To be sure, color as such animates everything, and it is possible to be carried by the pure vision of color to the loftiest heights, indeed, to contemplation of the universal. But one must add that color as such speaks to us so insistently of external things that we run the risk of remaining in the contemplation of what is external and vague, instead of seeing the abstract.

X But the value of a color comes from the opposition of another color, from the *relation* of colors, as you yourself rightly remarked.

Z This relation gives color its clear definition, and does away with the sensation of vagueness to which I referred before. But this does not contradict what I said. For instance: a red moon expresses something quite different from the silver-yellow moon we are now looking at.

Y To me, a red moon seems terribly tragic.

Z But that is not due to the moon's color alone, but to its position as well; the moon, when red, is generally close to the horizon, so that the horizontal line strongly dominates the vertical distance between moon and horizon. Thus we see once more that the relation of proportion sustains the expression of color. But this should not make us forget that the color of the sky around the lunar red also has its expressive value: blue is the opposite of red, and removes a good part of its "tragic" quality, and so on. The more we see the relation of colors, the less do we see color itself; we liberate ourselves evermore from the particular, and hence from the representation of the tragic.

Y In listening to what you both said about relations, something I was vaguely aware of became clear to me: that we ought to apprehend the visible as a whole from which nothing can be omitted, a whole in which all things are parts and therefore necessary. And now I see more and more clearly that the expression of the visible depends on the position of the parts of the visible.

Z Yes, all things are parts of a whole. Each part receives its visual value from the whole, and the whole receives its visual value from the parts. Everything is constituted by relation and reciprocity. Color exists only through another color, dimension is defined by *another* dimension; there is no position except by opposition to *another* position. This is why I say that relation is the principal thing (303–06).

SCENE IV

Close by, a mill clearly outlines its mass against the bright starry sky. The motionless wings of the mill form a cross.

How pure the blue of the sky is next to the blackness of the mill!

X Yes, the sky is pure, but so is the mill! Even though the mill seems very dark and colorless, it would be impossible to render our impression of the sky and of the mill with bright and dark colors alone. I have often experienced that. In a drawing, light and shade can do, but color—that's another matter! Blue calls for a color which counterbalances it. The Impressionists already exaggerated color, the neo-Impressionists and the Luminists went still further. To speak of my own experiences: I sometimes got a certain satisfaction from painting a mill red against the sky's blue.

X But that's not what we see now.

Z Our new vision is different from our optical vision, but the inner vision is not always conscious, and then—no matter how spontaneous this inner vision—we cling more or less to the optical vision, especially after the first burst of emotion has subsided. It is thanks to the impact of this first intuitive emotion that the studies and rough sketches of naturalistic painters are stronger and more beautiful than their pictures. Let us never forget that the aesthetic view is different from the habitual one. In general, what alone counts in art is to produce an emotion of the beautiful. Thus to the degree that we feel the purity of color before us more intensely, we should express it more purely. To put the matter better: when we learn to see more aesthetically, our task will be to express our emotion of the beautiful in a clear manner, and in terms of precise proportions and measurements. Then we can break completely with optical vision.

X But some magnificent things have nevertheless been done without going to such exaggeration!

Z What some call exaggeration others will look upon as merely a weak means of expression. Why argue for an individualistic art when history clearly reveals a tendency towards an ever stronger and purer expression of visible things? Our age beats the measure of life with greater force, the accelerated movement produces a more lively emotion, and this in turn requires a stronger expression. But we can also say that modern consciousness is turning more and more from the vague to the precise, or that the spirit of this age requires more clarity.

X There is no lack of exaggeration in this new age, but that may be due to pure imitation.

Z If this were so, we wouldn't see one and the same tendency everywhere, and in fields that are independent of each other. Let me add that human beings and artists especially hesitate to follow *the new* until they have understood it to be the true. Such understanding is still rare, but wherever it exists, the new can somehow be perceived superficially, because man is ready for such perception. And so there can be no question of what you call "imitation."

X But to return to the mill, if exaggerating the color proved satisfactory, why didn't you continue to paint in that manner, why did you drop all reference to the outward form?

Z Because with it the object continued to be present as an independent element in the plastic expression. And with the object present, the plastic expression is not *exclusively* plastic. When the object is represented, the emotion of the beautiful remains limited; that is why the object had to be eliminated (323 – 24).

33 • BERTRAND RUSSELL
(1872 – 1970)

The British philosopher Bertrand Russell was Ludwig Wittgenstein's teacher and T. S. Eliot's mentor. Russell's books range from *A Critical Exposition of the Philosophy of Leibniz* (1910) to *The Conquest of Happiness* (1930) and *New Hopes for a Changing World* (1951). *Principia Mathematica (Principles of Mathematics)*, written in collaboration with Alfred North Whitehead, was published in three volumes in 1910, 1912, and 1913.

Russell became a popular radio broadcaster during his later years. To the public, he was known for his fierce championship of individual liberties and his opposition to war. Russell's *Introduction to Mathematical Philosophy* (1919) was written in prison while he served a six-month sentence for publishing a pacifist article. In 1963, Russell founded the Bertrand Russell Peace Foundation for the purpose of developing international resistance to the threat of nuclear war.

Russell was a major logician who could easily have been the model for Dr. Spock in *Star Trek*. He shows, in "Structure and Minimum Vocabularies," the difficulty of defining color names and the source of this difficulty in physics, which generally has no mechanism for dealing with sensations or subjective phenomena.

From HUMAN KNOWLEDGE: ITS SCOPE AND LIMITS

Consider the definition of the word "red." We may define it (1) as any shade of color between two specified extremes in the spectrum, or (2)

as any shade of color caused by wave lengths lying between specified extremes, or (3) (in physics) as waves having wave lengths between these extremes. There are different things to be said about these three definitions, but there is one thing to be said about all of them.

What is to be said about all of them is that they have an artificial, unreal, and partly illusory precision. The word "red," like the word "bald," is one which has a meaning that is vague at the edges. Most people would admit that if a man is not bald the loss of one hair will not make him so; it follows by mathematical induction that the loss of all his hairs will not make him so, which is absurd. Similarly, if a shade of a color is red, a very tiny change will not make it cease to be red, from which it follows that all shades of color are red. The same sort of thing happens when we use wave lengths in our definition, since lengths cannot be accurately measured. Given a length which, by the most careful measurements, appears to be a meter, it will still appear to be a meter if it is very slightly increased or diminished; therefore, every length appears to be a meter, which again is absurd.

It follows from these considerations that any definition of "red" which professes to be precise is pretentious and fraudulent.

We shall have to define "red," or any other vague quality, by some such method as the following. When the colors of the spectrum are spread out before us, there are some that everybody would agree to be red, and others that everybody would agree to be not red, but between these two regions of the spectrum there is a doubtful region. As we travel along this region, we shall begin by saying, "I am nearly certain that that is red," and end by saying, "I am nearly certain that that is not red," while in the middle there will be a region where we have no preponderant inclination either toward *yes* or toward *no*. All empirical concepts have this character—not only obviously vague concepts such as "loud" or "hot" but also those that we are most anxious to make precise, such as "centimeter" and "second."

It might be thought that we could make "red" precise by confining the term to those shades that we are certain are red. This, however, though it diminishes the area of uncertainty, does not abolish it. There is no precise point in the spectrum where you are sure that you become uncertain. There will still be three regions, one where you are certain that you are certain the shade is red, one where you are certain that you are uncertain, and an intermediate region where you are uncertain as to whether you are certain or uncertain. And these three regions, like the previous ones, will have no sharp boundaries. You have merely adopted one of the innumerable techniques which diminish the area of vagueness without every wholly abolishing it

Let us suppose that I am seeing a certain colored patch, and that I call the shade of the patch "C." Physics tells me that this shade of color is caused by light of wave length λ. I may then define "C" as: (1) the shade of any patch that is indistinguishable in color from the patch I am seeing now; or (2) as the shade of any visual sensation caused by electromagnetic waves of wave length λ; or (3) as electromagnetic waves of wave length λ. When we are concerned only with physics, without regard to the methods by which its laws are *verified*, (3) is the most convenient definition. We use it when we speak of ultraviolet light, and when we say that the light from Mars is red, and when, during a sunset, we say that the sun's light is not really red but only looks red because of intervening mist. Physics, per se, has nothing to say about sensations, and if it uses the word "color" (which it need not do), it will wish to define it in a way that is logically independent of sensation.

But although physics as a self-contained logical system does not need to mention sensations, it is only through sensations that physics can be *verified*. It is an empirical law that light of a certain wave length causes a visual sensation of a certain kind, and it is only when such laws are added to those of physics that the total becomes a verifiable system. The definition (2) has the defect of concealing the force of the empirical law which connects wave length with sensation. Names for colors were used for thousands of years before the undulatory theory of light was invented, and it was a genuine discovery that wave lengths grow shorter as we travel along the spectrum from red to violet. If we define a shade of color by its wave length, we shall have to add that sensations caused by light of the same wave length all have a recognizable similarity, and that there is a lesser degree of similarity when the wave lengths differ, but only by a little. Thus we cannot express all that we know on the subject without speaking about shades of color as known directly in visual sensation, independently of any physical theory as to light waves.

It would seem, therefore, that if we wish for clarity in exhibiting the empirical data which lead us to accept physics, we shall do well to adopt our first definition of a shade of color, since we shall certainly need some way of speaking about what this definition defines, without having to make the detour through physics that is involved in mentioning wave lengths.

It remains, however, an open question whether the raw material in our definitions of colors should be a given shade of color (wherever it may occur), or a given patch of color, which can only occur once. Let us develop both hypotheses.

Suppose I wish to give an account of my own visual field throughout a certain day. Since we are concerned only with color, depth may be

ignored. I have therefore at each moment a two-dimensional manifold of colors. I shall assume that my visual field can be divided into areas of finite size, within each of which the color is sensibly uniform. (This assumption is not essential, but saves verbiage.) My visual field on this assumption, will consist of a finite number of colored patches of varying shape. I may start by giving a name to each patch, or by giving a name to each shade of color. We have to consider whether there are any reasons for preferring one of these courses to the other.

If I start by giving a name to each patch, I proceed to the definition of a shade of color by means of a relation of color similarity between patches. This similarity may be greater or less; we suppose that there is an extreme degree of it which may be called "exact likeness." This relation is distinguished by being transitive, which is not the case with minor degrees of resemblance. For the reasons already given, we can never be sure that, in any given case, there is exact color likeness between two patches, any more than we can be sure that a given length is exactly a meter. However, we can invent techniques which approximate more and more closely to what would be needed for establishing exact likeness.

We define the shade of color of a given patch as the class of patches having exact color likeness to it. Every shade of color is defined in relation to a "this"; it is "the shade of color of *this* patch." To each "this," as we become aware of it, we give a name, say "P"; then "the shade of P" is defined as "all patches having exact color likeness to P."

The question now arises: Given two patches which are indistinguishable in color, what makes me think them two? The answer is obvious: difference of spatio-temporal position. But though this answer is obvious, it does not dispose of the problem. For the sake of simplicity, let us suppose that the two patches are parts of one visual field, but are not in visual contact with each other. Spatial position in the momentary visual field is a quality, varying according to distance from the center of the field of vision, and also according as the region in question is above or below, to the right or to the left, of the center. The various qualities that small portions of the visual field may have are related by relations of up-and-down, right-and-left. When we move our eyes, the qualities associated with a given physical object change, but if the various physical objects have not moved, there will be no *topological* change in the part of the visual field which is common to both occasions. This enables common sense to ignore the subjectivity of visual position.

Concerning these visual positional qualities we have exactly the same alternatives as in the case of shades of color. We may give a name to each quality, considered as something which is the same on different occasions, or we may give a name to each instance of the quality, and

connect it with other instances of the same quality by the relation of exact likeness. Let us concentrate on the quality that distinguishes the center of the field of vision, and let us call this quality "centrality." Then on one view there is a single quality of centrality, which occurs repeatedly, while on the other view there are many particulars which have exact positional likeness, and the quality of centrality is replaced by the class of these particulars.

When we now repeat, in relation to the particulars which are instances of centrality, the question as to how we distinguish one of these particulars from another, the answer is again obvious: we distinguish them by their position in time. (There cannot be two simultaneous instances of centrality in one person's experience.) We must therefore now proceed to analyze difference of position in time.

In regard to time, as in regard to space, we have to distinguish objective and subjective time. Objective space is that of the physical world, whereas subjective space is that which appears in our percepts when we view the world from one place. So objective time is that of physics and history, while subjective time is that which appears in our momentary view of the world. In my present state of mind there are not only percepts but memories and expectations; what I remember I place in the past, what I expect I place in the future. But from the impartial standpoint of history my memories and expectations are just as much *now* as my percepts. When I remember, something is happening to me now which, if I remember correctly, has a certain relation to what happened at an earlier time, but what happened then is not itself in my mind now. My memories are placed in a time-order, just as my visual perceptions are placed in a space-order, by intrinsic qualities, which may be called "degrees of remoteness." But however high a degree of remoteness a memory may possess, it is still, from the objective historical point of view, an event which is happening *now*

We must now return . . . to the question whether we are to assume one quality of centrality which can exist at various times, or a number of instances of it, each of which exists only once. It begins to be obvious that the latter hypothesis will entail great unnecessary complications, which the former hypothesis avoids. We can bring the question to a head by asking what can be meant by "this." Let us suppose "this" to be some momentary visual datum. There is a sense in which it may be true to say "I have seen this before," and there is another sense in which this cannot be true. If I mean by "this" a certain shade of color, or even a certain shade of a certain shape, I may have seen it before. But if I mean something dated, such as might be called an "event," then clearly I cannot have seen it before. Just the same considerations apply if I am asked, "Do you see this anywhere else?" I may be seeing the

same shade of color somewhere else, but if in the meaning of "this" I include position in visual space, then I cannot be seeing it somewhere else. Thus what we have to consider is spatio-temporal particularity.

If we take the view—which I think the better one—that a given quality, such as a shade of color, may exist in different places and times, then what would otherwise be instances of the quality become complexes in which it is combined with other qualities. A shade of color combined with a given positional quality cannot exist in two parts of one visual field, because the parts of the field are defined by their positional qualities. There is a similar distinction in subjective time: the complex consisting of a shade of color together with one degree of remoteness cannot be identical with the complex consisting of the same shade of color and another degree of remoteness. In this way "instances" can be replaced by complexes, and by this replacement a great simplification can be effected (259–65).

34 • J. BACON
(1876 – 1931)

Bacon, a nineteenth-century British color theorist, is unusual on two counts. First, he questioned whether scientific theory—by which he meant the theories of Newton, Helmholtz, and Maxwell—could be reconciled with what we see. And, second, he was not led by an assumption that was widespread in his day: that one began the study of color by investigating scientific theory, and aesthetic understanding would follow in due course.

From THE THEORY OF COLOURING . . .

On Light

What we call light is an *effect* produced in the mind or spirit of an animated being by the action of a subtle matter on the sensitive expansion of the optic nerve, which is spread over the interior of the eye, and which is called the retina.

The action of this subtle matter, by some called ether—I prefer to call it the *light medium*—has been supposed to be exerted in straight lines, but the hypothesis that it is of a wavy or vibratory character has gained so much support that the relative lengths of the waves producing the colours of the solar spectrum are now given in most treatises on light

The movement of the atoms of light medium is transmitted from one to another, the intensity diminishing as the distance from the exciting cause increases; and besides the movement between atom and atom, there is also one of a symmetrical character, embracing a smaller or larger number

of atoms; it is this symmetrical movement which is called a wave. Modern discoveries teach us that the length of the wave determines the character of the mental effect which we call colour.

White light consists of a number of sets of waves existing in the light medium simultaneously, the length of the waves of each set being equal, but differing from that of every other set. It follows that each of the colours of the spectrum, obtained by decomposing white light by means of a prism, might be designated by the length of the waves that produce it, those of red being longest, and those of violet shortest; orange, yellow, green, and blue decrease in length, in the order in which they are named, as they leave the red and approach the violet. Since each colour has its *individual wave length, each is a simple colour.*

The orange, green, and purple of the spectrum are not secondary or compound colours; they have their proper wave measure, and are therefore as much entitled to the term primary as red or blue. We are naturally led from the decomposition of white light to its recomposition. Maxwell and Helmholtz offer elaborate and exhaustive experiments; only a few of the facts established by them will be needed for our purpose. The principal of those put forward by Helmholtz are that red and bluish-green produce yellow, and the following groups produce white light:—red + bluish-green + indigo, red + greenish-blue, yellow + indigo, and orange + blue. He considers red, yellow, green, blue, and violet to be primaries, as with them, in varying proportions of two or three together, he obtains all the other colours of the spectrum almost pure. In choosing three colours to be called primaries he would prefer red, green, and violet, these enabling him, by combinations, to produce the greatest number of colours. Maxwell's experiments led him to choose red, green and blue for his primaries. He calls the following couples complementaries: red to sea green; green to pink; and blue to yellow; these couples producing white light. It must be observed that the foregoing results are obtained only from coloured lights, not from pigments. Admitting the accuracy of Maxwell's observations, and the justness of his conclusions, it would appear to the unreflecting mind that we are bound, in reason, to put aside all our notions of colouring, based on the theory which takes red, yellow, and blue as primaries, and orange, green, and violet as secondaries, and accept or invent one based on Maxwell's choice. The charm of novelty is very great, and it often misleads men whose general attainments should make them superior to its influence; but, before adopting the new theory, it would be well to enquire into the grounds of the old one.

We will begin with a short statement of Newton's opinions, as they have been reproduced in almost all works on colour applied to the arts. He held that in white light there are three pure colours called primaries; the others result from the mingling of couples of these three, and are called

secondaries; thus, the orange results from the mingling of the red and yellow rays, the green from those of yellow and blue, and the purple from those of blue and red. Maxwell and Helmholtz have proved that the mingling of yellow and blue lights produces white light, not green; that yellow may be produced by the mingling of red and green, and is therefore a compound or secondary colour (as it is when so compounded, yet they agree that the *yellow* of the *solar spectrum* is a *simple* colour, giving rise to the paradox that yellow is *both simple and compound*). Newton's opinions were therefore mere assumptions, and afford the old theory no assistance. On experimenting with pigments, we learn that with reds, yellows, and blues, by judicious mixing in couples, orange, green, and purple can be produced, so completing the set of spectrum colours. Here the evidence in favour of the old theory is marked, while its bearing on the new one is not in any way confirmatory of its teachings; for instance, it is found impossible to get a yellow colour by mixing red and green pigments, while green can be obtained in all shades by mixing yellow and blue. It is difficult in the face of this evidence to call yellow a secondary colour, and green a primary.

By appealing to the human mind, we shall arrive at conclusive evidence of that relationship of colours to each other which is usually meant by the term complementary.

The colours that are complementary in an art aspect may be discovered by the following experiments:—

I suppose the observer to be capable to seeing all the colours of the solar spectrum. Obtain some of the following pigments in *powder*: rose madder, pale cadmium or No. 2 chrome, ceruleum [cerulean] and cobalt, orange cadmium, emerald green, and mauve; if this latter cannot be obtained, a mixture of rose madder and cobalt must do duty for purple. I have chosen the above colours because they (with the exception of mauve, which is chosen on account of its power) reflect a great deal of light to the retina, and so awaken the complementary image more rapidly. I shall now speak of them as red, yellow, blue, orange, green, and purple.

Cut an opening, three-quarters of an inch long, in a piece of *pure white* or *strictly neutral* grey paper, not less than six inches square. At the distance of a quarter of an inch from the edge of the hole draw a line parallel with it, and in the middle of the line put a dot thus:—

Place some of the red on a piece of paper so that it shall cover rather more than a space equal to that enclosed in the diagram between the figures 1 and 2, being careful to leave a clean straight edge on one side; to this straight edge adjust some orange to occupy a space equal to that between the figures 2 and 3; the space 3 and 4 will be covered with some yellow. Lay the paper with the aperture in it over this group of colours so that each will be seen to occupy one-third of the opening. Let the eye rest. Now look fixedly at the centre of the orange for a minute or two, the longer the better, then regard the dot in the middle of the black line, and the space between the line and the edge of the opening will be seen tinted with very delicate colours; green appears beside the red, blue beside the orange, and purple beside the yellow.

Treat the following triplets in the same way: yellow, green, and blue; green, blue, and purple; the complementary colours in these groups come as follows:—beside the yellow appears purple, beside the green a rosy red, beside the blue orange. Purple has yellow if it be made as nearly neutral as possible, but if it incline to red, then the yellow will be greenish; if to blue, then the yellow will tend to orange. The above blue must be compounded of ceruleum and a very little cobalt intimately mixed. Powder colours, from their opacity, are far more luminous than those which are ground up in a vehicle, so are preferable in these experiments. The above results will be very generally obtained, the exceptions will be due to some peculiarities of the eyes of the observer. I have called in the aid of young eyes, and those of adults, of cultivated and uncultivated ones, and am forced to accept their corroboration of my own experience as conclusive.

From these experiments, I deduce the following data: red has green for its complementary colour and blue and yellow have orange and purple respectively.

How can we reconcile the proposition, purple is the complementary colour of yellow, with that which affirms that blue is its complementary colour? Both are true, though inconsistent; the inconsistency ceases as soon as we regard things rather than words. I submit that the new theory of colour owes its existence to the misunderstanding or misapplication of the word complementary.

The colours yellow and blue, and red, green, and blue, may be complementary in the production of white light; *but it does not follow that there is any connection between the production of white light and the production of harmony in colour*; that there is any is pure assumption, which evidently arose from the apparent analogy between the order in which the colours exist in the solar spectrum, and the experience derived from the mixing of pigments; the orange seeming to be produced by the apparent mingling of the red and yellow rays; the green, where the yellow and blue came together, and the purple might be supposed to own its existence to the

mingling of the blue with the red rays of another and fainter series of colours. The assumption, however, did not affect the results, since it was made to accord with truth, as shown by man's mental perceptions of colour and experience in pigments. When close observations showed that the colours of the spectrum bear a relationship to each other very different from that ascribed to them, it was time to *lay aside the assumption,* instead of falling into absurd errors by ignoring the true basis for the theory of colouring and taking the false one, which they have done who reasoned from the now recognized phenomena of the composition of white light (9–15).

35 • KASIMIR MALEVICH
(1878 – 1935)

The Russian painter Malevich was the founder of Suprematism, an abstract movement intended as a successor to Cubism. Malevich set forth the principles of his new art in the 1915 manifesto, *From Cubism to Suprematism*. In 1927, he expanded the manifesto into a book, *Die gegenstandslose Welt (The Non-Objective World)*.

From ESSAYS ON ART 1915 – 1933

An Attempt to Determine the Relation Between Colour and Form in Painting

. . . We cannot say to Kandinsky, any more than we can to Cézanne, that colour ought to have its own individual form, since in their works, particularly in Cézanne, there is no colour at all, but there is painting. I could also speak of my own works: in one and the same picture I create the same forms but colour them with different colours. I said that I colour them in order to underline that in my own pictures I draw a strict distinction between colour and form. And in the case in point I colour the form with this or that colour not because red or blue corresponds to this or that form, but because I paint in colours according to the scale that has arisen in my creative centre.

To go further, elements of form and colour are also formed according to scales which, in their turn, are created in the process of various dynamic experiences or an aesthetic-artistic sensation.

Thus, all the laws of additional changes or changes in form are established by optics and based on the physical perception of the visual system. They may be inaccurate if they are not linked with the work of the artist's organism converting the laws of visual perception onto a new level.

Possibly there is no point in mixing these two questions, since the problems and aims of optical science are quite different from those of art and painting. It is one matter to examine the form of an object and its deformation on the optical level, and another to perceive phenomena on the artistic level; the artist may, and, indeed, should take an interest in the achievements of science in the field of colour and form, but he must be careful In any case the exploitation of the results of scientific analysis concerning the interrelations between colour and form will depend on its quality and nature, as well as the artist's ability to make use of the latter in his work without the work reminding us of a column from a scientific analysis.

In addition I would also state that in such cases two principles always begin to clash. Both claim supremacy—the principle of knowledge, the centre of consciousness, and, on the other hand, the centre of sub-consciousness, or sensation.

The creative process begins beyond the realm of knowledge, and in the majority of cases goes against all that the artist knows. He knows perspective, and draws the picture from the outside, according to perspective etc. This is the first stage in his creative process.

The second stage in the moment when the process passes over to the stage of representation, when the psychic level of intensity (if one may put it like that) begins to single out the image. But this still does not mean that the singling out of the image is the moment of realisation. This image is a figure of the subconscious centre and it is still a long way from the centre of consciousness. This is the completed process of creative realisation and nothing more.

The third stage is the inclusion of the image into the centre of consciousness. This centre may be termed analytical, and in it the image ought to receive a definite interpretation.

And if in this period the artist is able to introduce all his scientific knowledge, i.e. to put across creation in the third stage, under the control of knowledge, then it will not threaten his artistic creation. But if the artist cannot do this all his scientific knowledge will remain "as such", and the work transferred to the centre of knowledge will serve as a mere form, on which is conducted some definite analysis, and it will take the form of a column of data from some scientific experiment. The centre of knowledge will always bring artistic logic to its own logic. The logic of knowledge of anatomy will bring the artistic, non-anatomical image to academic anatomy.

I say this in order to stress that no scientific proofs are a law for the artist, and that the basis of verisimilitude in the physical structure of our eye, or its visual functions, cannot be a truth for the artist, either; his process of examination is not completed at the moment when the eye perceives the phenomenon—it is only completed when the representation which the eye puts inside the artist is transformed and comes out again.

From what has been said it will be seen that I am against the interference of science in the question of colouring and additional colours, as well as the interdependence of form and colour according to the line of painterly-artistic creation; I have, however, nothing against the artist's using scientific data.

Now let us carry out experiment into the changes in one's impression of rooms identical in size, but painted in different shades, for example, red, crimson, and ochre: we will find that the impression of the rooms' sizes will differ. If they are painted white they will seem much larger than in other colours: thus, in this case, colour influences our perception of dimensions and of space.

Hence we may draw the conclusion that with colouring an object in this or that way we can obtain a different space, scale and feeling of weight from it.

Likewise various geometrical figures like a polygon, circle or triangle, will, taken separately, produce a change in the space of their form when a change is made in their colouring, and will again demand a definite colour.

So, from these two examples we see that a room or geometrical figures, coloured in various colours give different perceptions of scale, i.e., a difference in space. The search for colour for various volumes gives us the corresponding colouring. But this still does not mean that every form has its own colour, since it is a question of perceiving space in a colour phenomenon.

Let us take another range of forms or lines which will change in size, if we make an especial use of the scales and directions of lines.

Thus two identical lines will give the impression of being different lengths if at each end of one is placed a v-shape pointing outwards, and at each end of the other a v-shape pointing inwards.

Then the impression of our perception of dimension is changed not by colour but by various other relations between linear elements and their directions.

I.e. the form of space in our optical perception is not only changed by colour but by other elements that surround it, regardless of whether they are coloured or colourless.

However, one cannot affirm on the basis of the last two examples that every form has its corresponding colour, although the examples we have given are almost proof. All such examples are concerned with the purely

physical construction of our eye and perception. They create a purely optical illusion or optical sensation, but not the perception of reality because the form has not changed its space, nor will it change with different colouring. Thus we see that in this analysis colour has its own space and form its own.

Such examples cannot be compared with works, nor can one create laws for works of art on the basis of optical data, since they have different first principles.

Some examples, not elaborated in our creative centre, remain the result of the eye's physical construction as well as of atmospheric influence and we relate them to optical changes in the perception of the space of form and colour. Others—works of art, to be precise—are related to spiritual or psychological changes in the perception of phenomena, elaborated into images— aesthetic, say, or artistic or dynamic. Here we see that the edifice of a work is built on the basis of other laws which in the majority of cases diverge from optical laws or the science of additional tones.

Hence we see that it is, perhaps, possible to solve the question of the relationship between form and colour by purely physical and optical means, but this does not exhaust the question, and it is still essential to turn for help to psychophysiology, since this is where the following threads lead us. Let us then continue our examination of the question.

We see different colours and forms in the spectra we have deduced from the existing systems of Impressionism, Cézannism, Cubism, Futurism, Suprematism etc Can these proofs be taken as confirmation that this or that scale really corresponds to each form of a work?

Can we say that a given scale does not correspond to the form of an Impressionist work, if it fulfils the basic aim of Impressionism, i.e. gives a sensation of light? If we cannot say this, how was the artist lucky enough to realise this correspondence? What scientific laboratory helped him to create this lawful colouring of the form?

In such cases it is always said that such decisions are determined by the artist's intuition, by his subconscious will.

Accordingly the organism of every artist contains a rather precise laboratory, which can beat hands down the best optical laboratory, since the solution of a problem like the relationship between light and form is a difficult task.

But in reality these two laboratories diverge and are mutually exclusive, the achievements of the second laboratory having as much significance for the artist as the science of anatomy or perspective has for art—none at all.

For the perception of the physical side of the world through subconscious sensation interpreted in the artist's imagination will not correspond to the verdicts of an optical laboratory. The optical perception serves as material for the artist's subconscious centre.

If for optical truth the form and colour "as such" are important, for the

artist they have no significance for he gives first place to *his impression of the phenomenon, not the phenomena "as such" which he is supposed to present according to all the rules of visual perception of the model*

Thus, the artist, in order to convey his Weltanschauung [philosophy, view of the world], does not create colour or form until light, as he senses it, arises in his imagination, since *the sensation determines the colour and form;* one should therefore speak about *the correspondence between colour and sensation* rather than form, or the correspondence between various sensations. *Colour and form can be examined as separate elements in physics, but in artistic creation they cannot be examined as two different elements with the help of which sensation is determined* since colour and form are the result of the same single sensation. In a work of art such a division is false, in an Impressionist work, for example, there is neither form nor colour.

Then one must place them in conditions giving different conclusions; but whatever these conclusions may be they will have nothing in common with the process of revealing sensation, since it is a mistake to divide whole colour sensations.

The Impressionists are sometimes reproached that their form is weak or completely lacking, that in his pursuit of the revelation of light sensation the Impressionist artist loses form. These reproaches serve as splendid confirmation of what I have just said. The Impressionist work is analysed here in different conditions into colour and form; hence such conclusions and the reproaches that are based on them. At the same time another reason is given—they do not know how to draw and cannot see. But if they paid more attention to colour and form than to light they would lose the latter.

This serves as proof of the fact that in this Impressionist sensation of the world there is no special form, nor is there colour "as such." Therefore they cannot be analysed by form or colour. If colour and form were defined as such, then the sensation of the world as light would disappear or disintegrate into two independent phenomena. The people who reproach the Impressionists with lack of form have usually gazed closely at the form of phenomena lying in aerial light space, and imagined that they are really the essence and content of Impressionism from the point of view of light; i.e., paying no attention to that which is the reality of Impressionism. For the Impressionists light was an element of Weltanschauung; but they did not care at all whether light corresponded to form or not (cf. Monet's "Rouen Cathedral").

Therefore one cannot reproach the Impressionists for lack of form or colour, since here it was the real sensation of "light" that was being determined. All objects or forms lying in the light space are for the Impressionist fortuitous phenomena, and the Impressionist artist makes use of them only insofar as they are essential for light vibrations, if, that is, he senses the latter (126–32).

36 • PAUL KLEE
(1879 – 1940)

Klee worked in Bern and Munich, where he exhibited with the Blaue Reiter group (1912). He initially worked in engraving. After a trip to Tunisia in 1914, he devoted himself to painting, a change of medium he explained by saying he was "possessed by color." Klee taught at the Weimar Bauhaus and the second Bauhaus in Dessau (1920 – 1931), and at the Dusseldorf Academy (1931 – 33).

From THE DIARIES OF KLEE
1898 – 1918

. . . March. And now an altogether revolutionary discovery: to adapt oneself to the contents of the paintbox is more important than nature and its study. I must someday be able to improvise freely on the chromatic keyboard of the rows of watercolor cups.

. . . The light-form. By this I mean the conversion of the light-dark expanse according to the law by which lighted areas grow larger when opposed to dark areas of mathematically equal size. This was observed previously by focusing my eye unsharply (as distinguished from the squinting used for measuring chiaroscuro). Now carried through with greater thoroughness by means of a lens (glass eye).

This magnifying glass brings into view at the same time the color essence of the natural phenomenon. All detail is simply eliminated.

The attitude of the will during this process is the following: not to let the form be dissolved by the light expansions, but instead to end by

recapturing these motions, contouring them and binding them firmly to each other. I can imagine this optical phenomenon in stone. Neo-plasticism, who knows!

. . . April. Launched a new offensive against the fortress of painting. First, white thinned out in linseed oil as a general base. Second, color the entire surface lightly by applying very large areas of different colors that swim into one another and that must remain free of any effect of chiroscuro. Third, a drawing, independent of and substituting for the unformulated tonal values. Then, at the end, some bass notes to ward off flabbiness, not too dark, but colored bass notes.

This is the style that connects drawing and the realm of color, a sav-ing transfer of my fundamental graphic talent into the domain of paint-ing.

. . . Cultivation of the means in their pure state: either the proportion of tonal values in itself; or line, as a substitute for omitted tonal values (as a boundary between tonal values); or else contrasts of color values.

For in art, everything is best said once and in the simplest way. . . .

. . . May. Now, before the types have been cultivated in their pure state, the devil of cross-breeding already shows up again. Must I break off the struggle and return to the first position: "the brushstroke in itself?" The brushstroke at most in a few situations, but in no case so as to give the impression of mass!

. . . Limited palette: 1. white, 2. black, 3. Naples yellow, 4. caput mortuum, 5. and 6. Possibly also permanent green and ultramarine. And the grays need watching! A warm gray: Naples yellow-black. Cool gray: white-black (244 – 45).

37 • HANS HOFMANN
(1880 – 1966)

Hofmann was born in Germany and studied in Paris (1904 – 14), where he became a close friend of the painter Robert Delaunay. Hofmann opened an art school in Munich (1915), then emigrated to the United States, continuing the school in New York City during the winter and in Provincetown, Massachusetts, during the summer. Hofmann's teaching influenced Jackson Pollock, Clifford Still, and other artists of the Abstract-Expressionist generation. Largely eclipsed by his teaching, Hofmann's painting seeks a middle ground between the bravura brushwork of Abstract-Expressionism and the cool geometry of Mondrian.

He felt that color creates light in painting, a reversal of theory in the physical sciences, which holds that light creates (or is more important than) color. Hofmann's reasoning is consistent, however, with that of Maxwell and Matisse, both of whom point out that in vision, the effects we call light are perceived as variations of color.

From SEARCH FOR THE REAL

On Light and Color

We recognize visual form only by means of light, and light only by means of form, and we further recognize that color is an effect of light in relation to form and its inherent texture. In nature, light creates color; in painting color creates light.

In symphonic painting, color is the real building medium. "When color is richest, form is fullest." This declaration of Cézanne's is a guide for painters.

Swinging and pulsating form and its counterpart, resonating space, originate in color intervals. In a color interval, the finest differentiations of color function as powerful contrasts. A color interval is comparable to the tension created by a form relation. What a tension signifies in regard to form, an interval signifies in regard to color; it is a tension between colors that makes color a plastic means.

A painting must have form and light unity. It must light up from the inside through the intrinsic qualities which color relations offer. It must not be illuminated from the outside by superficial effects. When it lights up from the inside, the painted surface breathes, because the interval relations which dominate the whole, cause it to oscillate and to vibrate.

A painted surface must retain the transparency of a jewel which stands as prototype of exactly ordered form, on the one hand, and as a prototype of the highest light emanation on the other.

The Impressionists led painting back to the two dimensional in the picture through the creation of a light unity, whereas their attempt to create atmosphere and spatial effectiveness by means of color resulted in the impregnation of their works with the quality of translucence which became synonymous with the transparency of the picture plane.

Light must not be conceived as illumination; it forces itself into the picture through color development. Illumination is superficial. Light must be created. In this manner alone is the balance of light possible.

The formation of a light unity becomes identified with the two dimensionality of the picture. Such a formation is based on comprehending light complexities. Color unity, in the same manner, is identified with the two dimensionality of the picture. It results from color tensions created by color intervals. Thus the end product of all color intervals is two dimensionality.

Spatial and formal unity and light and color unity create the plastic two dimensionality of the picture.

Since light is best expressed through differences in color quality, color should not be handled as a tonal gradation, to produce the effect of light.

The psychological expression of color lies in unexpected relations and associations (73–74).

38 • FERNAND LEGER
(1881 – 1955)

Fernand Léger, a prolific designer and painter, was born in Normandy, France. Early in his career, he was associated with the Cubist writers and painters, but after 1916 he returned to painting the human figure, set in a mechanized world of pipes, cogs, and other appurtenances of industrial machinery.

Léger had visionary ideas about the use of color. In "Colored Space," he asks us to imagine a world transformed by the use of color and by the fusion of painting, sculpture, and architecture. But Léger's conception remains utopian. Housing projects are rarely remarkable for their use of color, streets are not blue or yellow, and apartment walls are still painted white more often than any other color.

From NEW YORK SEEN, 1931

. . . . In daylight New York is too severe; it lacks color and if the weather is grey it becomes a city of lead.

Why not color the buildings? In the country of inventions what kind of gap is this?

Fifth Avenue, Red—Madison, Blue—Park Avenue, Yellow? Why not? And the lack of grass? New York has no trees. Medicine decreed a long time ago that green, specifically, is the color indispensable to life; we must live in color. It is as necessary as water and fire.

. . . Clothing manufacturers could be forced to produce a series of green dresses, of green suits . . .

Every month the dictator of color will decree the monthly or quarterly colors; the blue quarter; the pink fortnight! Trees will be walked through the streets for those who cannot get to the country. Moving landscapes decorated with tropical flowers, dragged slowly by plumed horses (53).

From MODERN ARCHITECTURE AND COLOR

Colored Space

Color is a human need like water and fire. It is a raw material indispensable to life. In every period of his existence and history, man has associated it with his joys, his acts, and pleasures.

Flowers are brought into the house; the most common objects are colored—clothes, hats, make-up. In everything that calls for the decorative impulse in daily life it is color which is of the principal interest. Inside and out it is everywhere triumphantly imposed. Modern advertising has embraced it, and the roads are framed in violent colors that break the landscape; a decorative life is born from this dominating preoccupation. Therefore it is the function of color—static or dynamic, decorative or destructive—upon *architecture* which is the purpose of this essay. The possibilities for a re-orientation of mural painting should now be utilized.

A blank wall is a *dead, anonymous surface*. It will take life only from shapes or colors that will give it life or destroy it. A colored wall becomes a *living element*. This transformation of the "Wall" through color will become one of the most exciting problems of the new architecture. But before approaching the modern mural, color must first be set free. But how is one to liberate color? Before the developments in painting of the last fifty years a color and tone were bound completely to an object, to a representational form. A dress, a figure, a flower, a landscape was obliged to be of a certain color. Then—so that architecture could command it unreservedly, so that the wall could become a new field for experience—it became necessary to extricate and isolate color from the objects that held it prisoner.

It was about 1910 that Delaunay and I began to liberate pure color in space. Delaunay developed in his own individual way, keeping the relationships of pure complementary colors (it was really the continuing of a larger and more abstract approach than that of the neo-Impressionists). I was seeking my own way in the opposite direction,—avoiding as much as possible complementary relationships, and developing the force of pure local colors. I obtained rectangles of pure blue and pure red in the painting *Woman in Blue, 1912*.

In 1919, in *The City*, pure color incorporated into a geometric design was realized to the maximum; it could have been static or dynamic—the important thing was to have isolated a color which had a plastic activity of its own, without being bound to an object.

It was modern advertising-art that first understood the importance of this new quality,—the pure tone from the pictures took hold of the roads and transformed the country-side. A mysterious abstract symbol of yellow triangles, blue curves, red rectangles spread before the motorist to guide him on his way. This was the new object. Color was free; it had become a new reality the color-object had been discovered. It was at this time that architecture also learned how to use this free color both inside and out. Decorative wall-papers began to disappear. The white wall suddenly looked quite naked. An obstacle, a dead-end,—experience began to turn toward colored space.

The apartment that I shall call the "habitable rectangle" begins to emerge. The prison-sensation turns towards unlimited colored space. The "habitable rectangle" becomes the "elastic rectangle". A light blue wall draws away, a black wall advances, a yellow wall disappears. Three appropriate colors laid out in dynamic contrast will be able to destroy the wall.

Destruction of a Wall

New possibilities are unending. A black piano for instance in front of a light yellow wall produces a visual shock which can cut the rectangle in half. The visual and decorative revolution will be still stronger if we arrange the furniture in the apartment unsymmetrically. Our visual education is symmetrical Modern decoration can become entirely new if we use a-symmetry From a fixed dead arrangement, without play or fantasy, one comes into an entirely free domain. We have all been educated in this symmetrical tradition, and how heavy it is! The proletariat—along with the middle class—is still completely tied to this traditional order.

A simple anecdote will demonstrate the force of this habit. When I lived in the Paris suburbs I had in my room a very large piece of antique furniture on which I arranged some ornaments. I always enjoyed placing them unsymmetrically;—the most important object on the left, the others in the center and on the right. I had a maid who used to clean the room every day. When I came home in the evening she had always re-arranged the objects with the largest in the center and the others symmetrically placed on either side. It was a silent struggle between us which could have gone on indefinitely, because she considered that my ornaments were "in disorder."

Perhaps it would take a round house to obtain "space and the visual destruction of the wall." The angle is a geometrically resistant force which it is hard to destroy. Externally the problem is vaster but also more novel.

The external volume in architecture, the sensations of weight and distance, can be reduced or augmented through the use of color. A bridge can become invisible and weightless through color-orchestration. Thus the "exterior block" is open to attack as was the interior wall.

Why not undertake a multi-colored organization of a street,—of a whole city? During the first world war I used to spend my furloughs in Montparnasse where I happened to meet Trotzky and we often talked about the thrilling problem of a colored city. He wanted me to go to Moscow; the idea of a blue street, a yellow street aroused his enthusiasm. I think it is in the housing- projects, where the workers live, that the need of color is strongest for the creation of artificial space. Nothing has so far been attempted. The poor man's family could feel the freedom of space, even with a fine art-work on the wall. They are first of all interested in light and color. These are the necessities of life. It is free color that is essential to urban centers.

An urban-center: a gathering of 1500 inhabitants. A multi-colored problem inside and out. A graded arrangement of static facades leading perhaps to a pleasant court in the center,—and in this court possibly some spectacular monument, moving and luminous,—as important as the church which temporal catholicism has imposed so well upon every village. Free color will play its part with the new modern materials, and light will violently orchestrate the whole. Light and color can exert untold psychological influences. A modern factory in Rotterdam furnishes an instance. The old factory was blackened and sad. A new one was completed, light and many-colored. The result was as follows: without any remarks to the workers, their appearance became quite al-tered,—neater and more tidy—they felt that an important event had occurred of which they were a part. Color and light had created this new evolution. It is not an external act,—it can, through rational development, change a whole society.

Paris, the 1937 Exposition. The organizers summon several artists to think up some sensational point,—some spectacular effect that would bring in visitors and permeate the memories of strangers long afterward. I suggested *Paris Completely White*; I asked for 300,000 unemployed to clean and scrub the facades. Create a white and luminous city,—in the evening the Eiffel Tower, like an orchestra-leader, playing the most powerful projectors in the world upon the streets (airplanes could have cooperated in creating this new fairyland)! Loud-speakers would diffuse melodious music in key with this new colored world . . . my project was thrown out. The cult of the old patines, of the sentimental ruins, the taste for

ramshackle houses, dark and dirty but how picturesque! The age-old dust that covers moving recollections from history did not allow my project to be realized

The multicolored hospital,—cure through color—an unknown world that has begun to interest young doctors. Green and blue wards for the nervous and sick, others yellow and red to stimulate the depressed and anemic.

Color, like music, holds that magic which envelops truth. Men who love truth, who think of living with it in the raw, without retouching are rare indeed. Creators of all denominations know how difficult it is to use color, how dangerous it is to put on too much. Expressive force lies in truth. A work of art is a perfect balance between real and imaginary facts.

Pure color is more realistic than the half-tone; but most people prefer the half-tone.

Color is a two-edged sword; either it runs amock which it is unchained, without restraint, or it lightly envelops objects with an aura of good taste that we call the "decorative life."

The future certainly cries out for the collaboration of the three major art-forms—architecture, painting, sculpture. No period since the Italian Renaissance has understood this artistic collectivity. It is our own which must take up the problem again under a different aspect. The successive liberations which, since impressionism, have allowed modern artists to escape from the old restrictions (subject, perspective, imitation of the human body) permit us our own realization of entirely different architectural ensembles.

New materials, free color, freedom to invent, can entirely transform the problem and invent new spaces. Above all we must avoid the sickening profusion and heaping-up of art-works that made the Renaissance a period of unparallelled confusion.

Every day one hears the world "Beautiful." The Beautiful Bridge, the Beautiful Automobile, the attempts at beauty expended upon strictly utilitarian structures show the great human need to escape through art. We use the same term for a beautiful sunset; there is the same word for natural beauty as for manufactured beauty; so let us build a monument to the beautiful. Why not? We can realize it, using the freedom acquired in the major art- forms: color, music, form, all have been liberated. When we evoke former epochs that have produced so many magnificent temples the result expresses only the past civilization. It is unthinkable that our own will not realize its own popular temples. Architecture has at all times been the plastic expression to which the people of the world have been most sensitive,—the most visual, the most grandiose. It dominates perspective and halts the view. It can be aggressive or welcoming, religious or utilitarian. In each case it is at our disposal with as much freedom as ever.

The exaltation of 80,000 spectators at a football-match is not the end of a civilization. A temple for contemplation is as authentic a need as the great sport-spectacles.

To realize a "dazzling spot," to unite the sentiments behind the brilliant light-houses, the bell-towers, the religions, the need for verticality, the great trees, and the factory-chimneys. Enthusiastic man lifts his arms over his head to express his joy in the height. To make high and free. To-morrow's work (n.p.).

39 • T. S. ELIOT
(1888 – 1965)

The American-born poet T. S. Eliot was a student in the doctoral program in philosophy at Harvard University but did not return from England during the First World War to complete the requirements for the PhD. Eliot's dissertation on the British philosopher F. H. Bradley (1846 – 1924) was published many years later.

In Eliot's poetry, as in Dante's, color imagery is handled in the structured manner that indicates refined visual sensibility. The prose passage below on Bradley, though slight, is a bold statement on the nature of the experience of seeing color, and is more consistent with the ideas of Bertrand Russell or Goethe than with those of Newton or Plato. Newton assumed that colors seen because of, say, a blow to the eye could be ignored because they were subjective—because we only *believe* that we see these colors. Eliot does not subscribe to a distinction between subjectivity and objectivity, believing (as did Goethe) that we see colors or we do not, and no third condition exists in which we just "think" we see them.

Though Russell would have approved, Eliot's reasoning departs from that of Plato, who had given three conditions for color: (1) light, (2) a functioning eye (the eye of a living creature which is not blind) and (3) objects on which the light falls, and from which the light is reflected into the eye, where it causes a sensation of seeing colors—the colors of the objects from which the light has been reflected. These three conditions are classic, repeated with only slight variation for 2500 years and carried into the physical sciences as a basic assumption about the nature of color.

Eliot's conclusion implies that two of Plato's three conditions are not necessary. The experience of seeing color can be caused by light reflected from objects to an eye. But, as in Newton's example of colors seen after a blow to the eye, a functioning eye is able to have limited color experiences that are artifacts of its own functioning. A more modern example than New-

ton's might be, say, colors seen after taking psychedelic drugs, or even the darkness we see at night, which is not caused by light reflected into the eye from objects.

From KNOWLEDGE AND EXPERIENCE
IN THE PHILOSOPHY OF F. H. BRADLEY

. . . [A] "red object" is an object which is otherwise known than by the quality red; it is an object which has been given a determined place in an order. The sensation is an object which has not yet thus been placed. It is incorrect, then, to say that we can have sensations of redness; redness is a concept; or to say that we have sensations of red. The sensation is of a red *something*, a red spot or area. And the discovery that the cause of the sensation is a pathological irritation does not affect the objectivity of the sensation in the least. The red "that" was there, and the fact that the object can not be further defined and verified does not make it any the less object (62).

40 • HENRY P. BOWIE
(active c. 1911)

We regard many of our ideas about color as self-evident, a sign that they grow from associations shared by most persons in our society. Human beings who live in non-Western societies, and who therefore share a different set of psychological associations, might conceptualize differently. This possibility accounts for interest in, say, anthropological studies of non-Western color names and color theories.

Traditional Japanese painting, as Bowie reports, is highly systematized. Its methods evolved over a period of many centuries. Black is regarded as a color in Japanese painting, as one of the five parent colors. Its mixture with yellow creates dark green and its mixture with red creates brown. Some modern red pigments based on dyes (for example, rose madder) produce purples rather than browns when mixed with blacks. These pigments were not used in traditional Japanese painting.

From ON THE LAWS OF JAPANESE PAINTING

. . . There are eight different ways of painting in color. I will enumerate them, with their technical, descriptive terms:

In the best form of color painting (GOKU ZAI SHIKI) . . . the color is most carefully laid on, being applied three times or oftener if necessary. On account of these repeated coats this form is called TAI CHAKU SHOKU. This style of painting is reserved for temples, gold screens, palace ceilings and the like. *Tosa* and *Yamato e* painters generally followed this manner.

The next best method of coloring (CHU ZAI SHIKI) . . . is termed CHAKU SHOKU, or the ordinary application of color. The Kano and Shijo schools use this method extensively, as did also the *Ukiyo e* painters.

The light water-color method, called TAN SAI . . . , is employed in the ordinary style of painting *kakemono* and is used by the Okyo school.

The most interesting form of painting, technically called BOKKOTSU . . . , is that in which all outlines are suppressed and *sumi* or color is used for the masses. Another Japanese term for the same is *tsuketate*.

The method of shading, called GOSO . . . , invented by a Chinese artist, Godoshi, who lived one thousand years ago, consists in applying dark brown color or light *sumi* wash over the *sumi* lines. This style was much employed by Kano painters and for art printing.

The light reddish-brown color, technically called SENPO SHOKU . . . , is mostly used in printing pictures in book form.

Another form similarly used is called HAKUBYO . . . or white pattern, no color being employed.

Lastly, there is the *sumi* picture or *sumi e* . . . , technically called SUIBOKU, . . . where *sumi* only is employed, black being regarded as a color by Japanese artists.

A well-known method by which the autumnal tints of forest leaves are produced is to take up with the brush one after another and in the following order these colors: Yellow-green (*ki iro*), brown (TAI SHA), red (SHU), crimson (*beni*), and last, and on the very tip of the brush, *sumi*. The brush thus charged and dextrously applied gives a charming autumn effect, the colors shading into each other as in nature.

There are five parent colors in Japanese art: Blue (SEI), yellow (AU), black (KOKU), white (BYAKU), and red (SEKI). These in combination (CHO GO) originate other colors as follows: Blue and yellow produce green (*midori*); blue and black, dark blue (*ai nezumi*); blue and white, sky-blue (*sora iro*); blue and red, purple (*murasaki*); yellow and black, dark green (*unguisu cha*); yellow and red, orange (*kaba*); black and red, brown (*tobiiro*); black and white, gray (*nezumiiro*). These secondary colors in combination produce other tones and shades required. Powdered gold and silver, and crimson made from the saffron plant are also employed. The colors, excepting yellow, are prepared for use by mixing them with light glue upon a saucer. With yellow, water alone is used. In addition to all the foregoing there are other expensive colors used in careful work and known as mineral earths (*iwamono*). They are blue (GUNJO), dark or Prussian blue (KONJO), light bluish-green

(GUNROKU), green (ROKUSHO), light green (BYAKUGUN), pea green (CHAROKU SHO) and light red (SANGO MATSU).

The use of primary colors in a painting in proximity to secondary ones originated by them is to be avoided, as both lose by such contrast; and when a color-scheme fails to give satisfaction it will usually be found that this cardinal principle of harmony, called *iro no kubari*, has been disregarded by the artist. Color in art is the dress, the apparel in which the work is clad. It must be suitably combined, and attract no undue attention (*medatsunai*). True color sense is a special gift (43 – 45).

41 • JOHANNES ITTEN
(1888 – 1967)

The Swiss painter and color theorist Johannes Itten taught at the Bauhaus (1919 – 23) and later directed the Zurich School and Museum of Applied Art (1938 – 53). The color class Itten organized at the Bauhaus was widely imitated and has become a standard core class in most art schools and many university art departments. The best known of Itten's several books are *The Art of Color* (1961) and *Design and Form* (1964).

From THE ART OF COLOR

We speak of contrast when distinct differences can be perceived between two compared effects. When such differences attain their maximum degree, we speak of diametrical or polar contrasts. Thus, large-small, white-black, cold-warm, in their extremes, are polar contrasts. Our sense organs can function only by means of comparisons. The eye accepts a line as long when a shorter line is presented for comparison. The same line is taken as short when the line compared with it is longer. Color effects are similarly intensified or weakened by contrast.

The physiological problem of contrast effects lies in the special field of aesthesiology, and will not be taken up here.

When we survey the characteristics of color effects, we can detect seven different kinds of contrast. These are so different that each will have to be studied separately. Each is unique in character and artistic value, in visual, expressive and symbolic effect, and together they constitute the fundamental resource of color design.

Goethe, Bezold, Chevreul and Hölzel have noted the significance of the various color contrasts. Chevreul devoted an entire work to "Con-

traste Simultané." However, a systematic and practical introduction to the special effects of color contrast, with exercises, has been lacking. Such an exploration of the color contrasts is an essential part of my course of instruction.

The seven kinds of color contrast are the following:

(1) Contrast of hue
(2) Light-dark contrast
(3) Cold-warm contrast
(4) Complementary contrast
(5) Simultaneous contrast
(6) Contrast of saturation
(7) Contrast of extension

Contrast of hue is the simplest of the seven. It makes no great demands upon color vision, because it is illustrated by the undiluted colors in their most intense luminosity. Some obvious combinations are: yellow/red/blue; red/blue/green; blue/yellow/violet; yellow/green/violet/red; violet/green/blue/orange/black.

Just as black-white represents the extreme of light-dark contrast, so yellow/red/blue is the extreme instance of contrast of hue At least three clearly differentiated hues are required. The effect is always tonic, vigorous and decided. The intensity of contrast of hue diminishes as the hues employed are removed from the three primaries.

Thus orange, green and violet are weaker in character than yellow, red and blue, and the effect of tertiary colors is still less distinct.

When the single colors are separated by black or white lines, their individual characters emerge more sharply Their interaction and mutual influences are suppressed to some extent. Each hue acquires an effect of reality, concreteness. Though the triad yellow/red/blue represents the strongest contrast of hue, all pure, undiluted colors of course can participate in this contrast.

Contrast of hue assumes a large number of entirely new expressive values when the brilliances are varied. In the same way, the quantitative proportions of yellow, red and blue may be modified. Variations are numberless, and so are the corresponding expressive potentialities. Whether black and white are included as elements of the palette will depend on subject matter and individual preference white weakens the luminosity of adjacent hues and darkens them; black causes them to seem lighter. Hence white and black may be powerful elements of color composition.

The same exercises might be worked out in patches of color without preassigned shapes. However, this procedure would involve hazards. The student would start experimenting with shapes instead of studying

color areas and tensions. He would draw outlines, and this practice is hostile to color design and should be strictly avoided. In most exercises, we use simple stripe or checkerboard patterns

Very interesting studies are obtained if one hue is given the principal role, and others are used in small quantities, merely as accents. Emphasizing one color enhances expressive character. After each geometrical exercise is carried out, free compositions in the same kind of contrast should be attempted.

There are many subjects that can be painted in contrast of hue. The significance of this contrast involves the interplay of primeval luminous forces. The undiluted primaries and secondaries always have a character of aboriginal cosmic splendor as well as of concrete actuality. Therefore they serve equally well to portray a celestial coronation or a mundane still life.

Contrast of hue is found in the folk art of peoples everywhere. Gay embroidery, costume and pottery testify to primitive delight in colorful effects. In the illuminated manuscripts of the Middle Ages, contrast of hue was used in manifold variations, often not from motives of aesthetic necessity but out of sheer pleasure in decorative invention.

Contrast of hue is dominant also in early stained glass, its primordial force actually asserting itself over the plastic form of architecture. Stefan Lochner, Fra Angelico and Botticelli are among painters who have based compositions on contrast of hue.

Perhaps the grandest example of its significant use is Grünewald's "Resurrection," . . . where this contrast displays all of its universalistic power of expression.

So in Botticelli's "Lamentation" (in the Pinakothek, Munich), contrast of hue serves to characterize the all-embracing grandeur of the scene. The totality of hues symbolizes the cosmic significance of the epochal event.

Here we see that the expressive potentialities of one and the same color contrast may be widely diverse. Contrast of hue may alike express boisterous joviality, profound grief, earthy simplicity and cosmic universality.

Among the moderns, Matisse, Mondrian, Picasso, Kandinsky, Léger and Miró have frequently composed in this mode. Matisse especially uses it in still-life and figure paintings. A good example is the portrait "Le Collier d'Ambre," painted in the pure colors of red, yellow, green, blue, red-violet, white and black. This combination expressively characterizes a young, sensitive and clever woman.

The Blaue Reiter painters Kandinsky, Franz Marc and August Macke worked in contrast of hue almost exclusively during their early period (36 – 37).

42 • NAUM GABO
(1890 – 1977)

The Russian Constructivist sculptor and theorist Naum Gabo was born Pevsner, but changed his name to avoid being confused with his brother, the painter and sculptor Antoine Pevsner. Gabo's early work (c. 1915) was made of bent sheets of metal, wood, cardboard, and celluloid. Later he used aluminum, bronze, steel, gold wire, and glass. Gabo was an inventive experimenter whose first kinetic sculpture (1920) consisted of a 30″ steel blade that transcribed a volume in space when moved by means of a motor.

The brothers collaborated in issuing *The Realist Manifesto* (1920) and in designs for Diaghilev's Russian Ballet (1927). The *Manifesto* required, among other things, that sculptors not paint over the natural colors of materials, a rule to which Gabo did not always adhere. The special problems of color in sculpture are not addressed in *Of Divers Arts* (1962). Instead, Gabo emphasizes the psychological aspects of color and the schism between scientific theory and human experience.

From OF DIVERS ARTS

There are no general terms for any color. In the visual experiences of our consciousness, black, for instance, is not the absence (by absorption) of the seven visible colors of the spectrum, as science defines it. Obviously, such a definition fits any other color of the spectrum when we observe it isolated from the rest of the spectrum's colors; therefore, it defines nothing about our perception of black as a color. The scientific fact of absorption does not prevent us from having a vision of black as a positive color in its own right equal to any other

color. Many of our dreams are dreamed in color, including black; and dreams, as all the scientists of today agree, are not phenomena outside our consciousness.

Neither is the scientific definition of white as the reflection of all seven bands of the spectrum valid in an artist's vision. I have yet to be shown in actual fact the white of snow produced by mixing those seven bands of the spectrum. In the same way, the white of snow and the white of a cloud on a sunny day are not the same white as the white of a piece of Carrara marble or the white of a chrysanthemum; each of them conveys a different experience of white.

I should go out of my way were I to attempt to explain in words the multitude of attenuations that a color carries into our visual experience

What kind of image comes to our consciousness when we say "red?" To a scientist in his laboratory, red is only one thing, the stripe produced by the longest waves on the visible band of the spectrum of light. To me, to you, as well as to the scientist as a human being, when he gets his experiences of color from life and not from his spectroscope, it may mean either nothing at all or an endless chain of images of a multitude of color experiences (89 – 90).

All colors, even in their seemingly identical hues, have a different identity in our vision of them. One and the same color acts differently on different surfaces. Colors change with the change of their place in space or on a surface, and their identity also varies with the time at which they appear in the field of our vision. They change not only according to the neighboring color—a fact by now known to every schoolboy—but in relation to the frame of our vision and its axis, i.e., to right or left of the axis, and up or down from it

Color affects the bounds of the shape in which it is enclosed and changes the form of surrounding space; it modulates distances, retards or accelerates the rhythm of our visual perception.

Color is the flesh of our visual perception of the world, not its skin. A visual experience of color is never flat, it is enveloped in light, permeated by light; and wherever light is there is space (96 – 98).

43 • STUART DAVIS
(1894 – 1964)

Stuart Davis studied with Robert Henri, and exhibited in the Independents' show that included The Eight and other artists rejected by the National Academy of Design (1910). After the First World War, Davis adopted an abstract style influenced by Léger. Davis's *Eggbeater* abstractions (1927 – 28) are based on an eggbeater, an electric fan, and a rubber glove, the artist's sole subjects during that period. Foreshadowing the interests of the Pop artists during the 1960s, other paintings include imagery from packaging. Like Van Gogh, Davis envisioned the emergence of a new conception of the role of color in painting.

From STUART DAVIS

Conversation between Stuart Davis and James Johnson Sweeney

Today I have a concept of color which I never even thought of before. Now I think of it as another element like line and space. I think of color as an interval of space—not as red or blue. People used to think of color and form as two things. I think of them as the same thing, so far as the language of painting is concerned. Color in a painting represents different positions in space. In drawing with color up and across you have also drawn a certain distance in relation to the polar extremes of the constants of the color solid. Color conceived in this way becomes a space or length interval. If you have monotony in the length of these intervals you have monotony in color. I believe color relations are not merely personal but objectively true (33 – 34).

44 • GYORGY KEPES

(b. 1906)

The local color of an object is its general color, the color of first impression that we mention in casual conversation. We say, for example, that grass is green and lemons are yellow. But how bright a lemon looks depends on its environment. And no lemon looks exactly the same yellow over every part of its surface.

The Impressionists may have been mistaken in assuming that the shadows on a lemon look violet or violet-tinged. But certainly the parts of the lemon's surface in shadow look different from those more strongly lighted. Also, the colors of the lemon in morning light differ from its colors at sunset. And any part of the lemon seen against a blue plate will look subtly different from a part seen against a white wall (an example of Chevreul's law of simultaneous contrast).

Art students since the Renaissance have been advised to look beyond local color—to study the range of color subtleties that can be seen by looking closely at any object. A counter-theory popular among Modernists during the early twentieth century argues, in effect, that one can drown in subtleties and miss the forest for the trees. In one sense, lemons are not really yellow. In another sense, they are, because we always think of them as yellow.

Kepes turned the question of whether or not to ignore local color into an idiosyncratic theory of art history that identified the Renaissance as a disaster and cited science as the authority for this conclusion. (The argument that the Renaissance was a low point in art history remains the minority view, though argued on various grounds and with varying degrees of skill.) Kepes praised ancient artists for painting objects in their local colors, criticized Renaissance artists for doing otherwise, and urged Modernists to go beyond the shallow naturalism of the Renaissance.

Modern art, though Kepes argues otherwise, is not really a return to local

color, and an argument could easily be made that the conception of local color itself is of a relatively modern vintage. The Sumerians covered wooden carvings of rams and calves with gold leaf, and gave the golden creatures blue beards. The Egyptians painted men a different color than women. We cannot assume that artists who paid no attention to light effects would have painted objects in the colors we now identify as the local colors of those objects. More likely, as Kepes allows, the use of color in pre-Roman art mingled observation and symbolic associations.

From LANGUAGE OF VISION

Representation of the relationship of colors

Early forms of representation invariably showed the local color of the object in spite of changes in illumination, just as they retained the constant brightness value, the actual size and shape of the object, regardless of perspective distortion. In the painting of the Paleolithic man, Assyrian and Egyptian artists, Greek vase painters, early European painters, children and primitives, color stood in a clear symbolic role for the objects as a whole and was not overloaded with details of minute observations. The color-areas were not handicapped in their elementary sensory qualities.

The more precise the observation of the appearance of the object and the sharper man's ability to distinguish optical effects, the less the color-areas on the picture surface could function in full sensory intensity. Just as the size and form of the object were altered by linear perspective, so the local color lost its absolute reference to the object. Since the Renaissance, representational tendencies have been focused upon the exact portrayal of the modification of local colors by the effects of illumination. Light and shadow, the reflection of one color on another, the color of the light-source, and other optical modifications were carefully recorded as painters strove for accurate representation of the optical appearances of objects from one fixed point of view. Unconditional surrender to the appearances of the thing was an inevitable consequence, and through such submission to a shallow naturalism, the sensory quality of the colors was gradually drained out.

It is a familiar experience that the sensory quality innate in a sign, in a word, in an event, comes in time to be absorbed by the thing for which it stands. Only by repeating a familiar word over and over again, for instance, can one bring back into it the sensory quality of its sound, make it independent of context, and restore its original sensory intensity. One must look at a familiar landscape from a position which gives an unfamiliar retinal image of the familiar relationships of its component

objects if one is to sense the original intensity of the colors of that landscape. Only then will the colors, before embedded in their objects, be set free to speak in their own pure language, the language of the senses. The consistent search to represent all apparent aspects of the visible surroundings led, paradoxically, to the liberation of the sensory quality of color. In the control of the play of light on objects, painters had included the space between the objects in the object-world. They had widened the representational grasp of objects by including the atmosphere, the air, as a light-modulating substance. They were trying to represent with pigment the space-filling light.

This attempt to find an adequate articulation of reflected light on pigments that could match the living, vibrating, sensory richness of the transmitted atmospheric light—the new subject matter—led ultimately to a new basis of representation. The painters scientifically discovered the laws of color mixing. They realized that they could not represent the luminosity of the transmitted light of atmosphere by mixing colors in the ordinary way, by the subtractive pigment mixing. In the scientific researches of Chevreul and Helmholtz they found their answer: color could be mixed on the retina. The device they invented to create this optical mixture of color light on the retina was the breaking up of the previously smoothly modelled color surface onto small color dots or lines. These were combined in an order that fused them on the retina into a luminous quality. This innovation opened the road in two directions. One was the rediscovery of the color plane as the basic building element of the plastic image—in its embryonic form a color spot of the impressionist paintings. The other was the conscious application of the additive color mixing which made it clear that the image is man-made, that the human factor is an integer element in the image, and that representation of spatial experiences cannot be the facsimile of the spatial reality, but must be a corresponding structure based upon the human receiving set.

The actual result in painting, meanwhile, was in most cases merely a short-hand record of vibrating color effect. Visual experience was formulated only in terms of the eye as a physiological apparatus, and the picture was simply a replica of the color dots on the retina blown up in the scale of the picture-plane. Here plastic organization reached the zero point.

The Space Dimension of Color

But here also new directions of plastic organization were inherent. The color spot now lived its own true existence. It could be tested in various functions on the picture surface. Dissociated from fixed illumination, the color surfaces manifested first of all their intrinsic spatial value. This inherent space dimension of color was controlled and explored for

building solids on the surface. After long aberrations when color was used only as coloring, and indicated the color of an object, color now constituted the object. The weight and the bulk of the mass were modelled from and by the advancing and receding colors. Forms could now grow from colors, and the structural use of color be made to give a sense of spatial reality that no previous representational method had achieved. To make the colors work in this structural sense it is necessary to understand all their spatial actions. The interest of the painters since impressionism has been concentrated on the testing of colors in their advancing, receding, expanding, and contracting actions.

New significance now attached to the fact that colors are perceived on the picture surface in a dynamic interaction with one another, so that each color quality has only a relative value, because it undergoes modifications due to its interrelationship with other color surfaces. This research necessarily included learning how one color modifies the other by being placed next to it. It sought also knowledge of active and passive characteristics—when and how one color arrests the eye with a greater power than another. The more knowledge he acquired, the bolder the painter became in dissociating the color surfaces from the object-belonging. The color dots of the impressionist painters, through the color facets of Cézanne; the decorative color pattern of Gauguin and Matisse, reached full growth in the work of the cubist and attained a final purity and power in the work of Malevich and Mondrian (164–66).

45 • HILAIRE HILER
(1898 – 1966)

Because bright colors were associated with folk and tribal arts, for at least 200 years good taste was associated with subdued, neutral, or achromatic colors. Goethe believed that an aversion to bright colors was characteristic of persons of refinement. Generations of art students were taught, as was Van Gogh, that paint in bright colors should be modulated, never used directly from the tube.

In a paper read to an audience of technicians, Hiler arrived at a different conclusion. He lauded what the Du Pont Company elsewhere summarized as "better living through chemistry." Bright new chemical pigments, Hiler thought, were a gift from technologists, and failure to use these colors in undiluted form amounted to a failure to appreciate what had been given. Later, organizations such as Experiments in Art and Technology worked to forge links between technology and the arts. But in a number of well-publicized cases, artists became ill from using new materials, particularly plastics. And the broader question that Hiler thought settled—whether on balance technology has been beneficial or harmful to society—is still open and controversial.

From THE ARTIST AND SCIENTIFIC METHOD

What have science and technology done for the artist? Among other things they have furnished him with the most extensive, purest and most brilliant set of pigments he has ever possessed. How has he utilized this wonderful equipment? He has, claims a well known art dealer, been busily mixing these carefully purified and beautiful colors

back into mud ever since their invention. This extreme statement might perhaps be qualified but with probably too few exceptions to count for anything. Artists have made little use of a technique which would enable them to control and coordinate the rich possibilities offered. That technique is scientific method. For a number of reasons that method is particularly applicable to the field of color.

Dr. Martin Fisher stated the problem very accurately when he said, "we are primarily interested in the emotional response." We are interested in how the color looks or feels, and not in what it is from a chemical or physical standpoint. In other words, for the purposes of this discussion we're interested in the affect of color on human beings; color as a stimulus or sensation. Thus it must be studied in the field of affective or applied psychology. It must not be confused with the colored lights, additive mixture, terminology, or other considerations of the physicist.

Once the viewpoint of the psychologist has been well established, some very interesting and practical factors present themselves. It becomes possible to analyze and arrange one portion of the world of color in an orderly and rational manner. That portion of the color world is the one which is most interesting to artists. The terrain bounded by the possibilities and limitations of light-fast opaque pigments. This type of color has been most usefully defined as "related" color to distinguish it from the pure colors obtained by transparent slides or other colored media of the physicist. Color obtained by these means is called "unrelated" color.

When the considerations implied are borne in mind it will be found that the artist has been painting in terms of *pigment* and not in terms of *color*, properly speaking, at all. A pigment is a substance, organic or inorganic, natural or synthetic, which has been prepared for use as a coloring material. The sources of these materials are widely diverse and as a group or collection, any psychological or aesthetic relationship they may exhibit is purely fortuitous. Because of cheapness, stability, good working qualities, or tradition, some of these substances may have acquired a very important place on the painter's palette. They may come to occupy a preponderant spot in his mind. From a psychological standpoint it is necessary to bear in mind that a popular pigment may be quite dull, and therefore unimportant when considered from the view of its psychological impact on human beings; or, in other words, its potential importance as a color. It has been quite well established experimentally that dull colors have little affect on the observer as compared to bright ones.

Yellow ochre, red ochre, venetian and Indian red, raw and burnt sienna, raw and burnt umber, terre verte, English red, puzolles earth,

VanDyke brown, and the Mars colors may be considered as examples of important pigments. Their general dullness makes them comparatively unimportant psychologically as colors. Their relationship to the brilliant and powerful pure colors which have "shock" value, is, in general, very poorly established. They are, without exception, shades or tones, grayed down versions of the strong, bright hues, a fact of much potential importance to anyone wishing to handle colors as distinguished from pigments, to manipulate colors for their own sake and that of their relationship to each other.

Please make no mistake. This is not a plea for the use of more brilliant colors or an expressed desire to see artists paint in a higher key. It is a suggestion that a study of pigments as colors can lead to a much clearer concept of the place each should occupy in relation to the other. If we wish to paint in terms of color rather than in a hit or miss fashion, by continuing to use a more or less heterogeneous collection of pigments, our best approach is through analysis, order and the creation of a structure. These qualities can be considered basic technical qualifications in more than one field. "The artist without theory," said Leonardo Da Vinci, "is like the mariner without a compass." Gustave Flaubert claimed that the art of the future would be more impersonal, more scientific. After saying that all of us will be affected by international technology whether we like it or not, Irwin Edman of Columbia University goes on to say:

"The great significance of the sciences is the method of detachment, of objectivity, of integrity to follow an inquiry wherever it may lead, a recognition of the conditions of nature and life which if men are to live without illusion, they must understand and control."

"Without illusion!" This statement must be qualified, for we must all obviously have an illusion of some sort. When this illusion reaches a point where it is shared by very few people however it may be called a delusion. I think we would all agree that many artists, or so-called artists, have only a more or less tenuous connection with the world of every-day reality. We might further agree that in trusting less to the conviction of their own genius they might better this connection. In short, they could profitably employ some of the inquiring humility of the true scientist.

By the utilization of scientific method the contemporary artist will be enabled to create for himself a new instrument. This use of the intellect need no more stifle the "intelligence of the heart" or the capacity for feeling on the part of the painter, than the knowledge of harmony, counterpoint, and the rules of musical composition, stifle that of the composer in possession of a well tuned piano.

The means for the building of an ordered and tuned color instru-

ment for the painter are at hand. We are now able to measure color accurately, qualitatively and quantitatively. With such a basis we may proceed by methods similar to those used in any scientific field. The word method must be stressed, because, for some time to come we must utilize theory and hypotheses until more experimental control can be exercised. Any scientist will know that this situation does not invalidate our efforts. Much of the relationship which can be mathematically . . . established between colors is, at least philosophically, fully justifiable. Our efforts are not only preferable to the alternative chaos, but avoid a great part of the feeling of anxiety which may accompany a less systematized approach. They are not only in the direction of social comprehension and a general integration, but are a delightful form of activity inasmuch as they lead to more powerful control of our medium.

When we have put our house of color and the color in our house in order we are enabled to see relationship, directions, and harmonies clearly, which existed vaguely, if at all for us before. We will have created a grammar, a semantics, and a color vocabulary both literally and figuratively which will remove much of the anguish caused by a comparative difficulty in the expression of feelings which we have never been able to codify or exteriorize for lack of a socially acceptable method.

Color must be separated into categories, or classified psychologically according to its content of hue, or pure bright color, black and white. Such a classification gives us bright pure colors, light clear colors, dark clear colors . . . and light, middle and dark, *dull* colors. For our purposes there are no other sorts of related colors.

For practical application of this approach for those artists who may think it is of interest, the study of scientific method and its accompanying objective thinking must be advised. Once the more general ground has been covered, the painter may begin the actual construction and manufacture of a rationalized set of paints. These may consist of a minimum of seven pigments; a maximum of several hundred hues, tints, shades and tones, with the earth colors placed where they belong. The permanence of his materials varies roughly in inverse ratio to the brilliance of the pigments he may wish to use as his highest key . . . but it should be stressed that this may now be excitingly high and complete with comparatively little sacrifice to permanence. The importance of such a method is that the projective imagination is used in quite a different way when the colors need not be visualized beforehand but can be actually seen and compared. The mixing of intermediates up to the threshold is a simple matter. The very considerable time and labor necessary to such a complete and literal procedure is well spent. Much of the time will be recovered through less trial and error mixing. The

apparatus is very suggestive and has inspirational qualities, it lessens the resistance which many feel towards beginning work. The subtle difference in the actual painting whether it be design or representation must be tried to be appreciated

Many new and beautiful concordances and oppositions will be perceived when our materials are seen in their proper mutual relationships. In some cases a startling correspondence with beautiful natural phenomena, thus far but dimly appreciated, will be revealed. We have at hand the possibilities of an ordered instrument of great potential aesthetic power. These possibilities must not be considered as a mere extension or complication of the older palette any more than the invention of the percussion piano-forte was a mere extension of the Spinet or Harpsichord. The existence of highly saturated light-fast pigments in our time is in itself highly indicative of a social need. The new instrument, because of possibilities of ordered relationship made practicable by other contemporary techniques for color measurement, is different in *kind* as well as in degree. A thorough understanding of such considerations will be eventually responsible for the emergence of a new type of artist with a potential path opened to him for reintegration into a post-war world which we may hope will be beautiful and colorful as well as streamlined and hygienic (3 – 10).

46 • KARL KNATHS
(1891 – 1971)

Knaths, an American painter, was born in Wisconsin and settled in Provincetown, Massachusetts in 1919. First attracted to the Impressionists, he later found greater inspiration in Millet and earlier masters. Knath's metaphor, in the following excerpt is distinctively his own. He questioned the academic conception, set forth by Henri and others, that a painting ought to have a dominant tonality. Henri's "super color that envelops all others" could be interpreted, Knaths thought, as an oppression, a hierarchical dominance of one color over others. A grouping of colors, on the picture plane of a painting or elsewhere, should more reasonably resemble a democracy, with each color allowed its fullest opportunity for expression.

From NOTES ON COLOR

The perception of color is shown by science to be a historic process: A development of the color-sense through progressive stages of chromatic awareness, so that the productions of many painters may be termed atavistic even today. As their work exhibits only a rudimentary conception of color-relations, they are unable to utilize the full possibility of color as manifested by the most advanced sensibilities of today. Such advanced sensibilities may employ only a few grey tones but they will produce a full color-sensation. On the other hand, an artist insensitive to color may use every conceivable color, but without discrimination it would end in a discordant conglomeration that precludes any possibility of a homogeneous color-sensation. Such a sensibility is in reality only conscious of light and dark relations. As far as color is concerned,

it is in a condition—in the domain of color—analogous to anarchy in society where the individual does not exist in any state of responsibility to others.

The search for order would again be analogous to a primitive society, in which each individual feels himself more as a member of a tribe than as a distinct person. Thus he would conform to the tradition of the tribe, usually, as this was imposed by some person who had become aware of his individuality and secured the means to impose his will upon the others. It would by a tyrannic order in which a hierarchy would be established to confirm the will of the leader. This occurs in a similar manner in painting when all colors are made to conform to a predominating color. Thus colors foreign to the predominating color could not exist in their full individual intensity. Colors are marshaled into a tonality. The golden tone, the silver nocturne are examples of supreme oppression. Sometimes the opposition is relaxed by a more tolerant hierarchy where only the extreme opposition is entirely suppressed, or allowed a hint of its own existence. As knowledge of color-relation advances, the restrictions imposed by tonality are relaxed. As a free society is envisaged in which each individual can exist in his own right without interfering with the right of others, just so the restrictions imposed by tonality fall away and colors existing in their own individuality can be juxtaposed and into just relationship with each other. This is the domain of color proper and is exemplified in many examples of contemporary color use. Even where tonal relations appear, they are used in a new sense. An understanding of the various kinds of relationship possible to color is always needed. Proper opposition can thus be established. Determinate relations are immediately recognized and the possibilities of equivalence utilized in the same free way as they are managed in the other plastic elements (n.p.).

47 • FABER BIRREN
(1900 – 1988)

Birren, founder of the color consulting firm of Faber Birren and Company, was born in Chicago and studied color theory with Walter Sargent. He became one of the most widely published writers on color in English, though his point of view was far more conservative than Sargent's and of interest largely as a reflection of the ideas which were current in color styling during the 1940s.

The Bauhaus artists had envisioned a democratic environment in which color and design were used to create better lives for ordinary people. In practice, industrial color styling was often authoritarian and manipulative. It appealed to businessmen and advertisers who wanted to believe that certain colors or combinations could encourage workers to work harder, or induce consumers to choose a package in a supermarket without regard for the content quality.

Children were not exempt as prospective targets when control through color was promised. Birren argues, in "Functional Color in the Schoolroom," that environmental color can injure if excessively bright shades are used. The argument is similar to Vanderpoel's theory that certain color combinations instill discipline while others encourage psychological disarray.

From FUNCTIONAL COLOR
IN THE SCHOOLROOM

It may come as a surprise to some readers that there are forms of art in which personal taste and feeling are looked upon as irrelevant if not

objectionable. One of these is functional color: the purposeful use of color in schools, hospitals, factories and offices. The surprise is not that color is useful and desirable but that subjective judgments about it are likely to lead to failure in its use.

Functional color had its beginnings about two decades ago in the hospital field. At that time, technical advances in illumination had made possible high intensities of light which in turn had made the glare of white walls intolerable. It was obvious that a surgeon about to perform an appendectomy was less concerned with the esthetic aspects of his environment than with its visual ones. The eventual scientific choice of a soft green to complement the tint of human blood and tissues and to overcome distracting brightness was thus a matter of factual study, and it set the basis for an art of color in which rational rather than emotional factors could be reckoned with in measurable terms.

Functional color finds many interesting applications, many successes and failures in the school field. One may hardly doubt the favorable influence of a pleasant and cheerful environment. Yet it is one thing to make children happy and quite another to serve the best interests of child vision and child welfare. And schoolrooms that are attractive to adults do not necessarily lead to well-behaved and well-adjusted children.

It requires little imagination to realize that color may be as distracting and as annoying as it may be delightful. Uses of color based more on exuberance than on wisdom may actually disrupt the child's concentration by scattering his attention and defying his efforts to think, see or act coherently. It is in every way as difficult to read a book against the competition of bright color in the field of view as it is to listen to a teacher against the distraction of noise. Yet schoolrooms in which the use of color is curiously chaotic are being designed constantly. Children may love a circus, but this hardly suggests that school interiors should have the same ecstatic qualities.

Even a cursory study of the principles of functional color will make it clear that beauty is merely incidental to a job well done in the interest of more practical results.

First of all, the element of brightness is more important than the element of hue. Eyestrain is muscular, and abuse of eyes is fatiguing in the same way that the taxing of any muscle is fatiguing. In an environment that subjects the child to needless glare or to excessive extremes of brightness, a chain of reactions will take place. As the attention wanders about the room, the muscles of the pupil of the eye alternately expand and contract. In an effort to orient himself comfortably, the child may thrust his body about in an unnatural way. Thus eyestrain may lead not only to poor vision, but it may affect posture and have an

adverse effect upon the growth of young bones.

In a long series of investigations made by D. B. Harmon in Texas, a definite relation was found between faulty vision and other physical and psychological disturbances in a school child. "59 per cent of the Anglo-American children in the elementary schools have refractive eye defects or various disturbances that are affecting or distorting their visual sensations." Harmon found, for example, that 62 per cent of school children having low physiological development and low educational ages had visual defects.

In any event, a sober study of school children and school environments will stress the need for an objective approach to color rather than a subjective one. If art training is to be beneficial for young bodies and minds, it should be confined to the school curriculum and not carried so far as the walls and furnishings of the classroom. In brief, functional color must deal with the tangibles of eyestrain, posture, fatigue, visibility. These factors are to be served less (if at all) by guesswork or "taste" than by an approach based on research and sound technical practice.

It thus becomes apparent that artists, versed simply in painting, design and interior decoration, may not be capable of writing the specifications for the painting of a schoolroom until they have some knowledge of the psychology of the human eye and of the psychology of the average school-age child.

For example, it might be assumed that, in order to cope with the impetuous nature of children, the school environment should be a restrained one and that cool colors rather than warm will have the most tranquilizing effect. But a study of child psychology will show that nervousness may be aggravated by things passive. Nerves are more easily "set on edge" by monotony than by stimulation. There is no doubt that children in kindegartens and beginning grades should be given surroundings of warm colors, such as pale yellow, pink and peach.

Kurt Goldstein, eminent neurologist, has written: "A *specific color stimulation is accompanied by a specific response pattern of the entire organism.*" In the functional application of color there are certain basic reactions to be noted and advantageously applied. "One could say that *red is inciting to activity and favorable for emotionally-determined actions; green creates the condition of meditation and exact fulfillment of the task.*" The italics here are Goldstein's.

For one thing, the contention of some interior decorators that the color of a room should depend on orientation (warm colors for north exposure, cool colors for south exposure) becomes irrelevant. In fact, because schools are little occupied in summer, the factor of orientation is of no great consequence. It is far more vital that the color effect suit the age level and the task: a warm environment (pink, peach, yellow)

for the elementary grades where life is more or less dominated by emotion, and a cool environment (green, blue, gray) for the secondary grades where more mental tasks are undertaken. Practices such as these have been successfully tried and proven scientifically right as well as esthetically pleasing.

As to a suitable color palette for schools, in general such hues as ivory and pale yellow have been found excellent for corridors, stairwells and those rooms that are deprived of natural light but are not used for critical seeing tasks. These colors suggest sunlight, add apparent luminosity to existing light sources and offer an interesting sequence with other more subdued tones recommended for classrooms.

In the classroom itself, a number of colors and color effects have been investigated. In the main, the two best hues have been found to be pale blue-green and peach. Pale yellows and blues are likely to appear rather bleak and monotonous. Tones such as ivory, buff and tan lack character and are associated more or less with conventions of the past, which were based partly on economic factors. However, peach (a combination of yellow and orange with white) and blue-green (a combination of blue and green with white) have subtlety and beauty and have been used with good results for rooms occupied for long periods of time.

The treatment of end walls in color has also been proven successful. Since pupils are usually seated to face in one direction, the front end of the room may be treated in a slightly softer and deeper tone. Such areas serve a number of functional purposes. They provide visual and emotional relaxation, which rests the eyes and allows for better visibility. The appearance of the instructor and the exhibition of any charts or materials are improved, simply because it is easier to see lightness against darkness than darkness against lightness. In brief, the whole process of vision reacts quickly to light objects and surfaces and slowly to dark ones. The end-wall treatment assures the best in seeing efficiency and comfort.

Good colors for end walls are medium blue-greens; soft grayish blues; deep peach or rose tones. These may be variously handled. The medium blue-green end wall may have pale blue-green sidewalls, or peach sidewalls where a more vigorous effect is desired. The deep peach or rose end wall may be used with warm tones on the sidewalls, or complementary tints such as pale green or blue. One impressive device has been to color the side and rear walls in a neutral tone such as light pearl gray.

Also, blackboards may be surrounded by deep tones rather than light ones, to reduce contrast and minimize visual shock. Current developments will undoubtedly lead to the replacement of blackboards

by materials of lighter tone. This will mean greater lighting efficiency and will make possible the general use of lighter colors in the classroom.

Although color functionalism is a relatively new science, its progress has been rapid, for the benefits of its application may be definitely proven through research studies and clinical tests. While individual accomplishments in the fine arts are often difficult to evaluate, functional color stands or falls on its measurable results (136–38).

48 • RICHARD F. BROWN
(20th Century?)

The Impressionists said that their paintings were based on scientific theory, that the small spots of broken color would fuse by optical mixture and create a richer effect than the mechanical mixture of colors. Brown addressed the question of whether Impressionist theory really worked in their paintings.

From IMPRESSIONIST TECHNIQUE: PISSARRO'S OPTICAL MIXTURE

In spite of all that has been written on color and light in the theory and practice of impressionist and neo-impressionist painting, a great deal of confusion on the subject still exists. Many interpreters maintain that the so-called process of "optical mixture" is paramount in impressionist technique. In recent years, however, the tendency has been to minimize its importance; and, certain statements of the artists themselves to the contrary, some critics have denied that optical mixture had any place whatever in the technique actually used by impressionists. Thus, J. Carson Webster, in an excellent discussion of this problem entitled "The Technique of Impressionism; a Re-appraisal" (*College Art Journal*, Vol. 1V, November 1944), corrected many common errors about optical mixture but went too far in his principally negative conclusions, even denying that the artists themselves had a clear idea of what they were about.

Most of the contradictory points of view found in discussions on the subject have been reached by reading documents, such as letters or recorded statements of the painters, then deciding what is meant by

optical mixture, and then looking at the paintings to see if they substantiate the conclusions. A better understanding of the problem may result if we try first to define what is on the canvas, then to compare this with what we see in nature, and finally to relate these findings to the historical documents.

This method entails a certain amount of atomistic analysis of paintings which unfortunately tends to do violence to the kind of unity essential to a work of art. It also requires reliance upon a color system and a color terminology derived from the scientific study of color. The use of such a system and of what may seem an overly technical vocabulary does not mean that the painters whose works we study knew or painted according to this system or thought in this terminology, but that these are merely means by which we may describe the facts existing on the canvas and determine the principles of color vision involved in perceiving these facts.

The works of a single artist, Camille Pissarro, may be chosen as illustrative. Although he never exemplifies the extreme ideal of impressionism, as does Claude Monet, Pissarro's total stylistic development presents, as much as that of any single painter can, all the technical methods and stylistic concepts adopted by the impressionist school in general. Pissarro, as the most constant and inveterate experimenter of the entire group, thus serves as the best barometer of impressionist trends in technique and style.

In order to discover one of the specific factors in Pissarro's technique that contributes strongly to the effect of bright sunlight, for example (only one of his principal aims), we may analyze the tonalities he employed in two paintings that achieve this effect.

The Factory Near Pontoise, . . . painted in 1873, is typical of this period in Pissarro's development

. . . For the purposes of this discussion, the customary terminology will be used as follow: *value* to mean the degree of darkness or lightness in respect to the total amount of white light present; *hue* to mean the redness, yellowness, blueness and so forth; and *intensity* to mean the amount of hue involved.

Attempts have been made to represent such a concept of color by matching up specified positions in all parts of the theoretical tone-solid with actual samples of color. The systems most widely known and used are those of Munsell and Ostwald. It is instructive to try to match the separate touches of pigment of some of Pissarro's paintings with individual small samples taken from the Ostwald manual. Perfect matches can seldom be found, of course, because of the unavoidably limited number of samples in the manual; nevertheless, a judgment made by means of a carefully specified and standardized color system is cer-

tainly more reliable than one made independently by an eye subject to all the deceptions of surroundings, colors, changing illumination, etc. The use of such a standard enables us to make a more accurate check upon the range of color used by the painter.

In examining Pissarro's painting of 1873 in this manner, we are impressed by two facts. First, Pissarro uses as complete a range of values as possible. His actual pigments go all the way up to pure white and as far down towards black as they can while still retaining any appreciable amount of hue content. He uses a number of devices, such as abrupt contrasts of value or hue to make the whites seem whiter and the darks as deep as possible. Secondly, in nearly all the colors he limits his range of intensities to a surprising degree. In this painting, amazingly few of the smaller colored areas extend farther away from complete neutral than Ostwald's second step. This means that the intensity range is restricted, for the most part, to less than thirty percent of the total range that can be attained by ordinary oil pigments.

Ten or fifteen years later, the tonal scheme in the majority of Pissarro's paintings is reversed. In *Spring Pasture*, for example . . . hardly a touch of color goes more than halfway down towards black from white, and most of the strokes of individual color are quite intense

What are the reasons for this variation in color scheme? They are, of course, infinite. But how does each tonality contribute to the effect of bright sunlight? Even in this lesser question there are a number of factors, but we may choose one as an illustration, that of surface reflectance of neutral light.

Any colored object in light reacts, in relation to the eye, in accordance with its inherent potentialities of hue, intensity and value. In total darkness, therefore, any object may be thought of as being at the zero point of value, hue and intensity . . . that is, invisible, If it is brought out into the light of a room, it will move up in value and out towards a fuller intensity according to its specific hue If taken to the window, its intensity and value will continue Outside in the bright sunlight, it will reach its maximum intensity When the illumination is increased, however, something else happens in addition to the selection of wave lengths or the partial absorption of white light. That is, the object not only acquires its color, but causes a certain amount of illuminating light to bounce off the surface of the object without being partially absorbed or selected. This neutral surface reflectance tends to increase in direct ratio to the amount of illumination and has the effect of neutralizing the color beneath it. Hovering over objects in strong illumination, this reflectance contributes very strongly to our realization of the presence of both the envelope of atmosphere around objects and the dominating light source itself. The critic Duranty recognized this

phenomenon in his apology for *La nouvelle peinture*, written in 1874, when he said that the most important single contribution of impressionism to date was its recognition that "great light" neutralized all things. This explains at least partially the tonality of Pissarro's painting of 1873.

What about *Spring Pasture*?

By raising all the values and extending the intensities, Pissarro was trying to increase the total *volume* of light coming to the eye—in other words to approximate more closely the total amount, or impact, of light that the eye would receive from the scene in nature. Oil pigments cannot, of course, compete with the strength of sunlight just as even an extended value scale in pigments cannot achieve the degrees of contrast that the eye experiences in looking at nature. In the more traditional handling of tones . . . the shadows, half-shadows and lights maintain on an unavoidably reduced value scale the same relative positions as the corresponding tones in nature, and thus a sense of reality is conveyed

. . . An increase in light enables any object to increase its selectivity of wave length of its specific color. Which does the eye perceive—the greater intensity of color, or the greater amount of neutral surface reflectance? Both: variations in angle between our eye and the objects, differences in angle between the light source and the objects, differing atmospheric conditions near the various objects, differences in our attention towards the scene before us, differences in our knowledge of the many objects before us and so forth, usually result in a fluctuation between the intense color of the objects and their neutral surface reflectance. Obviously, a palette using only the relatively neutral tones cannot represent this visual experience.

Although from the standpoint of pure physics the intensities could be pushed to extreme degrees by an increase in illumination, the limitations of the human eye make this *visually* unappreciable. The eye will remain sensitive to different hues and intensities up to a certain point; beyond this, any further amount of light fatigues the receptors which make distinctions of hue and intensity possible, and a whitish or neutral glare appears upon objects. The eye, however, constantly renews its efforts to identify the hue and intensity of the objects it perceives, and therefore in brightly illuminated scenes some degree of fluctuation between intensity and neutrality results from this limitation of the adaptation level of the eye. Here again, a painting in restricted intensities cannot reproduce this visual experience.

To achieve the scintillating, sunlit effect that fascinated Pissarro, the full intensity of objects, combined with the neutralizing effects of brilliant illumination, must somehow be expressed in paint.

In order to do this, Pissarro in at least one phase of his work kept his individual touches of pigment at fairly full intensity and modulated this intensity by juxtaposition of tones, thus maintaining a greater total volume of light coming from the painting to the eye of the observer. To be sure, he used in this type of work a great many touches of pure white pigment, which has the desired dual effect. The small spots of neutral white are interpreted as surface reflectance or glare, but beside them, in accordance with laws of simultaneous contrast, the touches of color seem more intense than they would beside tones of a lower value. The intensity of the larger areas is enhanced by placing yellow-green trees against blue sky, or reddish earth against blue-green grass, or similar arrangements whereby simultaneous contrast between more or less complimentary hues increases the intensity of each. Within these larger areas, however, depending upon their position in the scene, Pissarro restricts the hues to those that are very close to each other on the hue circle

In 1888 the American critic, William George Sheldon, asked Pissarro to define impressionism. Pissarro answered that there were two main principles: don't mix pigments; study the complementaries. He added that any student could comprehend the theory within a few minutes but that to achieve harmony and representation through its mastery took years of painting. He also said that what the impressionists sought above all was to study what they saw in nature.

The optical mixture practiced by the impressionists, therefore, does not necessarily mean the fusion of blue and yellow to achieve green (which is impossible), or even the fusion of red and blue to achieve violet (which is hard to illustrate by examples). Recent criticism has disposed of these fallacies quite effectively, but in doing so has gone too far in denying any place whatever to so-called optical mixture. An attempt to discover from their *paintings* what the impressionists meant by this term leads us to conclude that they understood what they were doing and had good reason for doing it (12 – 15).

49 • HERBERT AACH
(1923 – 1985)

Aach, an American painter, was born in Germany and studied at the Art Academy of Cologne. He came to the United States in 1939 and studied painting and color theory at Pratt Institute, the Brooklyn Museum School, and Stamford University. He worked as a consultant to the Sargent Art Materials Company and later taught at Queens College, where he served for a period as Chair of the Art Department.

From INSIGHT OUT

Gestalt of the Eye

John Ferren considers himself old fashioned in his use of oil colors as compared to those who use water-based polymer paints. Thus because of molecular structure—oil is large and tends to range from translucent to transparent; water is small, tends to pack tighter and, therefore, ranges from translucent to opaque—he maintains a luminous quality. This is much more associative to the maintenance of illusion, as compared to the water media's relative flatness. Yet proper manipulation could induce a characteristic similar to oil. Or, oil could take on a water look simply by the addition of a flattening agent like diatomaceous earth. Ferren achieves a masterly immaculate surface, although oil is much more difficult to handle flatly than the polymers. It is possible to enter his surfaces as one would enter a mirror, in comparison to Noland or Kelly, whose surfaces act like stop signs and prevent penetration. Olitski's recent surfaces fall half way in between. His spray-application tends toward a greater translucency, a

greater potential for illusion.

With technological innovations and improvements over the last 50 years, deterioration of color has been eliminated, in many instances, or slowed almost to imperceptibility. Yet longevity of color had been a calculated risk from the days of Rubens. It is no mere coincidence that the heightened use of color by the Impressionists coincides with the advent of the industrial revolution. Its usage as such has been rising since then, and a good case can be made that we are now at the threshold of an age of color. As such, John Ferren is one of the pivotal figures.

In an age that acknowledges the present and disavows the past, it is not at all surprising that painters also have cut themselves off from previous traditions. In color, the dry, matter-of-fact look permeates Noland, Louis, Kelly, etc. Yet the French look remains very much in Rothko, Gottlieb, Newman and even Reinhardt. The former are becoming more and more painting-as-object oriented, possibly due to a conflict of color-as-codex or color-as-environ. At a time when the end of painting is proclaimed, it is most encouraging to see Ferren carry forth. While his surfaces still eminate (sic) a French sensuousness, their *raison d'être* is uniquely American. The approach in his triptych is modular without the tiring repetitive look. And because of the emanation of its color, aside from a provocative religiosity, it suggests an environmental growth, an infinity, not like the long flow of Noland's stripes, but as continuity of experience. Anything that is relatively new requires new technical description and an effort of new eye alignment on the part of the spectator. Essentially each color area is, in itself, a space volume. As such, columns and lines, aside from their usual attributes, are basically condensed, therefore directed, space volumes, not differing or conflicting in the form/line sense. Thus space definition is no longer a function of the interaction of two hues or more at their edge meeting.

The temptation at first glance to categorize Ferren's paintings into the decorous hard-edge mold is tantamount to totally missing them. Penetration is required. It is simply structured color, possibly akin to the middleness of oriental music. In the triptych, each module produces its own rhythm which echoes in or to each other. Line is volume as well as demarcation, and placing in time related to musical interval, the melodic jumps of atonality. A variant of this is to be seen in *Bypass*. A strong red radiates outward from the center and echoes toward the periphery, a thematic repetition. In black and white this line volume created tension will just go flat.

We have entered into an age where perception in itself is becoming instrument and the gestalt of the eye a means of control. Op was a crude beginning. This is most effectively seen in *Duo*, where there is a dominant color volume, one for each eye. Place a hand or piece of paper between

your eyes and the same phenomenon maintains itself. The left one is an ovoid blue green, the right a rectangular red—sufficiently non-complementary to each other to become dissonant. A darkish blue ground acts as nothing but an interval. Towards the left vertical end of the painting is a blackish line volume that at first seems totally arbitrary. Just at the point when this severing of the eyes is about to become painful, this device tends to force refocusing and allows release, a discharge. What remains of the mandalas can no longer be considered an image or of symbolic significance. Yet the function of playing curve against straight remains, making one wonder what the next step will be. The work in its entirety exhibits a profound orchestration of color, Wagnerian without the bombast (66).

50 • AD REINHARDT
(1913 – 1967)

Reinhardt was known for his art, his wit, and his broad knowledge of Asian art. His black paintings were first shown in 1960. Each consists of a 60-inch square of stretched canvas divided into nine smaller (20″ x 20″) squares. Each of the nine smaller squares is painted a different shade of near-black. From a distance, each painting appears to be a single tone of black, a reductionism that influenced the Minimalists and the color-field painters.

Though Reinhardt explained the black paintings differently, they draw on the pictorial logic of Matisse's *Red Studio* (in that each includes a large area of a single color) and the color theories of the Impressionists. Optical mixture, difficult to achieve when the color areas meant to mix differ greatly in hue or value, occurs easily if all areas are sufficiently dark in value.

From ART-AS-ART:
THE SELECTED WRITINGS OF AD REINHARDT

Black as Symbol and Concept

I once organized a talk on black, and I started with black as a symbol, black as a color, and the connotations of black in our culture where our whole system is imposed on us in terms of darkness, lightness, blackness, whiteness. Goodness and badness are associated with black. As an artist and painter I would eliminate the symbolic pretty much, for black is interesting not as a color but as a non-color and as the absence of color. I'd like then to talk about black in art—monochrome, monotone, and the art

of painting versus the art of color. Here is a quotation from Hokusai: "There is a black which is old and a black which is fresh. Lustrous black and dull black, black in sunlight and black in shadow. For the old black one must use an admixture of blue, for the dull black an admixture of white, for the lustrous black, gum must be added. Black in sunlight must have gray reflections." I wanted to read that because that doesn't have any meaning for us.

I might, also, touch on some religious aspects of black, because I've been called a number of names like "the black monk" and so on. I suppose it began with the Bible, in which black is usually evil and sinful and feminine. I think a whole set of impositions have affected our attitudes toward white and black—the cowboy with the white hat and white horse, and the villain with the black gloves. And then the use of black all the way through the Bible, through Chaucer, Milton, Shakespeare, and a few others. Even in terms of color caste there are blacks and coloreds, what Harold Isaacs in *Encounter* once called a yearning for whiteness in the West, like high yellow and so on. There is a relation in Christianity to the black hell void and the white heaven myth, the blackness of darkness that is involved with formlessness or the unformed or the maternal, the hidden, guilt, origin, redemption, faith, truth, time. Black can symbolize all those. There's the black castle and the black knight; and I suppose in one way or another they all represent transcendency, which is interesting. And Lao Tse, "The Tao is dim and dark," and the Kaaba, the black cube in Mecca; there's the black rock in the dome of the rock in Jerusalem, and what the medieval mystic Eckhardt called the Divine Dark. But, as an artist, I wanted to eliminate the religious ideas about black. In art, of course, we've had monotone traditions in China. The chiaroscuro tradition is non-coloristic in the West. Negative—again that's a term like black; but the idea of negativity is not a bad idea any more, whereas once the positive seemed great and the negative seemed terrible. It's the negativeness of black, or darkness particularly, in painting which interests me. When you get into the dark-and-light experience in other fields, I think that would be something else.

I want to stress the idea of black as intellectuality and conventionality. There's an expression "the dark of absolute freedom" and an idea of formality. There's something about darkness or blackness that I don't want to pin down. But it's aesthetic. And it has *not* to do with outer space or the color of skin or the color of matter. As a matter of fact, the glossier, texturier, gummy black is a sort of objectionable quality in painting. It's one reason I moved to a sort of dark gray. At any rate its's a matte black. And the exploitation of black as a kind of quality, as a material quality, is really objectionable. Again I'm talking on another level, on an intellectual

level. [Shiny black] reflects, and it has unstable quality for that reason. It's quite surreal. If you have a look at a shiny black surface it looks like a mirror. It reflects all the activity that's going on in the room. As a matter of fact, it's not detached then.

The reason for the involvement with darkness and blackness is, as I said, an aesthetic-intellectual one, certainly among artists. And it's because of its non-color. Color is always trapped in some kind of physical activity or assertiveness of its own; and color has to do with life. In that sense it may be vulgarity or folk art or something like that.

Clive Bell made it clear that there was an aesthetic emotion that was not any other kind of emotion. And probably you could only define that negatively. Art is always made by craftsmen—it's never a spontaneous expression. Artists always come from artists and art forms come from art forms. At any rate, art is involved in a certain kind of perfection. Expression is an impossible word.

If you want to use it I think you have to explain it further. . . . Cultures in time begin to represent what artists did. It isn't the other way around. There was an achievement in separating fine art from other art. In the visual arts good works usually end up in museums where they can be protected (86–88).

51 • EDWIN H. LAND
(b. 1909)

Red, orange, and yellow are called warm colors, while green, blue, and violet are called cool, a difference that can be correlated with wave length (warm colors have longer wave lengths, cool colors have shorter wave lengths). A famous experiment by Edwin Land, inventor of the Polaroid camera, suggests that a basic difference exists between long and short wave lengths in the visible light range, a difference imperfectly explained, if explained at all, in color theory as we know it. Beyond this, Land's fascinating and controversial experiment is open to many interpretations. He made two black and white slides of a scene. The first was photographed through a red filter passing waves lengths longer than 585 millimicrons, the second through a green filter passing wave lengths shorter than 585 millimicrons. The slides were projected in register (aligned one on top of the other) on a screen, respectively through a red filter and a polarizing filter. All colors appeared, and when the polarizing filter was rotated, each color changed to its complement.

From VISUAL PROBLEMS OF COLOR

Color Vision and the Natural Image

We have come to the conclusion that the classical laws of color mixing conceal great basic laws of color vision. There is a discrepancy between the conclusions that one would reach on the basis of the standard theory of color mixing and the results we obtain in studying total images. Whereas in color-mixing theory the wave-lengths of the stimuli and the energy

content at each wave-length are significant in determining the sense of color, our experiments show that in images neither the wave-length of the stimulus nor the energy at each wave-length determines the color. This departure from what we expect on the basis of colorimetry is not a small effect but is complete, and we conclude that the factors in color vision hitherto regarded as determinative are significant only in a certain special case. What has misled us all is the accidental universality of this special case.

It was scientifically proper to base our earlier hypotheses about the functioning of the eye on our knowledge from this special case. Now, however, these recent experiments show that the special case is extraordinarily restrictive: The eye will see color in situations entirely unpredictable on the basis of older hypotheses Thus it may be necessary to build a new hypothetical structure to explain the mechanism for seeing color. The purpose of this paper, however, is not to discuss internal visual mechanisms, but rather to begin the description of the laws for a large *general* case—laws describing the relationship of the sense of color in the human eye to the structure of *total images*, laws in which wave-length of stimulus and intensity of stimulus will play entirely new roles.

APPARATUS

For these experiments two black-and-white photographic positive trans-parencies are made in a split-beam camera, so that they are taken at the same time from the same viewpoint through the same lens One is taken through a Wratten No. 24 [red] filter, passing wavelengths longer than about 585 [millimicrons] . . . , and one through a Wratten No. 58 [green] filter, passing wave-lengths shorter than about 585 [millimicrons]. These two photographic records will be referred to hereafter as the "long record" and the "short record," respectively. The picture is exposed so that the gray scale appears to have the same densities in both records.

The two records are projected in a double-lens projector and su-perimposed exactly on a screen by means of a registration system. In front of each lens is a pair of polarizers mounted so that the intensity of the light in each beam can be varied separately. In projecting, the long record is projected ordinarily through a red filter (Wratten No. 24), and the short record through a neutral density filter of about 0.3 (when the polarizers are not being used). The half of the projector containing the long record will be referred to hereafter as the "long projector," and the other as the "short projector."

CHROMATIC PHENOMENA

The experiments demonstrated were the following:

Experiment 1.—The double projector is turned on, a filter transmitting red (Wratten No. 24) is placed over the lens of one projector and the polarizers are rotated to change the observed color of the screen from full white to full red, traversing the various shades of pink in between. Thus the screen is seen in the colors expected on the basis of classical color theory.

Experiment 2.—The red filter is removed, and the two components . . . are shown separately by occluding first one of the projectors and then the other, so that the audience may see the two black-and-white images produced by the beam-splitting camera. The differences to be expected in any color-separation photographs between the picture taken through the red filter and the picture taken through the green filter are pointed out to the audience.

Experiment 3.—With the short projector occluded, the long record is shown projected through the red filter. Then the lens of the short projector is uncovered so that the black-and-white picture is combined with the red picture. Instantaneously the portrait appears in full color: blonde hair, pale blue eyes, red coat, blue-green collar, and strikingly natural flesh tones. (While it is not the primary purpose of these experiments to achieve verisimilitude, one is impressed by the frequent acceptability of this and many of the other pictures as lovely color photographs.)

Experiment 4.—The room lights are turned on full, flooding the screen with light, and it is shown that there is no visible time lapse between snapping off the lights and the appearance of full color in the picture.

Experiment 5.—The room lights are brought up from darkness to a medium level at which objects in the room can be clearly seen in color, but at which there is not so much light that the picture is washed out entirely. It is shown that the eye sees color in the room and color on the screen at the same time and that, furthermore, the colors on the screen are not changed by having the surrounding room illuminated in white light. This experiment gives the first premonition that multiple color universes can coexist side by side, or one within another.

Experiment 6.—In this picture . . . the audience is to compare the pink states on the map with the yellow pencil; and the yellow pencil with the white pencil and the white marmalade jar which holds the pencils. It is pointed out that since classically all the colors on the screen would be pink, it is particularly important to note the difference between the pinks and the yellows and equally important to notice the strong sense of whiteness in the white objects. This is the first demonstration that it is not necessary to use traditional complementary colors to produce white, a fundamentally important fact in the image situation. The green-blue color

of the large book entitled *Bartlett's Familiar Quotations* is contrasted with the deep-blue stripe on the air-mail letter, as well as to the blue tax stamp and the pale blue ocean on the map. The gamut of colors in this picture includes also the brown wooden box, the green blotter, the black inkstand, and the red lettering on the magazine. It is pointed out that this slide demonstrates dramatically that the transition from one stimulus (here, either red or white) to two (here, red *and* white) is the tremendous step: the full gamut of color appears. (The addition of a third stimulus does enrich the colors somewhat, but we do not know whether what is missing is due to inadequacy of technique or to the need of a little help from a third stimulus.)

Experiment 7.—A colorful, picture, notable for the auburn red hair and the green sweater, is used to show that the field that counts in the image situation is not determined by angular subtend. The observer finds the sweater to be green even when he stands so close to the screen that the sweater fills a large portion of his field of view; and he also finds the sweater to be green when the image is made small and the observer is at a distance from the screen.

Experiment 8.—The same picture is shown with the red filter placed on the short projector, and with no filter on the long projector, except that the polarizers are turned to give the best color. The sweater is now reddish and the hair greenish, and the lips an intense blue-green, illustrating the phenomenon of hierarchical reversal, usual, to be sure, in any color photography system but particularly important here because it demonstrates that the colors are independent of what the observer expects, and that the system, in spite of use of the new "arbitrary" primaries, behaves like any system of color reproduction.

Experiment 9.—A slide is shown in which there are twelve colored objects photographed against a gray background divided into twelve numbered squares . . . It is pointed out that, except for the orange on square No. 2, each object could appropriately be any color, so that there can be no prior association between the name of the object and the name of the color of the object; thus one would not know that the telephone is red, the paper stapler gray, or the design of the teacup, on square No. 12, dark blue. It is pointed out that this slide has been used to interrogate naive observers and that, except for the color-blind, marked consistency was found in their reporting of the color names.

Experiment 10.—Using the same standard-objects slide as for Experiment 9, a pair of polarizers is placed in position in front of each projector, the relative brightness is varied from the position in which only the red image shows, to the position where just the white image shows. The audience is asked to indicate the two extremes at which color first appears; that is, with only the red image on the screen, the white is slowly

added, and the colors at the point where they first appear are noted. Then, with only the white image on the screen, the red is slowly added, and as the colors appear they are again noted. It is pointed out that when color does appear at both extremes it appears at the same time for all the objects on the slide. It is demonstrated that the ratio of stimuli can be varied enormously—with some pairs of stimuli by ratios as high as 100 to 1—without altering the color name given to each one of the objects.

Experiment 11.—In this experiment a duplicate of the short record is superimposed on the short record already in the projector, thus doubling its contrast. A single long record is used, so that it has the original contrast of the previous experiments. Thus for the short record in places where, in the previous experiments, a fifth of the light was transmitted, the slide now transmits a twenty-fifth; in places where a tenth was transmitted, the slide now transmits a hundredth; in places where all the light was transmitted, the slide now transmits all the light. Since no change was made in the long record, the same amount of light is transmitted by it as was transmitted in the earlier experiments. It follows, therefore, that for each object on the slide there is now a new ratio of long to short stimulus, and it would be expected classically that each object would now be a new color. Actually, the objects retain their original color names, demonstrating the stability of the colors of an image with respect to the contrast of the component images, and illustrating further that color is independent of the quantity of the stimulus defined locally. It is pointed out that we must not let the casualness of the statement that we have doubled contrast in one image without doubling it in the other obscure in our minds the amazing fact that utterly new pairs of ratios give the same colors in the same places.

Experiments 12, 13, 14, and 15 are designed to demonstrate further that color at a point in an image is independent of the wave-length composition of the radiation coming from that point. While with changes of filters there is a slight over-all wash of color in extended background areas, objects retain their original color identity. (Many of the audience sitting off the axis of the projector are unable to witness the following four experiments because of the extremely low light level resulting from the dark filters.)

Experiment 12.—A slide showing multicolored groceries on a table top . . . is shown with Wratten No. 24 [red] and no filter on the one hand, and on the other hand with Wratten Nos. 24 and 58 [green].

Experiment 13.—A bowl of fruit on a table top . . . is shown with Wratten No. 70 [deep red] . . . and Wratten No. 73 [dark yellow-green]

Experiment 14.—The slide in Experiment 13 is shown with Wratten No. 73 and Wratten 49B [dark blue]

Experiment 15.—The same slide is shown with Wratten No. 47B [dark blue] . . . and no filter.

Experiment 16.—It is demonstrated to the audience that the filter Wratten No. 73 which passes a narrow band of yellow may be used as a shorter member of a wave-length pair, and as a longer member of a wave-length pair, depending on what is picked to go with it. (*Note*: Experiments 13 and 14.)

ACHROMATIC PHENOMENA

Experiment 17.—Three identical black-and-white transparencies are used, two in superposition on each other in one projector, one in the other projector. These are projected with red and green filters, and the question arises: What colors should one expect? One expects color for two reasons, either classically because of the varieties of ratios of red to green or in terms of our new approach because the numerical value of many of the ratios are equal to ratios which existed in the image which showed color in Experiment 9. Actually, one finds that the whole slide is uniform in color and nearly colorless, even though many of the ratios of stimuli for the various objects are the very ratios that existed when the slide appeared in full color.

Experiment 18.—The short record is placed in the short projected and no record is placed in the long projector. One sees the wash of red light over the image from the short projector. The polarizer on the long projector is varied over its range. In spite of the fact that all possible ratios of stimuli have been on the screen, there appears only a uniform wash of the colors in their classical mixtures.

Experiment 19.—Another class of achromatic phenomena is introduced by this experiment in which a photographic step-wedge, running horizontally, is placed in one projector, and a step-wedge, running vertically, is placed in the other projector. Thus, in superposition on the screen, the wedges create 256 possible ratios of the two stimuli, arranged, however, in a geographically systematic way. The colors mix only in a classical sense, red and white giving a vague pink, and red and green showing some red, some green, and some yellow.

Still another class of nearly colorless situations is exemplified by Experiments 20 and 21.

Experiment 20.—The map slide . . . is projected with the long and short record far out of registration. The gamut of colors is strongly restricted. While going beyond the classically expected colors, there is only the smallest suggestion of the new colors which here are few and unsaturated. The images are slowly brought into registration. At the instant of perfect registration, the full gamut of color snaps into appearance.

Experiment 21.—A picture of one scene is placed in the long projector, and a picture of a different scene is placed in the short projector. The

limitations on color are similar to those in Experiment 20: there is almost none.

A NEW CO-ORDINATE SYSTEM

A new co-ordinate system is shown which describes color in images and which predicts the achromatic situations (Fig. [1]). A remarkable thing about the new co-ordinate system is that it is physically dimensionless, involving a ratio of ratios and holding constant an arbitrary pair of wave-lengths. In this co-ordinate system the percentage of available short-wave stimulus is plotted against the percentage of available long-wave stimulus The first message of the co-ordinate system is that color in an image is indeed independent of the over-all flux in the individual component images and, second, that the color at a point in an image is independent of the wave-lengths of the radiation at that point. This is true of what is seen with a large variety of pairs of wave-lengths and relative brightnesses

Fig. 1.—Co-ordinate system.

Fig. 2.—Co-ordinate system with loci of colors.

We now study our twenty-one experiments in terms of the co-ordinate system. Slides such as those in Figures 3, 4, 5, 6, 7, and 17 are measured as indicated above, and the results are shown in Figure [2]. Here we see that in this new dimensionless co-ordinate system the grays fall on a straight line at an angle of 45° to the axes, warm colors being to one side of the gray and cools to the other.

Doubling the contrast of the image, as in Experiment 11, rotates the gray line, which carries with it the family of warm and cool colors,

disposed as they were originally on either side of the gray line; in Figure [3] imaginary lines have been drawn through some of the colored areas, the lines originating at 0.1 representing points in an image of normal contrast, the lines originating at 0.0001 indicating the new position of those points when the contrast of one of the images has been doubled. The significant fact is that the colors themselves remain constant for the observer, in spite of this translation in the co-ordinate system, as if the eye were indifferent to the change in position of the array as a whole as long as the relative positions of the color points in the array remain unchanged.

Fig. 3.—Elastic transformation of co-ordinate system effected by doubling contrast in one image.

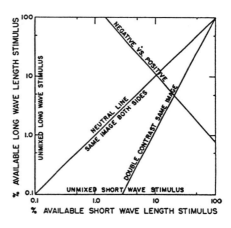

Fig. 4.—Co-ordinate system showing straight lines representing ratios in achromatic images.

Achromatic Situations.—When the points in the images in Experiments 17 and 18 are plotted on the diagram they are found to fall on straight lines (Fig. [4]), suggesting that this is the criterion for whether or not an image is achromatic, and possibly suggesting further that if the points measured in an image fall on any smooth continuum in the diagram, such an image may also be achromatic. For three identical images in Experiment 17 all the points fall on a line (which is in the same position as the gray line in the double-contrast image of Experiment 11). When a single image in one projector is combined with a wash of light in another, as in Experiment 18, measured points will fall on the straight line parallel to one of the axes. As the observer's eye moves over the field of the crossed wedges in Experiment 19, in any direction, the points traversed, when measured, will

fall on simple smooth curves on the diagram of the co-ordinate system.

If the wedges were continuous instead of being step-wedges, then one might think of the crossed wedges as being the continuum which is the co-ordinate diagram as a whole.

The last class of situations, which are nearly colorless, includes the out-of-register images of Experiment 20 and the two different images of Experiment 21. If one thinks of the fusion of the components of the colored image on the retina as being analogous to the central fusion of the two members of the stereoscopic pair on the two different retinas, then it seems plausible that the sense of color might be greatly diminished when the component images on one retina are out of register, just as the three-dimensional sense will be greatly diminished, indeed destroyed, if the members of the stereoscopic pair do not lie in "registry" on the corresponding points of the two retinas. A second way of thinking, which will not be discussed in this paper, has to do with the relationship between the way the eye moves over the geography of the image and the trace of the point on the geometry of our diagram.

Experiment 22.—To test the hypothesis that continua in general, and straight lines in particular, have a special significance in our co-ordinate system, one may ask the following question: If the measured points in the image fall on a straight line at *right* angles to the 45° line in the co-ordinate system, what colors will appear? Now if a negative image is placed in one projector and the positive from that negative is placed in the other projector, . . . then the measured points *will* fall on a line at right angles to the 45° line. The red filter is placed on the long projector and no filter is placed on the short projector; the negative and positive images are registered carefully. Is the co-ordinate system a good prophet? All ratios of stimuli are present in these images which are geometrically identical and in register. Will this be an image in good color, or will it be essentially colorless? The answer is that the co-ordinate system *is* a good prophet. There are only reds and whites, and a little pinkness. This is further support for the hypothesis that stimuli whose measurements are disposed on a straight line in our co-ordinate system do *not* "mix" to give color. (The control picture, the two positives taken and shown in our new "standard" way, . . . is vividly colored.) This negative-positive pair promises to be one of the great clues to the nature of color vision

Because of the limitations of flexibility imposed by using filters, a dual monochromator has been built since the time of the symposium. The work with this instrument has supported the experiments shown at the symposium and has enabled us to arrive at a meticulous description of the separation of wave-lengths, as a function of wave-length, that is required to see the gamut of colors for experiments like those described above (372–86).

52 • JOSEF ALBERS
(1888 – 1976)

Albers, an influential teacher, color theorist, and painter, was born in Bottrop, Germany, and taught at the Bauhaus School in Weimar. After emigrating to the United States (1933), he taught at Black Mountain College in North Carolina (1933-1949) and later became Chairman of the Department of Architecture and Design at Yale University (1950). His series of concentric squares painted on masonite, titled *Homage to the Square*, experiments with the effects of various color juxtapositions.

Interaction of Color, a poetic distillation of the principles of the color class Albers taught at Yale, was published in 1963 in a limited edition with silk-screened color plates. A paperback edition followed in 1971.

From INTERACTION OF COLOR

Color recollection—visual memory

If one says "Red" (the name of a color)
and there are 50 people listening,
it can be expected that there will be 50 reds in their minds.
And one can be sure that all these reds will be very different.

Even when a certain color is specified which all listeners have seen
innumerable times—such as the red of the Coca-Cola signs which is
the same red all over the country—they will still think of
many different reds.

Even if all the listeners have hundreds of reds in front of them
from which to choose the Coca-Cola red, they will again select

quite different colors. And no one can be sure that he has found the precise red shade.

And even
if that round red Coca-Cola sign with the white name in the middle
is actually shown so that everyone focuses on the same red,
each will receive the same projection on his retina,
but no one can be sure whether each has the same perception.

When we consider further the associations and reactions
which are experienced in connection with the color and the name,
probably everyone will diverge again in many different directions.

What does this show?

First, it is hard, if not impossible, to remember distinct colors.
This underscores the important fact that the visual memory is very poor
in comparison with our auditory memory. Often the latter is able
to repeat a melody heard only once or twice.

Second, the nomenclature of color is most inadequate.
Though there are innumerable colors—shades and tones—
in daily vocabulary, there are only about 30 color names (3).

From color temperature to humidity in color

. . . Any measuring of light-dark qualities is not unrelated to a scaling of light-heavy relationships. Light-dark and light-heavy lead easily to soft-hard comparisons; or quick-slow and early-late connect with young-old and with warm-cool, as well as with wet-dry.

Such and other chain connections have led even to such opposites as here and there, indicating spatial differentiation.

The two most comprehensive of the above polarities in color are first, light-dark and light-heavy, and second, the temperature contrast warm-cool.

In defining the placement of such contrasts within color circles, we will see, besides their uneven distribution and their so-called neutrals separating them, their slight overlappings of each other when we compare one circle with the other

As to warm and cool, it is accepted in Western tradition that normally blue appears cool and that the adjacent group, yellow-orange-red, looks warm. As any temperature can be read higher or lower in comparison with other temperatures, these qualifications are only relative. Therefore, there are also warm blues and cool reds possible within their own hues.

But when these temperature indicators, red and blue, are combined with color neutrals, as whites, blacks, and greys, and with their mixtures, particularly in mixtures with the temperature neutrals green and violet, then personal interpretations of temperatures may easily become disparate.

Therefore, it will be comprehensible that such theories of interpretation may lead to and end in personal beliefs. So it is not surprising that the warm-cool principle in color which successfully dominated the Munich school of painting around the turn of the century resulted finally in fruitless controversies.

It was successful in gaining followers by offering a theory for defining spatial relationship of colors, through their higher and lower illusional temperature. As this warm-cool relationship was closely connected with the light-dark contrast, the hardest but apparently lasting conversion then was that light was cold and shadows warm, at least outdoors. It split up in factions of different beliefs about the function of cool and warm with regard to spatial directions in painting, whether the *here* contra *there* was decisive, or the *above* contra *below*, or the *in* contra *out*. A clear example of these opposites is the contrast between Boucher's receding deepening with vermilion red, and Reubens' advancing heightening with white.

All this may be a reason why the warm-cool contrast is not in fashion today, although a new theory declares warm near and cool far, because the former is of longer and the latter of shorter wave length, and they are, therefore, optically registered in different ways. But optical and perceptual registration are not necessarily parallel (59–61).

53 • SIDNEY GEIST
(b. 1914)

The problems of color in sculpture, as Geist, an American sculptor, points out, are different from those of painting. The work is designed to be seen from different vantage points, and the integrity of the volume must be respected. Ancient stone sculpture was often painted to make it look more lifelike. Limestone carvings from Egypt, placed in tombs, survive in some cases with their paint relatively intact. Carvings from Greece and Cyprus sometimes show scraps of paint. Passages in Homer suggest that sculpture and architectural friezes on temples were accented or entirely painted with bright colors.

After the Renaissance, large-scale sculpture was rarely painted, although applied color was regularly used in folk art and the ceramic arts. Sculpture came to be appreciated as an art of volumes, not surfaces. This in turn raised the question of whether applied surface colors were advisable.

From COLOR IT SCULPTURE

Eight years ago a group of painters held a panel discussion on color at the Artists' Club in New York. I had had a show of painted sculpture several months before, and so at one point, after the discussion was opened to the floor, the chairman of the evening asked me to say something about color in sculpture. I mumbled a few words to the effect that the problems of colored sculpture were different from those of painting, that black and white and the primary colors were particularly adaptable to sculpture, and that, oddly enough, it seemed impossible to paint an object purple. This last remark raised a furor of indignation

and protest. I was taken aback. I had not thought to lay down a rule; I thought I was describing something I had observed. In the years since then I have had little reason to amend my statement; except for a Chinese vase and a woman's umbrella, every purple or lavender object I have seen has been offensive, and I must conclude that purple can only be used sparingly in sculpture and at some risk. (Was Gelett Burgess, *who published art criticism*, merely writing nonsense verse when he wrote, "I never saw a purple cow, I never hope to see one . . . "?) Nor is purple alone in presenting difficulties for sculpture; maroon, Indian red, the ochers and umbers, even dark green—all are doubtful when applied in sculpture over large areas.

While it was possible to discuss colored sculpture in a gathering of artists, there were many quarters, including artists' circles, where it was not condoned. The main reason, of course, is the continuing influence of Renaissance sculpture, whose chief glories were impaired by the bronze and marble monuments of ancient Greece. That the classic works had been denuded by time of their original applied color, that the ancient cultures, Oriental and Occidental, all painted their sculpture, that most Western sculpture up to the Renaissance was painted, and that primitive and folk sculpture is painted—all this historical evidence still has great difficulty in prevailing over a four-hundred-year-old tradition of sculpture in bronze and white marble, a tradition abetted in this century by the work of Brancusi, Arp and Moore. The modern taste for uncolored sculpture (relaxed only for the minor ceramic arts) has found theoretical support in this century in the mystique of "truth to materials" and in that more recent and ever-growing exclusiveness which has come to define modern artistic disciplines: the tendency to "purity," the wish to be constituted of one set of elements and purged of all others.

From this high-minded pole of prohibition we have lately shifted to the opposite pole of permissiveness. The effect has been gradual. Early in the century, in a period marked by revolutionary inventiveness, Picasso, Archipenko and Laurens in Paris made colored sculpture, as did some members of De Stijl and the Russian modernists. Nadelman began to use color around 1917 in the United States. Turku Trajan made his early painted sculpture in the twenties; it was completely overlooked, he said, because "no one had a chance against Lachaise." Early in the next decade, Noguchi did a long painted relief in Mexico, and in 1933 Paul Jennewein made a pediment for the Pennsylvania Museum of Art in terra cotta covered with colored glazes. There was talk of polychromy, a few carved reliefs at Radio City were painted, and the WPA fostered a number of experiments. In these years Carl Walters made his humorous animal and figure pieces in ceramic, Calder first showed his

brightly colored mobiles, and the various materials of which Surrealist objects were made fostered the idea of color in sculpture. In 1940 Eugenie Gershoy showed some small figures charmingly painted; and about that time Harry Holtzman did an elegant column of square section painted around the top in Mondrianesque fashion, and Ibram Lassaw did some painted sculpture that resembled nerve ganglia and other biological phenomena. After the war and doubtless on an impulse originating in Picasso's colored ceramics, Léger and Miró in Europe and a number of artists here began to do colored sculpture in ceramic, glass and other materials. The amount of colored sculpture has grown suddenly, and a list of recent workers in this mode in the U. S. alone would include Arnold, Beal, Bladen, Campbell, Chamberlain, Daphnis, Diller, Doyle, Forakis, Geist, Ginnever, Halkin, Hokanson, Hudson, Kelly, King, Langlais, Lassaw, Linder, Magar, Marisol, Myers, Navin, Neri, Nevelson, Oldenburg, Smith, Sugarman, Wattas, Weinrib, Westermann, Zogbaum.

The efflorescence of colored sculpture which we are witnessing is only about six years old. Not unified by any school or theory or art (except for those manifestations known as "pop"), it constitutes a new category whose outlines are indistinct and whose origins and purposes remain undefined. The critic of this new sculpture may well ask a number of troublesome questions. Does not all sculpture by virtue of being material, have color? Does a touch of color, or the use of subtle or quiet color, qualify for the title of colored sculpture? What is the relation, in a construction, between colored materials and applied paint? Is a sculpture painted all blue more "colored" than a white marble? Do the mottlings and rust of welded sculpture qualify as color? Is painted sculpture a new category or a confusion of categories? Is it distinguishable from what might be called sculptured painting?

The maker of this sculpture, on the other hand, brushes these questions aside. His color is usually obvious, even clamorous. He draws no comfort from history, and the term "polychromy" is not in his vocabulary. His claim to freedom permits him to "do whatever he wants." This is not to say that he has no relation to history: he may do whatever he wants as long as he does not repeat history. He employs the whole range of colors and paints, whether conventional, luminous or metallic, and he occasionally resorts to chemistry. And he works in the vast array of natural and manufactured materials which modern technology and transport have made available. We note the recent introduction to sculpture of colored light, both incandescent and neon.

The uses of color in sculpture may be distinguished stylistically. One may speak of imitative naturalism, in which the sculpture is painted to look, in most cases, like real human figures; since the effectiveness of

this kind of painting depends on an equally imitative kind of modeling, the total result is one of arrested actuality. Whereas imitative picture painting achieves abstraction mainly by the flatness of the surface, sculpture painted in this manner achieves abstraction by virtue of the immobility of the object and the change in size from the subject. This kind of sculpture is rarer than one would imagine (I discuss a recent version below), its best examples to be found in Italian religious sculpture, its worst in the products of St. Sulpice.

The widest use of color in sculpture may be seen in a stylized realism, in the application of color to figural sculpture according to any of a number of conventions. The sculpture to which such color is applied is made, too, in a wide range of non-naturalistic styles or conventions, and the combined effect of color and sculpture here is a heightened expressive realism, a representation of the world that exhibits artistic invention rather than the skills of imitation. The use of color here ranges widely from the descriptive to the decorative to the symbolic.

Cubism, and that means Picasso, employs color to penetrate the surface of the object in order to increase awareness of the interior.

When color is applied to non-representational sculpture, as in Neo-Plastic, Suprematist and Constructivist work, it becomes, like the form, actual, concrete, self-referring. In this mode this century saw for the first time a sculpture of colored masses and planes arranged according to an invented logic and independent of nature. The three schools named above had a tendency to paint or construct separate units of form in different colors, making color distinction correspond to form distinction. Though this early rigid scheme of coloration has for the most part disappeared, the more fluid use of color in recent work is much indebted to its liberating effect.

In a closer, more technical view of color application, we observe that historically color is most often used to *demark forms* already indicated in the sculpture. In much folk art, and in such sophisticated examples as the work of Elie Nadelman, William King and Anne Arnold, color can typically *create forms* where none are indicated in the sculpture; thus, details like a mustache or the hair of the head, a ribbon, the lips, fingernails and clothing are painted upon continuous, unaccented form. If in the two foregoing cases color separates parts from the whole, there are others, such as the work of Louise Nevelson, where it serves to *unify the parts* of the sculpture. Color, in its function as a surfacing medium, is occasionally used to *neutralize the material* in which a sculpture is made, to cover its "nature," render it more abstract, as in Calder's stabiles. Color in certain instances has been used contrapuntally to flood over what would seem to be natural formal boundaries, and so to *deny, oppose or absorb form*. It can be used to *distort form*, seeming to create

prominences where none exist, and suppressing those that do exist.

Three contemporary sculptors employ a kind of *negative color* that jars our color sense: Peter Agostini's white plaster casts of real objects offer a world from which all color has been sucked out; George Segal's white plaster figures in real settings make a world of bleached husks from which everything has been sucked out; Claes Oldenburg has made facsimiles of familiar objects in cloth, painted white and called "ghosts." White in Louise Bourgeois's sculpture has a *psychological* effect; this sculptor uses color to create a mood and to designate personalities among her groups of shapes.

Trajan, 1887–1959, left a large and impressive body of work, all of it elaborately colored. His main theme was the human figure, sometimes draped, and he did some horses. His early work was faithful to nature in its modeling and delicate in its use of color. But as time went on he took ever greater liberties with the human form, while his color became correspondingly adventurous. His working method consisted of a constant alternation of modeling (in a kind of cement) and painting, usually over a period of years on one piece; in chipping material away, he would reveal color laid on some time before. Besides doing sculpture Trajan made paintings in a loose Post-Impressionist manner. Often he made paintings of the subject of his sculpture, and the dappling of the paintings would find its way to the sculpture; at other times he used continuous color, and then a female figure might be generally blue, a male figure red. Trajan developed a system (too intricate for me to follow) of form and color symbolism based on a study of flowers and animals and on arcane knowledge, and it served him well. Here and there one of his figures, or a part of a figure, is an unreadable mixture of form and color, but for the most part his highly varied *oeuvre* has a surprising beauty, in which his private system is felt if not understood. I cannot help thinking—and regretting—that this unusual sculptor is neglected because he worked alone, outside of all groups, and in a realm where few had ventured.

Among recent sculptors, Claes Oldenburg has brought a well-developed expressionist color-sense to sculpture. His form remains readable under his bold and painterly application of color because of the familiarity of his subjects, but it is never, in Clive Bell's term, "significant form." In his own way Oldenburg has created a striking imagery of a populism related to Léger's.

The means of imitative naturalism have been used for *trompe-l'oeil* effect by Jasper Johns. His *Painted Bronze* is a bronze can and brushes painted in imitation of the originals. Since the subject is immobile, there is no loss of mobility in its translation into bronze; since it is cast in bronze, there is no change in size. The eye is fooled and so, too, are

the most customary expectations of what is to be found in art. Robert Watt's tray of ten cast frankfurters, each painted a solid color and the series going from white to black with a last one in shiny nickel, is but one of the many charades of art and games of reality and illusion that color makes possible when applied to objects.

Sculptors can manipulate color as mass when they use tinted plaster or cement, variously colored woods or stones, plastics. One of the most successful of these pursuits is that of John Chamberlain, who for some time has been making constructions from parts of painted automobile bodies. The simultaneity of the form-color handling and the resistance of the material give his work an exactitude of color and a quality of immediacy and energy. Yet Chamberlain seems to me to be closer to painting than sculpture, probably because his color sense is clearer than his structural faculty: I have the impression of a man-made metal bouquet. Curiously, now that Chamberlain is painting his sculpture himself, his color has a prettiness it did not have in the past.

Some of the more interesting explorations of color sculpture of the moment are those of George Sugarman and David Weinrib. Their approaches differ radically, and it is doubtless a failure of objectivity that makes me more sympathetic to that of the former. Sugarman carves and builds up masses and accretions of forms; these he paints in large sections of flat, bright, intense color. His sculpture is composed of surprising, even startling, juxtapositions of bold color-masses. *Criss-Cross*, painted in restrained tones, has a harmony that is unique in his work, but he is in any case fresh, inventive and stimulating.

While Sugarman, by his own statement, conceives form and color together, making a limited range of adjustments in the course of work, Weinrib begins with a generalized structural scheme which is realized after a long series of adjustments and changes. All is touch-and-go, necessitated by the variety of shape, color, size, direction and weight, the nervous imagery, its far-flung articulations and the complexity of relationships that are immediate, serial and across space. His mixture of colored materials and paint, of ready-made shapes and fashioned ones I find ambiguous, and I am put off by his complexity (that is, not always convinced of its necessity), but his work is in constant progress, and he aims at an orchestration of elements that has rarely been achieved in sculpture.

In discussing David Smith in a recent catalogue, Clement Greenberg said, "the question of color in Smith's art (as in all recent sculpture along the same lines) remains a vexed one." As for Smith, the observation is true. (I don't know what "sculpture along the same lines" refers to.) The reason for the difficulty is, I think, the fact that Smith is so strong a designer that his sculpture is complete when he has finished

fashioning it: the addition of color is then decorative, willed, not neces-
sary, cosmetic.

My own recent preoccupations have been with this matter. I have
painted my sculpture for many years, and for many of the reasons
noted above. My color was always bright and hard because I decided
early that I did not want a time-worn, patinated surface; I thought that
a new piece of painted sculpture should look as new as a Brancusi. This
brightness often had a shocking public effect; what surprised me was
that it often had a humorous effect too, and that may well have been
caused by a union of serious form and gay color. At any rate, some time
ago I came to feel that my sculpture, no matter how fully planned as
color-and-form entity, could stand unpainted, and that color was an
adornment, an interesting addition, but cosmetic. How to reduce the
distance between form and color while making a form (and a mono-
lithic form) in one stage and painting it in another, a procedure I seem
unable to change? My solution at the moment is to suppress my design-
ing instinct to make a mute form, a kind of un-design, which is only
fulfilled or justified by the addition of color. I make what amounts to a
space that calls for color. The aspect of sculpture as shape is here
scanted (though I am led to new shapes), and the sculpture, when suc-
cessful, becomes a field for color movement. Yet I do not wish to
approach painting or compromise a sentiment I have about sculpture. I
would have my color be sculptural.

If the question of color in sculpture remains, in Mr. Greenberg's
excellent word, a vexed one, it is a question to which a high enthusiasm
and a broad range of abilities have addressed themselves. Sculpture is
on the way to regaining the easy commerce it had with color before the
Renaissance. The color sculptor may now say, while admiring
Michelangelo's carving, *I too am a sculptor* (91–98).

54 • GEORGE RICKEY
(b. 1907)

The American sculptor Rickey was born in Indiana and spent his childhood in Scotland. Early in his career Rickey was a muralist. Later he worked with mobiles (c. 1945) and kinetic sculpture (c. 1950). In *Constructivism: Origins and Evolution* (1967), Rickey suggests that the Constructivists and their heirs originally turned away from color, which had become excessively burdened with theory. Like Van Gogh, he believed that color would be of greater importance to artists in the future.

From CONSTRUCTIVISM: ORIGINS AND EVOLUTION

Color

The systematic study of color is about two and a half centuries old. Newton discovered, at the end of the seventeenth century, that light was color. Goethe made his own more subjective kind of study, at the end of the eighteenth and recorded it in his *Farbenlehre*. Statements in Delacroix's *Journal* in the middle of the nineteenth show the beginning of a wider awareness

With increased knowledge came increased sensibility and it was now the artist's turn to make advances. The Impressionists and their followers exploited the phenomena of color vibration and simultaneous contrast of complementaries, described by Chevreul (1786 – 1889), the chemist in charge of the Gobelins tapestry works. Gauguin, Van Gogh, Seurat, and Signac sharpened the color sensibilities of every connoisseur who came to

know their paintings; and Cézanne demonstrated to a whole generation of artists the relation of color to volume and space. Van Gogh professed emotional constants for certain colors but his response to them was clearly sensual. The Fauves, though their color seemed ferocious, broadened the range of acceptable color and led to the intense colorist effects of the mature Matisse, Rouault, and Klee. In art schools, while the study of human anatomy declined, erudition in the anatomy of color deepened and became a foundation for such colorist painters as Manessier, Afro, Rothko, Poliakoff, Francis, Morris Louis, and Noland. Eventually color theory, with its vocabulary, became part of every academy's curriculum, including the Bauhaus. The most advanced color teaching in the world now takes place at the Hochschule für Gestaltung in Ulm, where both Albers and Max Bill have taught. An alert schoolboy today knows more about color than did Newton or Delacroix.

As the properties of color became better understood, their application to expressive purposes (which had been recognized before Delacroix) was extended by such figurative artists as Munch, Soutine, Nolde, and Beckmann, and by Kandinsky in nonobjective painting. A familiar anatomy of color was essential to Tachism and Abstract Expressionism.

The highly subjective nature of color has led artists interested in form to renounce it. The Cubists painted in monochrome. Malevich drew and painted the first Suprematist images in black and white, parsimoniously adding a little red, then a little yellow and blue

Mondrian adopted an arbitrary and virtually fixed system of primary color signals. One group of the Bauhaus faculty adopted similar signals, in spite of the presence of Klee and Kandinsky, for whom color was an expressive instrument of enormous range. The balance between color as meaning or emotional trigger and as a complex sensory experience has been held by Albers. His book, *Interaction of Color*, composed after a lifetime of study and produced in collaboration with his students, reveals in trenchant text and diverse, beautifully executed color plates, the spectrum of human color sensations. It was seen by reviewers as following Chevreul's theories. However, Albers proves Chevreul's basic concept of color mixture to be false. He rejects rules for color juxtaposition and, instead, presents an independent way to develop a sensitive eye Albers demonstrates that we almost never see what a color really and physically is, and that Ostwald was right to state that it is first a psychological problem.

Though close to Constructivism all his life and a contributor to it, Albers has stood apart, recording and demonstrating the nature of color. His own painting has remained subjective and personal. Despite the apparent uniformity of his *Square*, he is a romantic, albeit a highly disciplined one. For him the problem of form lies not in the shape of the container but in

what is contained, the color itself. The homage is not to the square, but to color. "Form, which includes color," he says, "demands unending performance and invites constant reconsideration."

Albers is not concerned with once more assembling old and new knowledge "about" color, nor with its physics, optics, nor with wave lengths, nor projection through lenses on our retina. All this he compares with acoustics, which cannot provide musicality, either on the creative or the appreciative side. His concern is "with what happens behind and beyond the retina with the psychological, more precisely the perceptual changes of color through interaction and interdependence." By "interaction" Albers means perceptual phenomena which "actually happen" and he relates both "action" and "actual" to "act," "actor," and "appearance," in the stage sense. Colors are actors; they constitute a cast; they perform. He teaches us to develop sensitivity to color and to its constant deceptions, and thus to recognize its perceptual (not optical) illusions. "Such recognition will enable us to make these illusions not only a deception but a means of broader color instrumentation."

Renunciation of the emotional appeal of color was reiterated by the postwar generation. "Color leads to subjective expression and response," states one recent manifesto. The same statement a decade earlier would have supported the other side. With the trend toward self-effacement, depersonalization, distrust of spontaneity, rejection of the acquired taste of an élite, color was seen as a self-indulgence or a trap. The first public renunciation, probably not thought significant at the time, was the exhibition of monochrome painting by Yves Klein in London in 1950. The impact of such painting on other young Europeans was to be enormous and to lead finally to all-white, all-black, or black-and-white exhibitions with titles as "Schwarz Weiss," "Weiss auf Weiss," "Weiss Weiss Weiss" ["Black White," "White on White," "White White White"].

Achromatism was recognized as a movement in America in a "White on White" exhibition at the De Cordova Museum in Lincoln, Massachusetts, in 1965. Achromatism appears in the work of Uecker, Piene, Peeters, Tomasello, De Vries, Levinson, and Nevelson among the many shown in the De Cordova exhibition. Vasarely has lived in both camps. His black-and-white pictures have a detached, anonymous bite; his more recent color mosaics of circles, ellipses, and squares have the sonorous harmony of a romantic temperament.

Optical phenomena, with their non-aesthetic, dizzying, even nauseating, color situations, have been exploited for their direct impact on the spectator. This use of color is far removed from romantic or expressionist communication or mood or meaning. It is not only free of association, it is independent of ideas of harmonious order or any other kind of pleasure. A further step would be to rid it of any subjective bias, pleasant or

unpleasant, by leaving the hue, intensity, size, or placement to chance, to mathematical formula, or to the whim of the spectator—all of which have been done (e.g., in the paintings of Lohse, Kelly, Bill).

A further use for non-associative color is for topographical effect—to separate areas as in maps. Ellsworth Kelly, Leon P[olk] Smith, and Youngerman have used color in this way to separate figure and ground, as has been done for centuries in flags, signs, and crests. Tadasky sometimes uses it in concentric circles. Sedgley uses it inversely in his "targets" to fuse circles together which are in fact separate; Stella to separate stripes; Baertling to separate triangles, though he goes further in giving his color dissonances a special sting. George Sugarman uses topographic color in three dimensions to separate or punctuate wooden forms, as does Anthony Caro on his steel beams, while other English sculptors paint colored shapes in contradiction to the form, like the camouflaged ships of World War I.

Thus the heirs of Constructivism, after a suspicious withdrawal from color, have begun to find how rich a resource it is, that it is one more manifestation of nature which can supply them with useful tools, or simply be presented to the spectator as a force (223 – 26).

55 • LOUISE NEVELSON
(1900 – 1988)

During the 1950s and 1960s, the American sculptor Nevelson exhibited large walls or environments assembled from found objects: pieces of scrap wood arranged inside stacked boxes. Her earliest wall pieces were painted entirely black, with some later examples entirely gold or entirely white. Like the painter Franz Kline, who for a time limited his palette to black and white, Nevelson was often asked why she used those colors in preference to others. In interviews with Diana MacKown, Nevelson discussed her associations with black, white, and gold, and her thoughts about creating an environment that was entirely a single color.

From DAWNS AND DUSKS:
TAPED CONVERSATIONS WITH
DIANA MacKOWN

. . . About what black . . . the illusion of black means to me: I don't think I chose it for black. I think it chose *me* for saying something. You see, it says more for me than anything else. In the academic world, they used to say black and white were no colors, but I'm twisting that to tell you that for me it is the total color. It means totality. It means: contains all. You know, this is one of the most interesting things to me, that people have identified with black all their lives and, for some reason, they identify black with death or finish. Well, it may be that in the third dimension black is considered so. It's a myth, really. But after painting, using color . . . Now, I don't see colors, as I've often said, the way others do. I think color is magnificent. It's an illusion. It's a mirage. It's a

rainbow. But why not? It's great. I was considered quite a colorist, and I can appreciate that artists in the past centuries used color—that it was right. And they were symphonies. Certainly I'm a great admirer of Bonnard or Matisse. I think Bonnard used color of that tone, we'll call it not a minor key but a major key—the treble clef. Well, he reached a symphony of color. Now if you can do that and you *want* that it almost becomes no color, because it's a mirage of light. There isn't a color that isn't of that intensity if you can get that essence and *not* think of it as a color. Not only black and white and gold and silver, but you can also go to the rainbow and you can see in the sky the purples and the blues.

But when I fell in love with black, it contained all color. It wasn't a negation of color. It was an acceptance. Because black encompasses all colors. Black is the most aristocratic color of all. The only aristocratic color. For me, this is the ultimate. You can be quiet and it contains the whole thing. There is no color that will give you a feeling of totality. Of peace. Of greatness. Of quietness. Of excitement. I have *seen* things that were transformed into black, that took on just greatness. I don't want to use a lesser word (125 – 26).

. . . If you paint a thing black or you paint a thing white, it takes on a whole different dimension. The white and the black invited different forms. The tones, the weights, are different. See, when I did the work in these colors, I think a state of mind enters into it. And that is enough, because basically this is what has to happen to visual art. Forms have to speak, and color. Now the white, the title is *Dawn's Wedding Feast*, so it is early morning when you arise between night and dawn. When you've slept and the city has slept you get a psychic vision of an awakening. And therefore, between almost the dream and the awakening, it is like celestial. White invites more activity. Because the world is a little bit asleep and you are basically more alive to what's coming through the day.

I feel that the white permits a little something to enter. I don't know whether it's a mood . . . probably a little more light. Just as you see it in the universe. The white was more festive. Also the forms had just that edge. The black for me somehow contains the silhouette, essence of the universe. But I feel that the whites have contained the blacks with a little more freedom, instead of being mood. It moves out a little bit into outer space. . . .

Then the gold came after that. Now you see, gold comes out of the earth. It's like the sun, its like the moon—gold. There's more gold in nature than we give credit for, because every day there are certain reflections where the sun rays hit and you get gold. Every nail we use gives off a light which is almost gold, or silver. Look how many people

open cigarette packages. And look, we open this, and look at the light from this paper. It's gold and silver and look how many millions of people are opening this and never see this. That's reflection. That's as pure light as any of the most choice gold and silver in the world.

Gold is a metal that reflects the great sun. And then when you put it on, it's an essence of a so-called reality in the universe. Consequently I think why, in my particular case, gold came after the black and white is a natural. Really I was going back to the elements. Shadow, light, the sun, the moon. If I could speak the way I feel, all these things are in nature, but they symbolize different things. And don't forget that America was considered the land of opportunity. I was asked to be on a panel once and there were rich bankers and someone in the audience asked, "Mrs. Nevelson, how did you happen to pick up old woods on the street?" I said, "Well, I come from the Old Country. I came to Rockland when I was four and a half years old, then I came to New York. And they promised that the streets of America would be paved with gold."

I do think of gold in two ways. One is that the world is shining. Then I also think somewhere there's another element of materialistic quality. I mean it symbolizes so much—the sun and the moon—and somehow, while it comes out of the earth, it's already more sophisticated. It's more that humans have given it something. And you cannot divorce it totally. For instance, we can reverse it. I can say that white is mourning and black is marriage. I can do it consciously. But gold I can't do it. Because the minute you have gold it takes you over. Its splendor. And an abundance. And that abundance is really materialistic.

I think the gold enhanced the forms, enriched them. I loved it. I remember one wall, *Royal Tides* [1961], an exhibition at Martha Jackson's, where the forms were big. It isn't that I felt I explored the gold to the end. The only thing is that there was something in me drawing me to the black. I actually think that my trademark and what I like best is the dark, the dusk. But I've never left anything. That isn't the way I work. I might take up something I was doing twenty years ago, it doesn't matter. The procedure once was that an artist moved from one thing to another. So the first woods I did were in black, then I went into white, then to gold, and so on. Museum people said, "Oh now, what is going to be your next color?" And I said, "I never left anything." It's true. I don't let anything escape from me. You don't give a thing or throw out a thing. You re-orient a thing. If it's necessary that something should come out at a given time, you can take it out. But it isn't destroyed. It's still part of our awareness. You could live a thousand years or even a million years and you cannot say that you have finished with a period. I never felt I explored the ultimate black.

When I worked on the white and gold sculpture, I had two separate studios. One was at 41 Spring Street and the other 216 Mott Street. And I worked at the same time in both. There were many reasons for it. The eye gets caught here and there. Now when I worked on the white, I didn't want my eye distracted by anything. When I worked on my blacks, I didn't want my blacks or golds detracted from. Because I again wanted total environment. As close as possible to what I was working on. And I think it was great to do it. . . .

 . . . [at the Venice Biennale] I was given the three large galleries. I painted the entrance room gold, which was circular, so that was the gold environment, first. Then in the two larger galleries, on the right was white, on the left black. I covered the glass ceilings, which were like skylights, with material the color of each environment (144 – 47).

REFERENCES

1. Aristotle. 1984. "On Colours." In *The Complete Works of Aristotle* (Vol. 1). Ed. by Jonathan Barnes. Princeton, NJ: Princeton University Press.

2. da Vinci, Leonardo. [1802] 1957. *The Art of Painting*. Trans. by John Francis Rigaud. New York: Philosophical Library.

3. Lomazzo, Giovanni Paolo. [1584] 1844. *Trattato dell' arte della pittura, scultura ed architettura*. Rome: Presso Savario del-Monte. Trans. by John Donohue as "Symbolism of the Principal Colors."

4. Boyle, Robert. [1664] 1964. *Experiments and Considerations Touching Colours: First Occasionally Written, Among Some Other Essays, to a friend: and now suffer'd to come abroad as THE BEGINNING OF AN EXPERIMENTAL HISTORY OF COLOURS*. New York: Johnson Reprint.

5. Newton, Sir Isaac. "Letter to Oldenburg, 6 February 1671–72." In *Philosophical Transactions of the Royal Society of London*, 6 (1671-72). London: The Royal Society.
 Newton, Sir Isaac. [1730] 1952. *Opticks, or a Treatise of the Reflections, Refractions, Inflections, and Colours of Light*. New York: Dover Publications, Inc.

6. Goethe, Johann Wolfgang von. [1840] 1970. *Theory of Colours*. Cambridge, MA: The M.I.T. Press.

7. Chevreul, M.E. [1845[1980. *The Principles of Harmony and Contrast of Colors*. New York: Garland Publishing Company.

8. Field, George. 1858. *Rudiments of the Painter's Art; or, A Grammar of Colouring*. London: John Weale.
 Field, George. 1885. *Chromatography, A Treatise on Colours and Pigments for the Use of Artists* (4th Edition). Mod. by J. Scott Taylor. London: Winsor and Newton.

9. Pach, Walter (Ed.). 1948. *The Journal of Eugène Delacroix*. New York: Hacker Art Books.

10. Hay, David Ramsay. 1845. *The Principles of Beauty in Colouring Systematized*. London: William Blackwood and Sons.

11. Baudelaire, Charles. 1955. "On Color." In *The Mirror of Art*. Trans. and Ed. by Jonathan Mayne. Oxford: Phaidon Press, Ltd.

12. Southall, James P.C. (Ed.). 1962. *Helmholtz's Treatise on Physiological Optics* (Vol. 2). New York: Dover Publications, Inc.

13. Maxwell, James Clerk. [1890] 1965. *Scientific Papers*. Ed. by W.D. Niven. New York: Dover Publications, Inc.

14. Rood, Ogden Nicholas. [1879] 1913. *Student's Textbook of Color: or Modern Chromatics with Applications to Art and Industry*. New York: D. Appleton and Company.

15. Whistler, James McNeil. [1890] 1967. *The Gentle Art of Making Enemies*. New York: Dover Publications, Inc.

16. Vanderpoel, Emily Noyes. [1901] 1903. *Color Problems: A Practical Manual for the Lay Student of Color*. Boston: Lockwell and Churchill Press.

17. Gauguin, Paul. 1938 "Notes on Painting." In Trans. John Rewald's *Gauguin*. New York: French and European Publications, Inc.

18. Roskill, Mark (Ed.) 1963. *The Letters of Vincent Van Gogh*. New York: Atheneum Publishers.

19. Ostwald, Wilhelm. [1903] 1907. *Letters to a Painter on the Theory and Practice of Panting*. Trans. by H.W. Morse. New York: Ginn and Company.

20. Ross, Denman Waldo. 1919. *The Painter's Palette: A Theory of Tone Relations, An Instrument of Expression*. Boston: Houghton Mifflin Company.

21. Munsell, A.H. [1905] 1961. *A Color Notation: An Illustrated System Defining All Colors and Their Relations by Measured Scales of Hue, Value and Chroma*. Baltimore: Munsell Color Company.

22. Planck, Max. n.d. *A Survey of Physics: A Collection of Lectures and Essays*. Trans. by R. Jones and D.H. Williams. New York: E. P. Dutton and Co., Publishers.

23. Seurat, Georges. 1966. "Letter to Maurice Beaubourg." In Elizabeth Gilmore Holt's *From the Classicists to the Impressionists*. New York: Double-day Anchor.

24. Rood, Roland. 1941. *Color and Light in Painting*. Ed. by George L. Stout. New York: Columbia University Press.

25. Rewald, John. 1943. *Georges Seurat*. Trans. by Lionel Abel. New York: Wittenborn Art Books.

26. Henri, Robert. 1923. *The Art Spirit*. Comp. by Margery Ryerson. Philadelphia, PA: J. B. Lippincott Company.

27. Kandinsky, Wassily. [1926] 1947. *Point and Line to Plane*. Trans. by Howard Dearstyne and Hilla Rebay. New York: Dover Publications, Inc.

28. Bragdon, Claude. 1932. *The Frozen Fountain*. New York: Alfred A. Knopf, Inc.

29. Benson, William. [1868] 1930. *Principles of the Science of Color Concisely Stated to Aid and Promote Their Useful Appearance in the Decorative Arts*. London: Chapman and Hall.

30. Sargent, Walter. [1923] 1962. *The Enjoyment and Use of Color.* New York: Dover Publications, Inc.

31. Barr, Jr., Alfred H. [1908] 1951. "Matisse Speaks to His Students: Notes by Sarah Stein." In *Matisse: His Art and His Public.* New York: The Museum of Modern Art.

32. Seuphor, Michel. n.d. *Piet Mondrian: Life and Work.* New York: Harry N. Abrams, Inc.

33. Russell, Bertrand. [1948] 1962. *Human Knowledge: Its Scope and Limits.* New York: Simon and Schuster.

34. Bacon, J. 1925. *The Theory of Colouring: Being an Analysis of the Principles of Contrast and Harmony, In the Arrangement of Colours, With Their Application to the Study of Nature and Hints on the Composition of Pictures, &c.* London: George Rowney and Company.

35. Malevich, Kasimir. 1971. *Essays on Art 1915–1933.* New York: Wittenborn Art Books, Inc.

36. Klee, Paul. 1964. *The Diaries of Klee: 1898–1918.* Ed. by Felix Klee. Berkeley, CA: University of California Press.

37. Hofmann, Hans. 1948. *Search for the Real.* Andover, MA: Addison Gallery.

38. Léger, Fernand. [1931] 1969. "New York Seen, 1931." Trans. by Henry Geldzahler. *Art Forum,* 7:5 (May).
 Léger, Fernand. 1946. "Modern Architecture and Color." In *American Abstract Artists Catalog.* Trans. by G. L. K. Morris. New York: Ram Press.

39. Eliot. T. S. 1964. *Knowledge and Experience in the Philosophy of F. H. Bradley.* New York: Farrar, Straus, and Giroux, Inc.

40. Bowie, Henry P. 1911. *On the Laws of Japanese Painting.* San Francisco, CA: Paul Elder and Company.

41. Itten, Johannes. [1961] 1973. *The Art of Color.* Trans. by Ernst Van Hagen. New York: Van Nostrand Reinhold.

42. Gabo, Naum. 1962. *Of Divers Arts.* The A. W. Mellon Lectures in the Fine Arts, National Gallery of Art, Washington, DC, 1959. London: Faber and Faber.

43. Sweeney, James Johnson. 1945. *Stuart Davis.* New York: The Museum of Modern Art.

44. Kepes, Gyorgy. [1944] 1949. *Language of Vision.* Chicago: Paul Theobald.

45. Hiler, Hilaire. 1945. "The Artist and Scientific Method." A Paper prepared for the American Artists' Professional League, presented at a meeting of the Inter-Society Color Council. Hotel Pennsylvania, New York, February 24th.

46. Knaths, Karl. 1946. "Notes on Color." In *American Abstract Artists Catalog.* New York: Ram Press.

47. Birren, Faber. 1949. "Functional Color in the Schoolroom." *Magazine of Art,* 42:4 (April).

48. Brown, Richard F. 1950. "Impressionist Technique: Pissarro's Optical Mixture." *Magazine of Art,* 43:1 (January).

49. Aach, Herbert. 1967. "Insight Out." *Arts*, March.

50. Rose, Barbara (Ed.). 1975. *Art-as-Art: The Selected Writings of Ad Reinhardt*. New York: The Viking Press.

51. Land, Edwin H. [1959] 1961. "Color Vision and the Natural Image." In *Visual Problems of Color Symposium* (Vol. 1). New York: Chemical Publishing Company.

52. Albers, Josef. 1963. *Interaction of Color*. New Haven, CT: Yale University Press.

53. Geist, Sidney. 1967. "Color it Sculpture." In *Arts Magazine Annual*.

54. Rickey, George. 1967. *Constructivism: Origins and Evolution*. New York: George Brazilier, Inc.

55. Nevelson, Louise. 1976. *Dawns and Dusks: Conversations with Diana Mac-Kown*. New York: Charles Scribner's Sons.

PERMISSIONS

Henri, Robert: From *The Art Spirit*. Copyright © 1923 by J. B. Lippincott Company. Copyright renewed © 1951 by Violet Organ. Reprinted by permission of Harper and Row Publishers, Inc.

Kandinsky, Wassily: From *Point and Line to Plane*. Reprinted by permission of Dover Publications, Inc.

Bragdon, Claude: From *The Frozen Fountain*. Copyright © 1932 and renewed 1960 by Henry Bragdon. Reprinted by permission of Alfred A. Knopf, Inc.

Benson, William: From *Principles of the Science of Colour Concisely Stated* Reprinted by permission of Chapman and Hall, London.

Sargent, Walter: From *The Enjoyment and Use of Color*. Reprinted by permission of Dover Publications, Inc.

Barr, Jr., Alfred H.: From *Matisse: His Art and His Public*. Reprinted by permission of The Museum of Modern Art.

Reprinted from *Piet Mondrian: Life and Work* by Michel Seuphor. Published in 1958 by Harry N. Abrams, Inc., New York. All rights reserved.

Russell, Bertrand: From *Human Knowledge: It's Scope and Limits*. Copyright © 1975 by the estate of Bertrand Russell. Reprinted by permission of Simon and Schuster, New York and Unwin Hyman Limited, London.

Klee, Paul: From *The Diaries of Klee: 1898 – 1918*. Copyright © 1964 by The Regents of the University of California Press. Reprinted by permission of the publisher.

Hofmann, Hans: From *Search for the Real*. Reprinted by permission of the Addison Gallery of American Art, Andover, MA.

Léger, Fernand: From "New York Seen." Reprinted by permission of Henry Geldzahler; from "Modern Architecture and Colour." Reprinted courtesy of The American Abstract Artists.

Eliot, T. S.: From *Knowledge and Experience in the Philosophy of F. H. Bradley*. Copyright © 1964 by T. S. Eliot. Reprinted by permission of Farrar, Straus and Giroux, Inc., New York and Faber and Faber, Ltd., London.

Itten, Johannes: (1961) 1973 Trans. Ernst Van Hagen *The Art of Color*. Permission granted by the Publisher. All Rights Reserved.

Gabo, Naum: From *of Divers Arts*. The A. W. Mellon Lectures in the Fine Arts, National Gallery of Art, Washington, DC, 1959. Copyright © 1962 by The Trustees of the National Gallery of Art, Washington, DC. Reprinted by permission.

Sweeney, James Johnson: From *Stuart Davis*. Copyright © 1945 by The Museum of Modern Art. Reprinted by permission.

Kepes, Gyorgy: From *Language of Vision*. Reprinted by permission.

Hiler, Hilaire: From "The Artist and Scientific Method." Reprinted by permission of The American Artists' Professional League.

Knaths, Karl: From "Notes on Color." Reprinted courtesy of The American Abstract Artists.

Birren, Faber: From "Functional Color in the Schoolroom." Reprinted by permission of Mrs. Wanda Birren.

Aach, Herbert: From "Insight Out." Reprinted by permission of Doris Aach.

Land, Edwin: From "Color Vision and the Natural Image." Reprinted courtesy of Chemical Publishing Co., Inc., New York, NY.

INDEX

OTHER BOOKS FROM DESIGN PRESS

DRAWING AND PAINTING FROM NATURE
by Cathy Johnson
Focusing on pencil, pen and ink, and watercolor, this practical, illustrated volume suggests ways to perceive nature from a fresh perspective and capture those perceptions on paper.
Hardcover $27.45 Book No. 50002

CALLIGRAPHY TIPS
by Bill Gray
Gray's latest book of tips explores the various styles of hand lettering, major written alphabets, basic tools, materials, and techniques.
Paperback $12.60 Book No. 50001

THE VISUAL NATURE OF COLOR
by Patricia Sloane
This important and scholarly study analyzes color theories from the sciences, philosophy, and the arts, aiming for an understanding rooted in visual experience.
Hardcover $29.60 Book No. 50000

LOGIC AND DESIGN
by Krome Barratt
This unique combination of text and graphics examines key principles of design and their relationship to art, mathematics, and science.
Paperback $16.60 Book No. 50012

PRINCIPLES OF VISUAL PERCEPTION
by Carolyn M. Bloomer
Combining psychology and art theory, this text explores how we construct meaning from visual information and how the physiological aspects of visual perception are influenced by culture and experience.
Hardcover $27.45 Book No. 50004